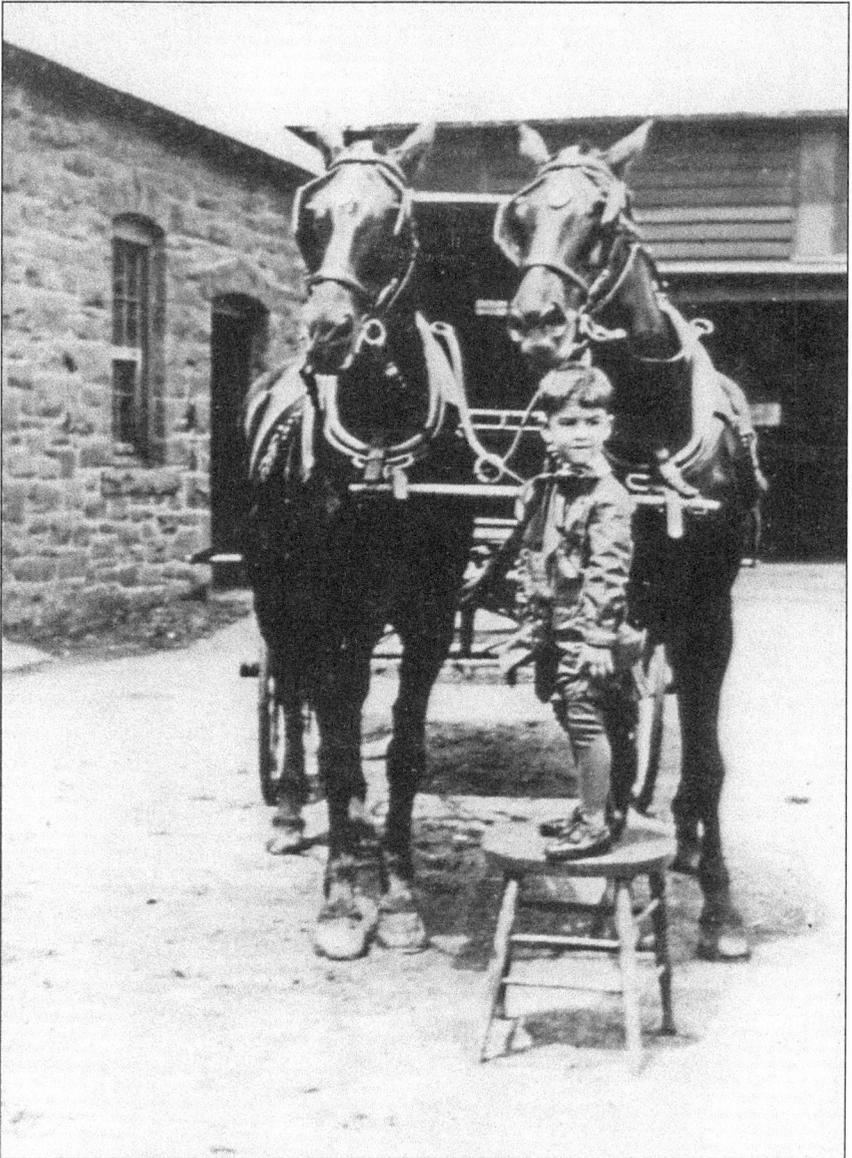

Paul F. Ryan (1907–1995) is pictured with Gyp and Peg about 1912 in the stable area behind the residence of Ralph Hart Ensign (1834–1917). Paul was the nephew of Ensign's caretaker, Patrick J. Ryan. Now the Courtyard on Mall Way, the stables were built by A.J. Ketchin & Son and were made of brownstone from their quarry on Quarry Road, now owned by the Simsbury Land Trust. (Courtesy of Nancy Hall Lindstrom.)

ON THE COVER: This 1907 ivy-clad building, designed by Hartford architect Edward Hapgood and built by A.J. Ketchin & Son, is Simsbury High School during the 1923–1924 school year. After the high school moved in 1960 to a new wing on the junior high school on Firetown Road, the building served as Belden Elementary School. It was renovated in 1983–1984 and became Simsbury Town Hall. (Courtesy of the Simsbury Historical Society Collection.)

IMAGES
of America

SIMSBURY

IMAGES
of America

SIMSBURY

Mary Jane Springman and Alan Lahue
for the Simsbury Historical Society

ARCADIA
PUBLISHING

Published by Arcadia Publishing
Charleston, South Carolina

Library of Congress Control Number: 2011924174

For all general information, please contact Arcadia Publishing:
Telephone 843-853-2070
Fax 843-853-0044
E-mail sales@arcadiapublishing.com
For customer service and orders:
Toll-Free 1-888-313-2665

Visit us on the Internet at www.arcadiapublishing.com

This book is dedicated to the founders of the Simsbury Historical Society:

Charlotte P. Crofut
Nellie G. Humphrey
Mary H. Humphrey
George Mitchelson
Ella B. Ensign
Joseph R. Ensign
Mary Winslow
Arthur E. Humphrey
A.T. Pattison
Lucius W. Bigelow

Kate Stocking
Mrs. Jeffrey O. Phelps Jr.
W.A. Stocking
Henry E. Ellsworth
Nellie G. Eno
Mary C. Eno
Harriette P. Eno
Richard B. Eno
Harriett S. Case

CONTENTS

ACKNOWLEDGMENTS

The authors would like to thank the Simsbury Historical Society, especially Pres. Kevin Gray, for proposing this book. Among those who have helped us along the way, Jackson Eno and Richard Curtiss stand out. Both have provided advice and images from their extensive collections to supplement the images in the historical society's archives. The majority of the photographs in this book are from the historical society's archives, which include gifts from countless donors, like Roland Wolf and William Hayes, and we wish we had the means to thank them all.

For the special attention and encouragement they gave us, we are grateful to Charlotte Bacon; Angela Church; Bill Curtiss, consultant on railroads; Lorraine Curtiss, consultant on Tariffville; Karen Dlubac; Christopher Fisher, photography; Donna Hopkins, archivist for First Church of Christ; Mary Mitchell; Joan Nagy, consultant on Tariffville; James Ray, consultant on Simsbury United Methodist Church; Celia Ann Roberts, general reference; Ieke Scully; Mel Smith, historian for Trinity Episcopal Church; Barbara Strong; Barbara Tuller; and Kurt Wilson.

We also appreciate the gracious help given by the staffs of the Simsbury Public Library, Simsbury Genealogical and Historical Research Library, Connecticut Historical Society, and Connecticut State Library History and Genealogy Unit.

Unless otherwise noted, all images are from the archives of the Simsbury Historical Society.

INTRODUCTION

In the mid-1600s, families from Colonial Windsor, Connecticut, began to move west into an area called Massaco in the Farmington River Valley. They were an enterprising people, drawn by the stands of yellow pine trees used to make pitch, tar, and turpentine for shipbuilding. They also needed land to settle. The broad, flat meadows and rich soil on either side of the Farmington River must have seemed ideal for homes and farms. By 1670, several permanent settlements were in place, and the Colonial legislature granted them town privileges, incorporating the area as the town of Simsbury.

The new town covered 100 square miles. Granby (including East Granby) and Canton broke away to form new towns, and the Scotland District joined Bloomfield. By 1879, the town boundaries enclosed just 34.5 square miles, the size of Simsbury today.

Distinct villages evolved from the original settlements. On the east side of the river, Griswold Village, now known as Tariffville, tapped into the strong flow of the river at "the Falls" and early became an important manufacturing center. Terry's Plain was the site of the first home, first school, and first ferry in Simsbury. Farther south, a cluster of homes and businesses took shape as East Weatogue. It sat below a notch in the Talcott Mountain ridge, which made travel to Hartford relatively easy.

West of the river, there grew the settlement of Weatogue. By 1734, a bridge connected it to East Weatogue and a road to Hartford. A northerly road from Farmington intersected with the Hartford road. With the roads came stagecoach routes, and Weatogue's fortunes rose. Just to the north was the village of Hop Meadow. It was chosen by the drawing of lots to be the site of the first meetinghouse, which served both as the seat of town government and the official church.

Soon, land by the river was entirely claimed, and people ventured farther afield. One settlement, called Case's Farms, then Farms Village, is now West Simsbury. The Meadow Plain and Bushy Hill Districts reached to the town's border with Avon. Westover Plain in the north was better known as Hoskins Station once the railroads arrived. The tableland west of Hop Meadow became Firetown.

In most respects, the local economy resembled other New England towns. Small stores and tradesmen set up shop in the villages to provide goods and services. Sawmills, gristmills, distilleries, and cider presses were built wherever there was the need and the waterpower to run them. Everywhere, farms dotted the landscape and produced a variety of crops, including tobacco.

Tobacco, along with dairy products, had always been a cash crop. Its commercial significance grew in the 19th century when cigars became popular. This area of Connecticut grew a fine-grade leaf used as the wrapper, or outer layer, of a cigar. Late in the century, it risked being displaced by an even finer wrapper leaf grown in Sumatra. Rather than lose their position in the market, Connecticut farmers learned to grow Sumatran tobacco in the shade of cotton mesh tents that simulated the growing conditions in the East Indies. Local farmers adopted the new method, and eventually, the cotton tents covered fields all over town.

Two major industrial sites developed in Simsbury. The village of Tariffville was the home of several carpet manufacturers, the last of which suffered a disastrous fire in 1867. The present brick mill building was constructed in 1868 and housed in succession makers of screws, cutlery, silk, woolens, and lace. By the time the Tariffville Oxygen and Chemical Company closed its doors during the Great Depression, the era when Tariffville was the village with the fastest-growing population in town had already ended.

In 1836, Richard Bacon, a mine superintendent, joined forces with an English firm to manufacture safety fuse, a type of cord that allowed miners to safely detonate the black powder used to blast away rock. The first factory was set up near Bacon's home in East Weatogue. After a fire in 1851, Joseph Toy acquired control of the company and moved it, operating as Toy, Bickford & Company, to its present location on Hop Brook at the southern end of Simsbury Center. By the early 20th century, it was known as the Ensign-Bickford Company and was the major employer and leading corporate citizen in town.

Many buildings at the "manufactory" were made from brownstone taken from local quarries. The company also built neighborhoods of small houses that it rented, and later sold, to its workers. Together with the factory buildings, they gave sections of the town a distinctive architectural look. To the north along Hopmeadow Street, generations of the officers of the firm—the Toys, Ensigns, Ellsworths, Curtisses, and Darlings—built elegant homes that graced the street. Some have been torn down and replaced, while others have been converted to commercial uses.

As the town grew and roads and bridges improved, the villages became less isolated, but still maintained their special identities. Photography, newly popular in the mid-1800s, recorded them. With the start of the Civil War, young uniformed men from Simsbury visited the portrait studios in Hartford to have their images made before marching off to Southern battlefields. Relatives, wives, and sweethearts flocked to the studios, too, for mementos to give to the soldiers.

After the war, Simsbury's population was not large enough to support its own studio, so itinerant commercial photographers visited regularly in hopes of persuading residents to pose in front of their homes or with a favorite horse or pair of oxen. Using glass negatives, the Howes Brothers of Ashfield, Massachusetts, produced some of the clearest photographs in this book. King T. Sheldon of Winsted, Connecticut, plied his trade in town, as did the Northern Survey Company of Massachusetts. At the turn of the 20th century, entrepreneurs developed a lucrative business selling postcards with images of local homes, businesses, and scenic views.

The photographs and postcards in this book provide views of Simsbury's past up to the time of World War II. In them, its possible to recognize familiar streets without paving or curbstones or spot one of the lamps that lit the night before electric streetlights. Horses and oxen shared the roads with early automobiles and trucks. Most of the one-room district schools that preceded today's consolidated schools are represented, as well as some of the teachers and students. Venerable homes that are still standing can be seen as they once were, sitting amid fields and barns. Others appear as they were before they were lost to fire or the depredations of time or were refitted for new uses.

Railroads have a prominent place in the area's history. They shipped local products to markets near and far and helped make the Ensign-Bickford Company a world leader in the manufacturing of the safety fuse. They carried students back and forth to school, tourists to Simsbury's agricultural fairs, the faithful to revivals, and brought back as summer residents those native sons who had left for the big cities to make their fortunes.

More than a nostalgic look at the past, the images here provide a glimpse of the changes in Simsbury and its progress toward the town of today.

One

Hop Meadow and
Northern Districts

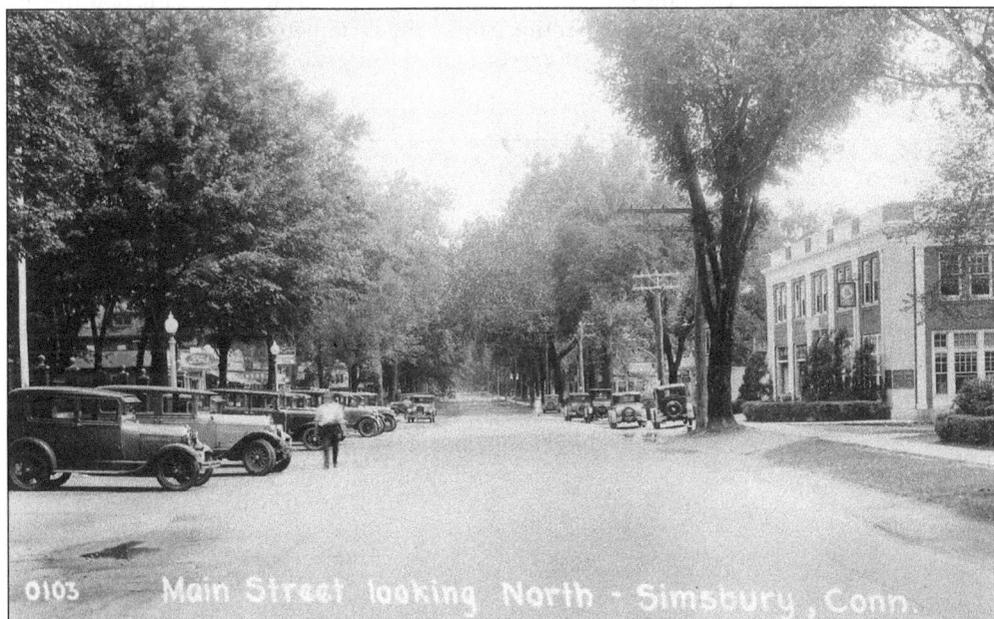

Simsbury's central business district along Hopmeadow Street had begun to look as it does today by the mid-1930s. However, the road appears narrow and tree shaded as it continues northward, quite different from the modern road, Connecticut Route 10 and US Route 202. Notice the Ford dealership sign on the left. (Courtesy of Richard E. Curtiss.)

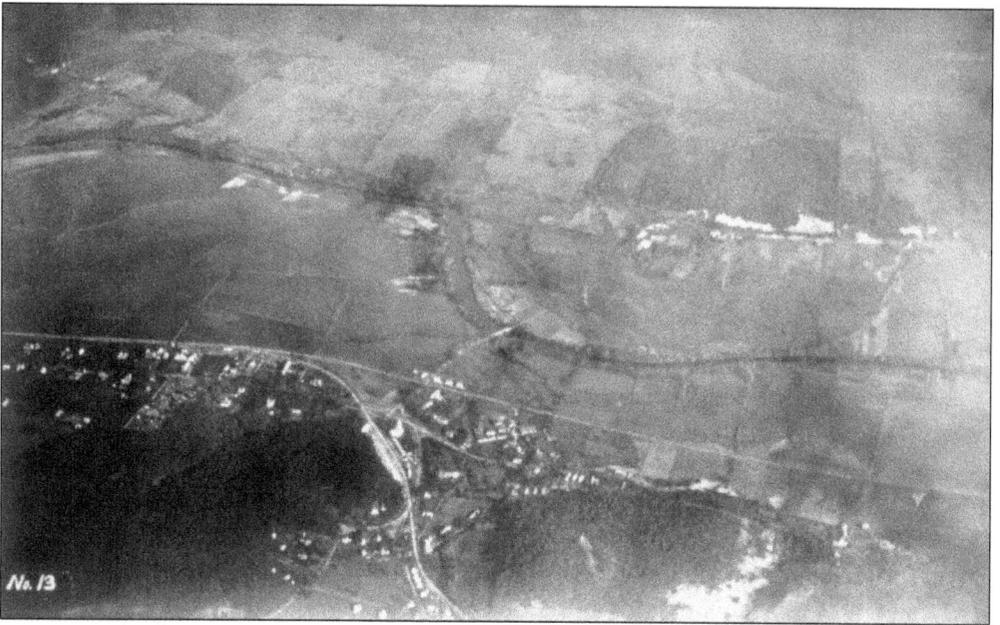

Photographer John G. Doughty took these views of Simsbury from about a mile above the ground while on an 1885 balloon ascension. The photograph above looks west to east and shows the white Congregational church with its steeple and the Hartford & Connecticut Western Railroad running behind it. That railroad curves north and runs parallel to the New Haven & Northampton (Canal Line) Railroad on the eastern edge of the town's business district. The photograph below looks north, showing the two railroads side by side running between Williams Hill, now the site of the Westminster School, and the serpentine path of the Farmington River. Light patches are plowed fields, sand banks, or other forms of exposed soil. (Courtesy of the Connecticut Historical Society, Hartford, Connecticut.)

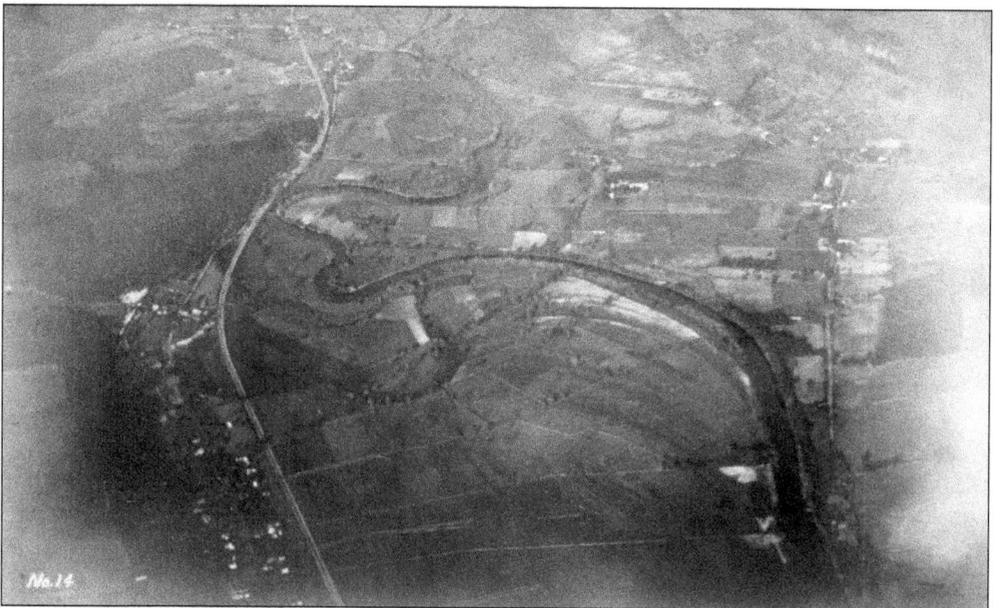

Calvin Barber built these arched culverts in 1826 to carry the Farmington Canal and Main Street, now Woodland Street, over Hop Brook. His brownstone quarry was on the south side of the brook. This photograph was taken about 1942, before the culverts were partially destroyed in the 1955 flood. The past owner of the stereoscope slide below wrote on the back, "On the Tow Path of the Old Canal, Simsbury, Conn. July 25, 1893." The Farmington Canal (1828–1847) ran from New Haven to the Connecticut border at West Suffield, where it joined the Hampshire & Hampden Canal and continued to the Connecticut River at Northampton, Massachusetts. (Both, courtesy of Connecticut State Library.)

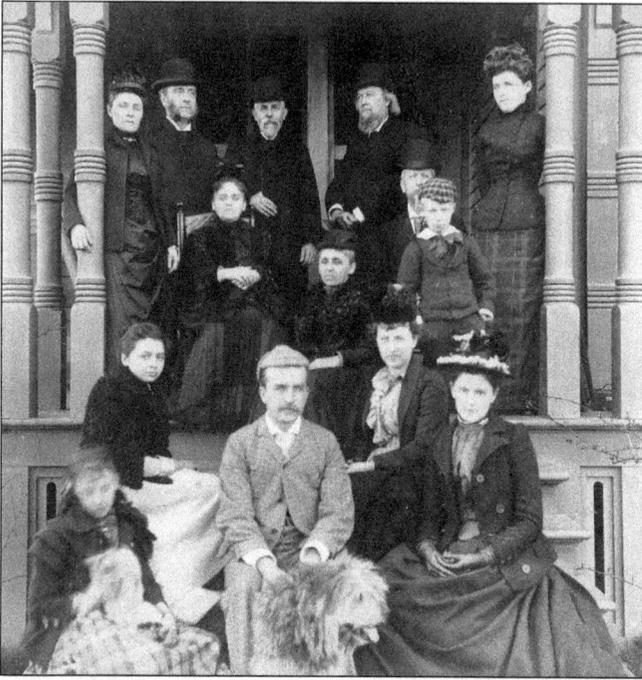

Writing on the back of this photograph identifies Ralph Hart Ensign, located behind the child. Holding the dog is his son Joseph, and holding the cat is his daughter Julia. One of the women is his wife, Susan Toy Ensign, daughter of Toy, Bickford & Company founder Joseph Toy. Another of Toy's daughters, Julia Toy Buck (top left), is next to her husband, Rev. Charles Buck.

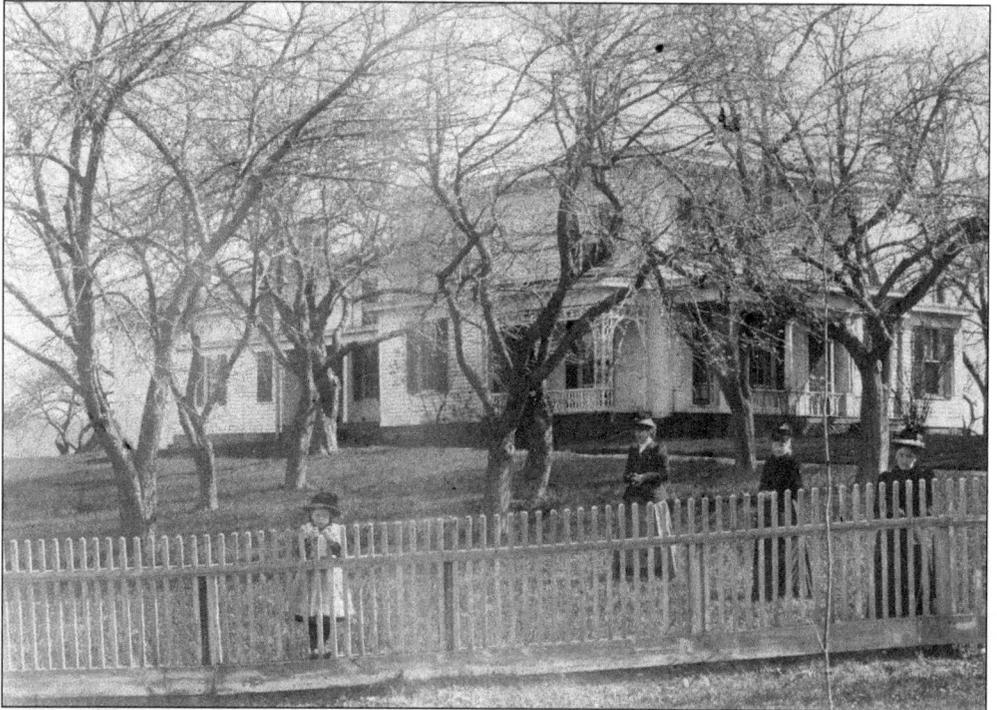

Mary Florilla Seymour Toy, the widow of Joseph Toy, wrote that this photograph was taken about 1891 in front of her home, which stood on Chestnut Hill (now 690 Hopmeadow Street). At the fence is her daughter Josephine Seymour Toy, around seven years old. The women are, from left to right, Mary, Mrs. William Whitehead, and Annie Ryan. Later, the house was divided, and the back section was moved to Woodland Street for Ensign-Bickford Company worker housing.

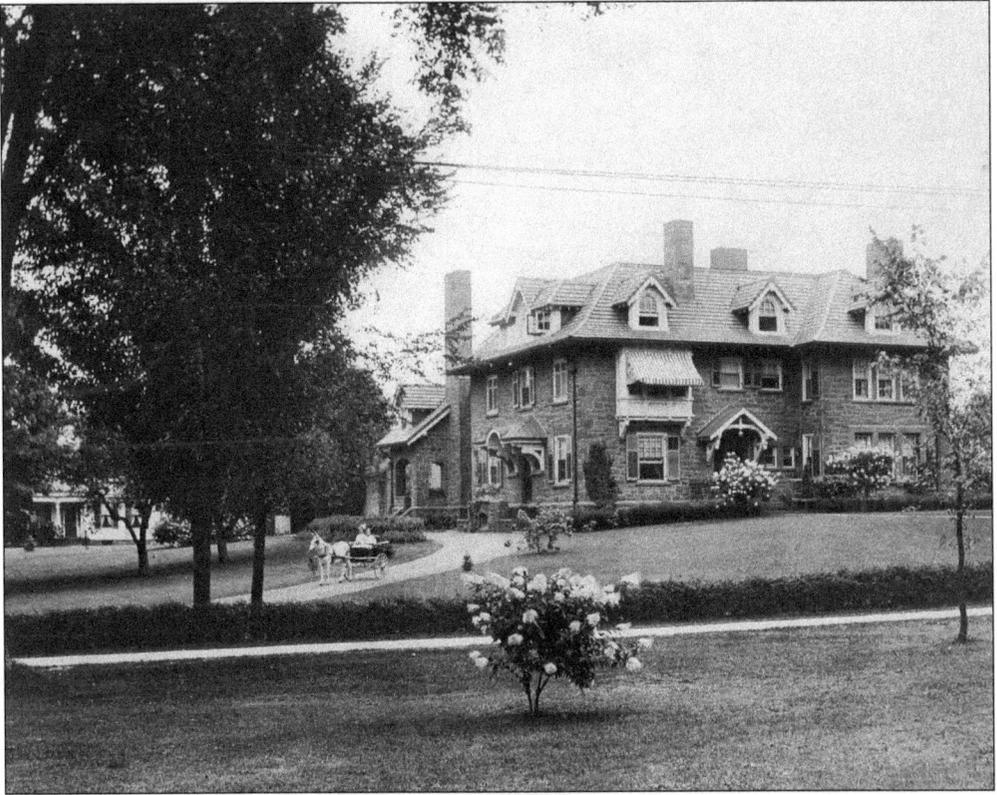

Joseph Ralph and Mary Phelps Ensign built this brownstone home in 1905–1906 on the site of Joseph Toy's long wooden house. The front of the Toy house was moved eastward and became the head gardener's cottage. Shown above, the children in the pony cart are the Ensigns' only child, Mary, called "Polly," and her cousin Bob. The photograph below shows the back gardens. Joseph Ensign succeeded his father, Ralph Hart Ensign, as president of the Ensign-Bickford Company. In 1955, the First Church of Christ bought the 25-room house and used it for a time as a parish house. Now, it is a branch of Webster Bank.

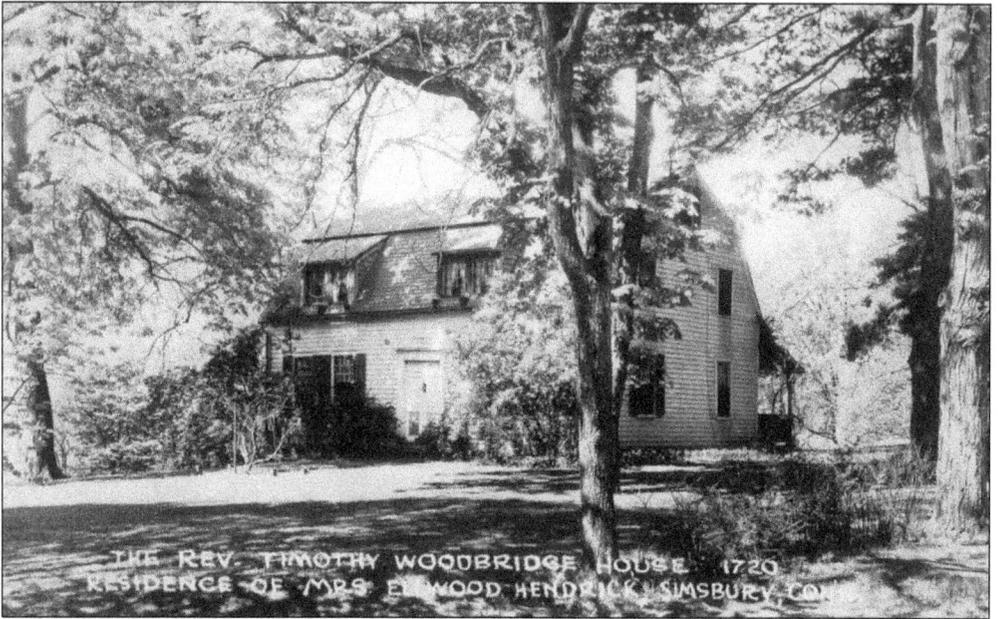

Sent from Hartford by his father to oversee his gin distillery on Hop Brook, Horace Belden (1793–1861) lived in this nearby house, built in 1795. He married Rachel Selina Fowler of Suffield in 1830 and brought her to this house, where they had five children. The house stood at 25 West Street but is now on the grounds of Simsbury Historical Society at 800 Hopmeadow Street.

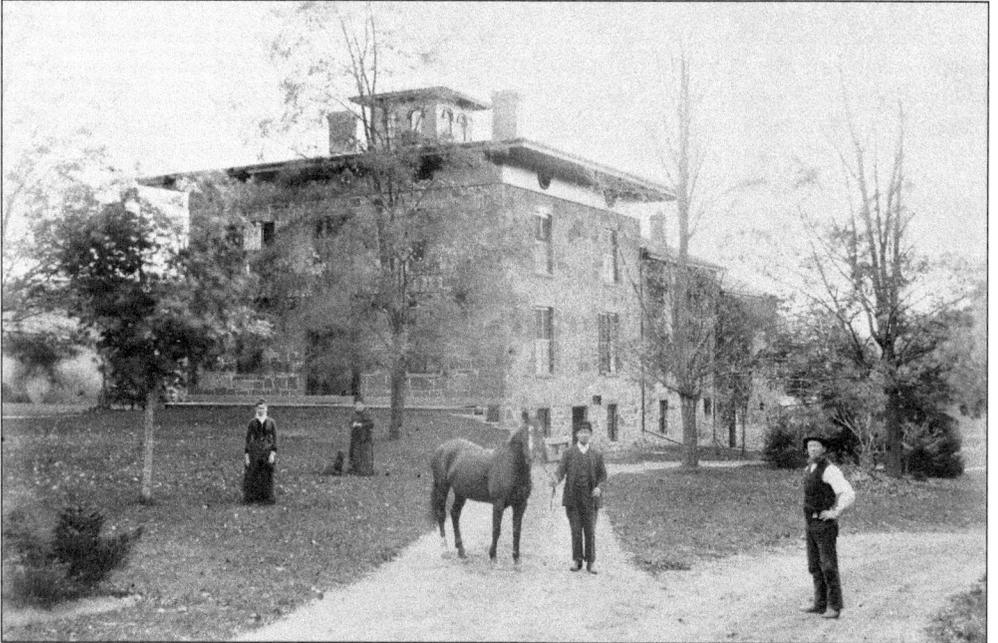

Horace and Selina Belden built this house between 1853 and 1855 from brownstone quarried on Hop Brook's south side. The woodwork was done by Orestes Wilcox. It became the home of their son Horace, a philanthropist who donated most of the cost of building the 1907 high school and Central School. Torn down in 1997, the house has been replaced by condominiums at 1 West Street. (Courtesy of the Clark Collection, Connecticut State Library.)

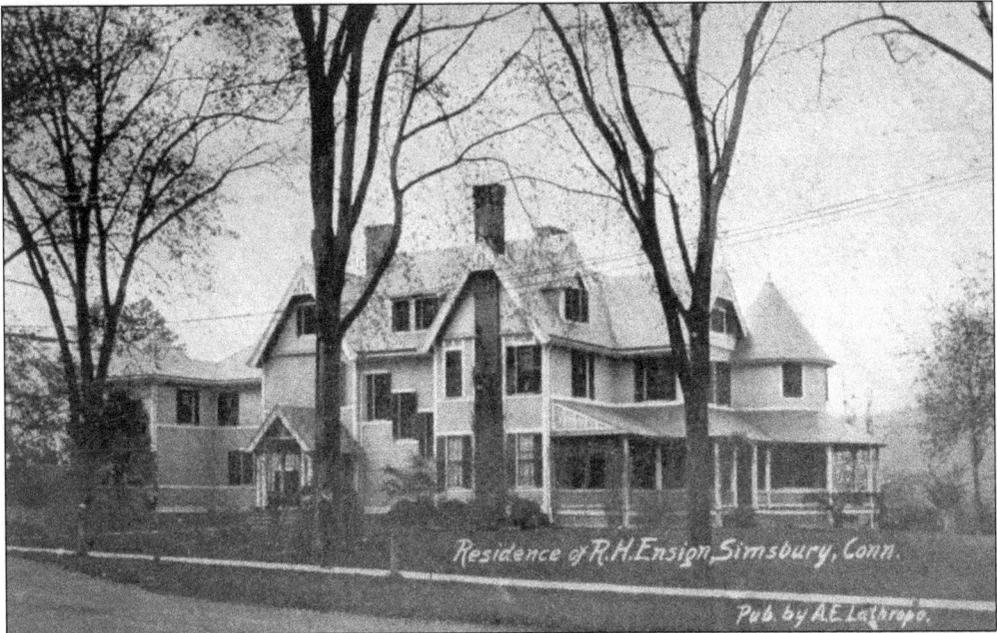

Residence of R.H. Ensign, Simsbury, Conn.

Pub. by A.E. Lathrope.

Ralph Hart and Susan Toy Ensign built "Treverno" in 1881. After the death of his father-in-law, Joseph Toy, in 1887, Ralph Ensign succeeded him as head of Toy, Bickford & Company. The name then became Ensign, Bickford & Company. He held that post until he died in 1917. The home passed to their daughter and her husband, Julia Whiting Ensign and Robert Darling. (Courtesy of Richard E. Curtiss.)

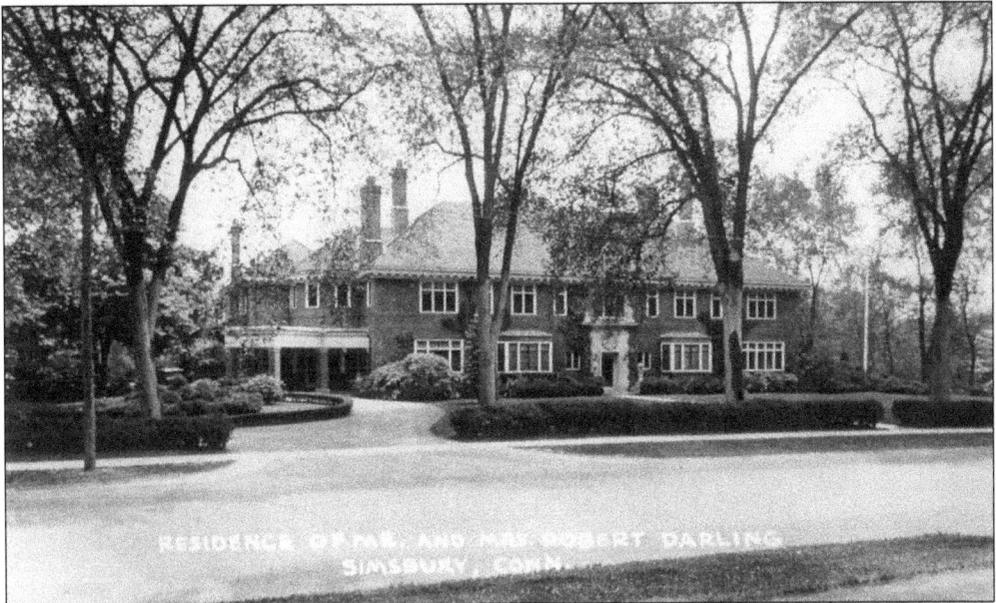

RESIDENCE OF MR. AND MRS. ROBERT DARLING
SIMSBURY, CONN.

The Darlings decided to tear down the wooden Treverno and replace it with a brick-and-cement house. It is believed that Julia Darling had a great fear of fire. Her wish was that the house would eventually be a medical facility. After Robert Darling, a former chairman of the Ensign-Bickford Company, died in 1957, Dr. John L. Cannon bought the house and converted it to doctors' offices.

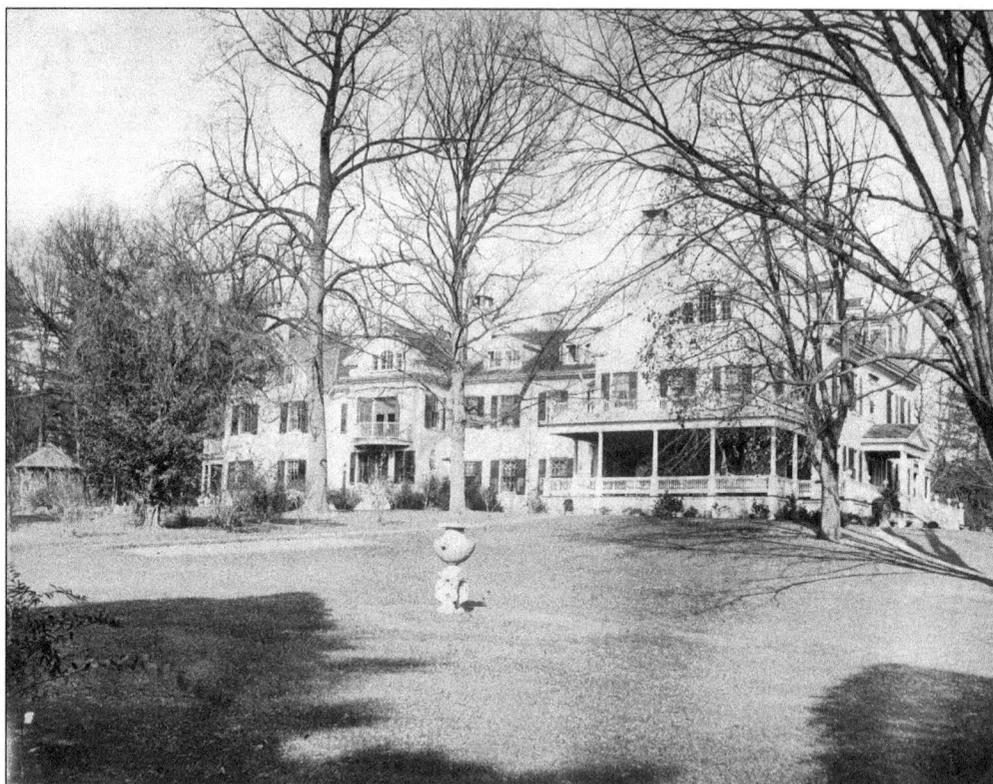

Elisha Phelps (1779–1847) built this house in 1822, and it was expanded by his daughter and son-in-law, Lucy and Amos Richards Eno, with even more rooms added by their daughter Antoinette Eno Wood. Today, it is the Simsbury 1820 House country inn. The south veranda, shown here, has been removed, and the Simsbury Public Library occupies this south lawn and gardens. (Courtesy of Jackson F. Eno.)

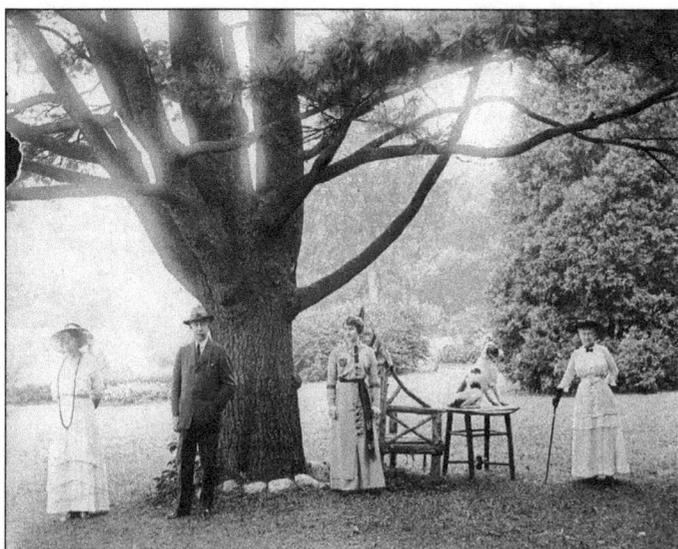

Antoinette Eno Wood (far right) invited the whole town each Fourth of July to an ice cream social and band concert. From the time of her father's death in 1898 until her death in 1930, she used "Eaglewood" as her summer residence, just as her parents had. She is shown here with her brother William Phelps Eno, called the "Father of Traffic Regulation and Transportation Engineering." (Courtesy of Jackson F. Eno.)

Gifford Pinchot (1865–1946) was born in his Eno grandparents' summer home in Simsbury and visited frequently until the death of his aunt Antoinette Eno Wood (1842–1930). He became the first chief of the US Forest Service and was twice governor of Pennsylvania. The Pinchot Sycamore on Hartford Road is dedicated to him. This scene of ice harvesting on the Eaglewood pond would have been familiar to him. Although Mrs. Wood did not sell ice, the commercial ice business was a significant part of the town's economy. Horace Belden had an icehouse behind the First Church of Christ where blocks of ice were loaded into railroad cars.

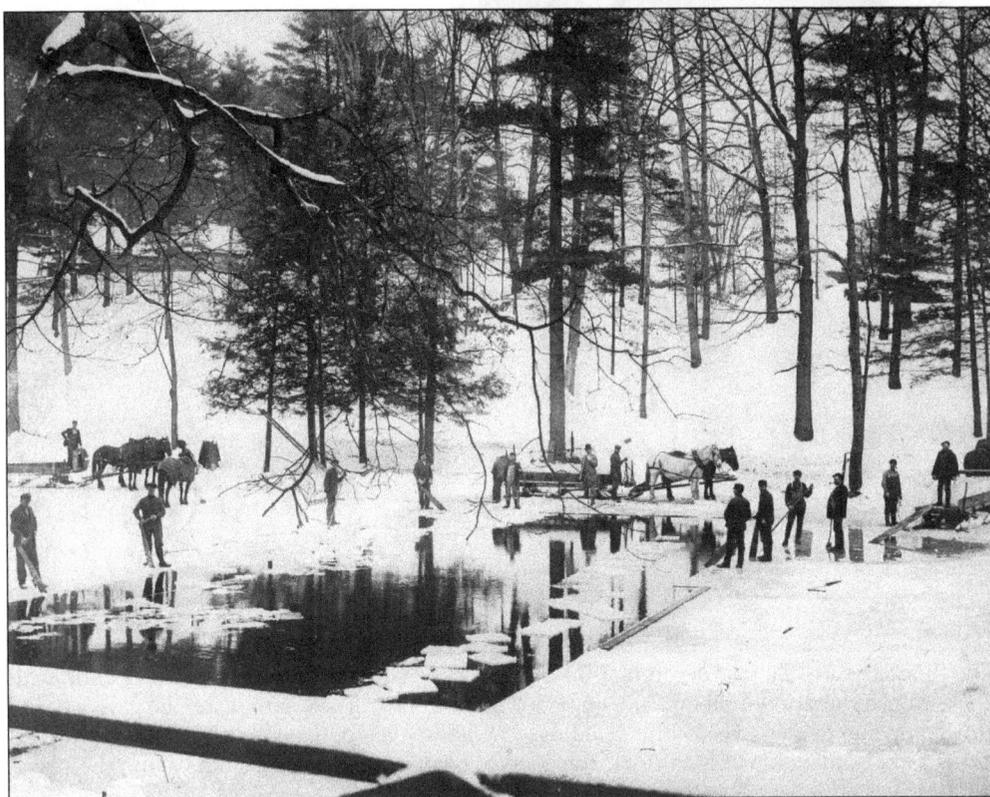

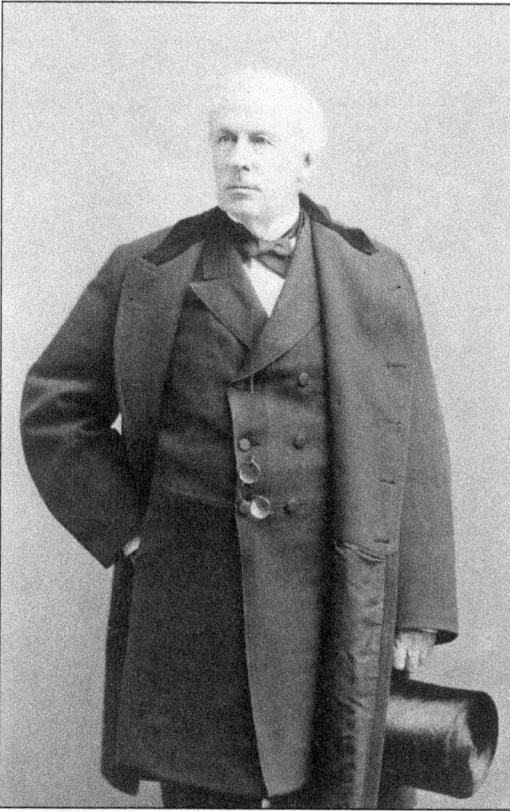

Amos Richards Eno was born in Simsbury in 1810. After attending Rev. Allen McLean's select school, he learned the dry goods trade and started a business in New York. He built his great fortune by investing in real estate and building the Fifth Avenue Hotel. His generosity included refurbishing the Simon Wolcott farm and giving it to Simsbury as a home for its poor and establishing the library.

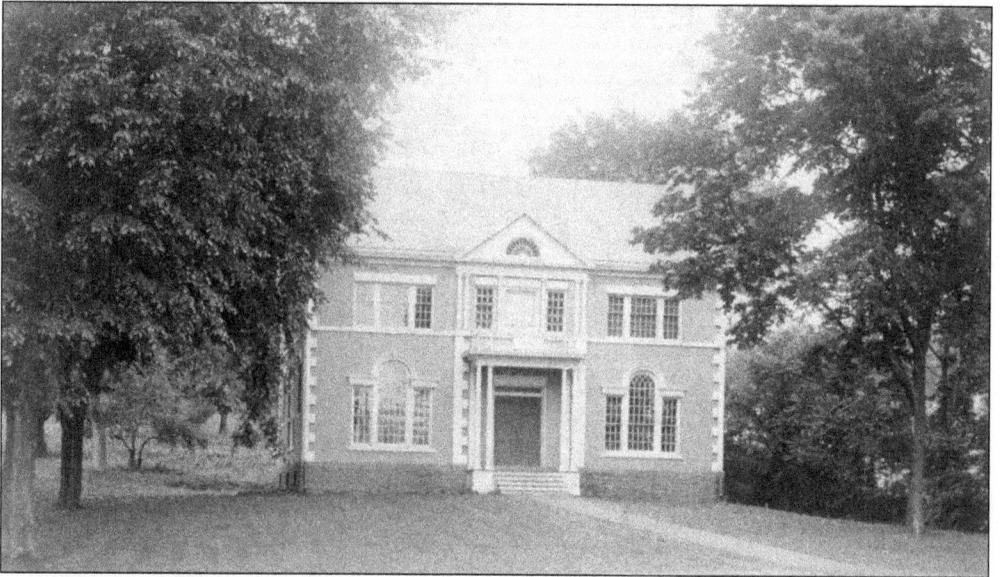

The Simsbury Free Library began in 1874 in the second story of the Hopmeadow School, with books from a subscription library and an endowment from Amos R. Eno. Later, he gave a parcel of his land and money to erect this building. The library was designed in the Colonial Revival style by Hartford architect Melvin H. Hapgood to complement the residences along the street. It was dedicated in January 1890.

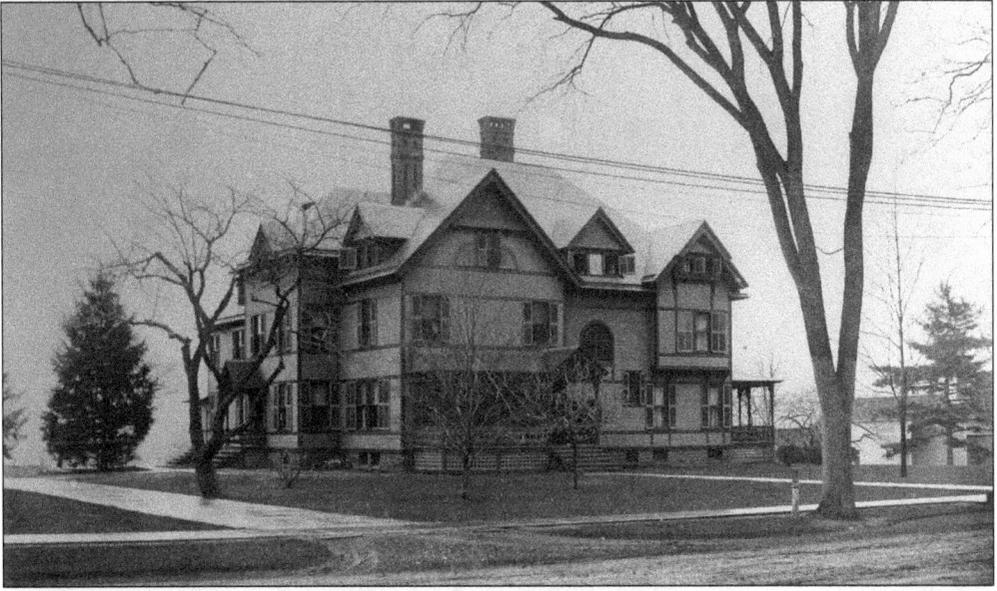

Lemuel Stoughton and Ann Toy Ellsworth built "Roskear" in 1888. She was Joseph Toy's daughter. He became treasurer of the Ensign-Bickford Company, and their son Henry and grandson John became presidents. The house was demolished in 1969. The Simsbury Bank and Trust Building, constructed on the site, incorporated original interior wooden doors and stained-glass windows from the dining room. It now serves as a Bank of America branch.

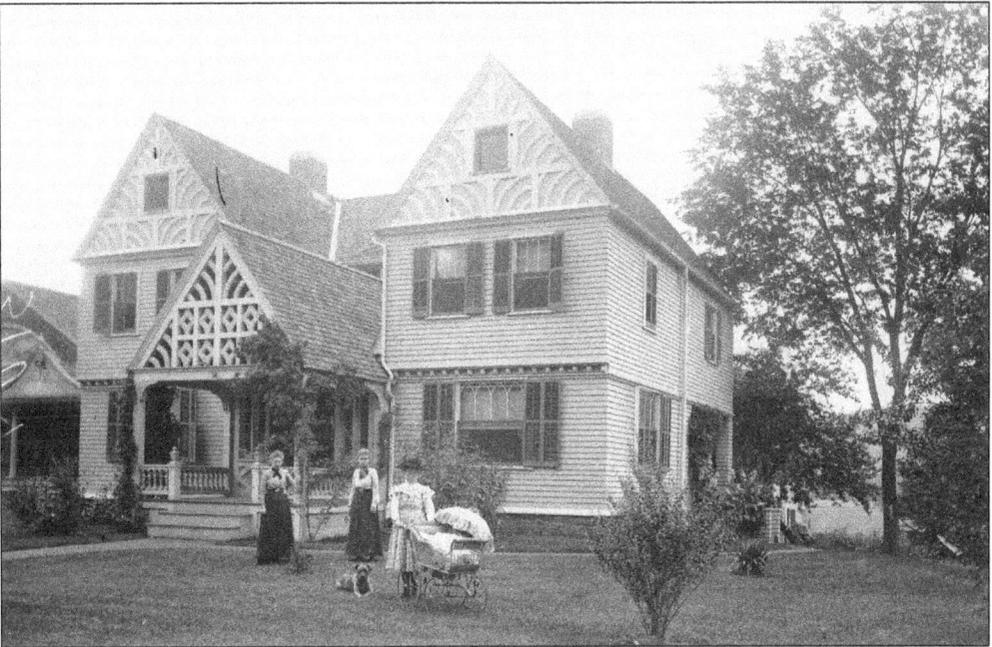

Alexander T. Pattison married Ella Wilcox, whose father, Judson Wilcox, had established the Wilcox general store. They built this house in 1896 around the corner from the store, and the house still stands at 750 Hopmeadow Street. (Notice the Casino that was then on the left.) Pattison, a two-term Republican state senator, served on many business and civic boards, including the Simsbury Bank and Trust and the Simsbury Free Library. (Courtesy of Ashfield Historical Society.)

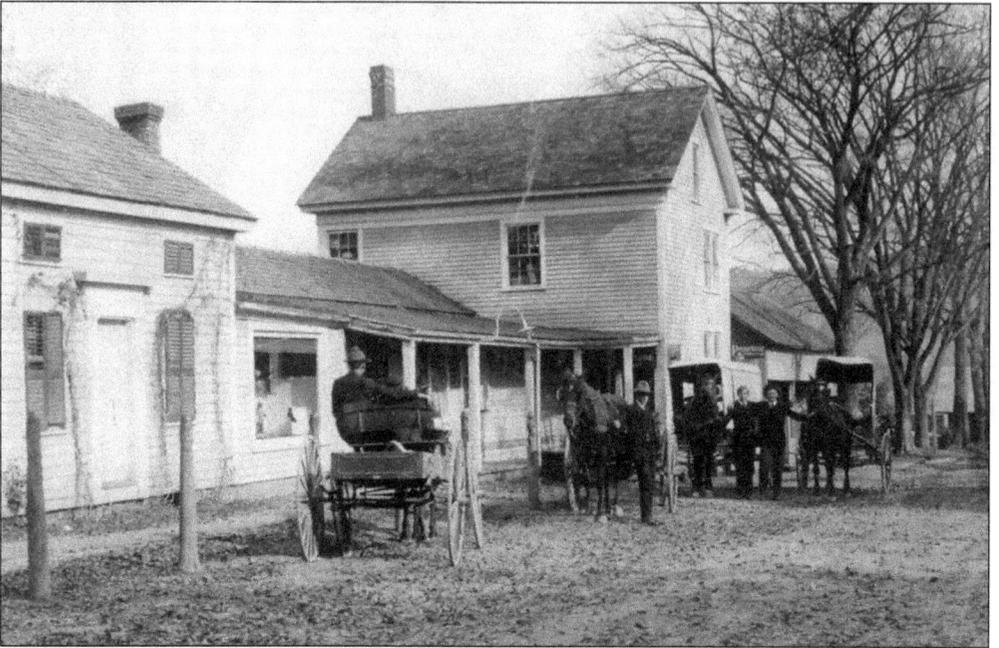

The buildings that once housed this general store still stretch along the north side of Wilcox Street. Judson Wilcox, brother of Watson Wilcox, established Wilcox & Company in the 1850s. In 1926, the store was renamed Pattison & Company. In the photograph below, Alexander T. Pattison, the proprietor, stands on the right. George E. Pattison, his brother, is in the last row, third from the left. Others are believed to be Elbert Potter (upper left), Minnie Selby Pommeau (top row), Charles Vincent (right of Pommeau), Ethel Hall Kennedy (seated), Oliver Tuller (first row, third from left), and Charles W. Hall (first row, left of cloth bag).

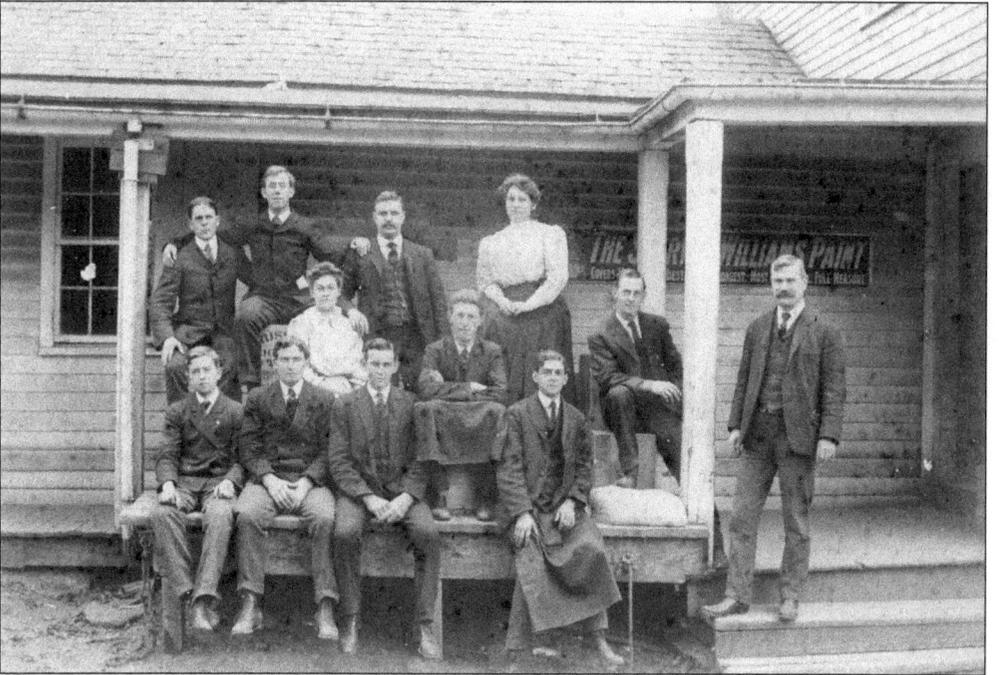

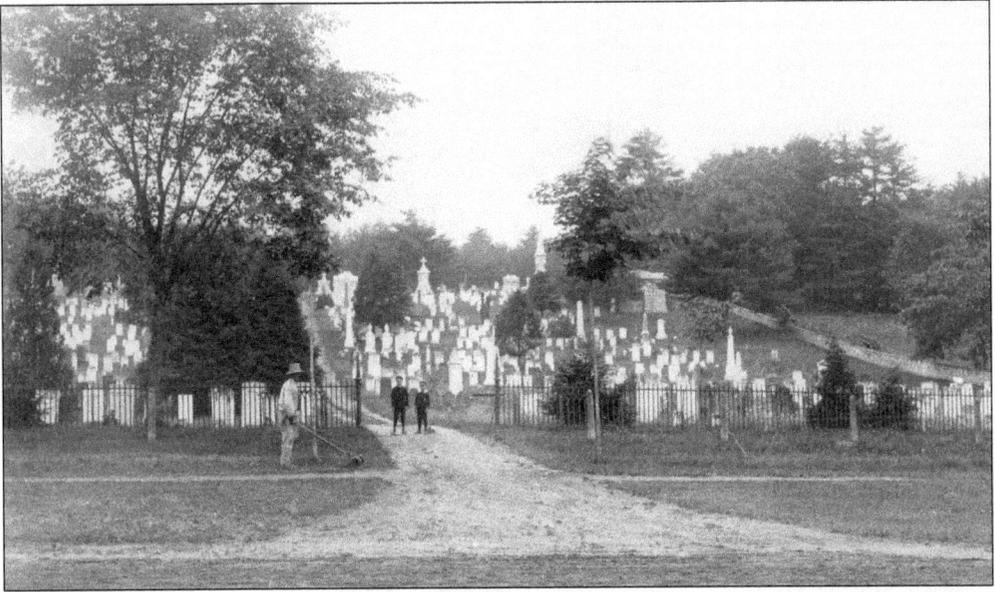

The oldest gravestone in Simsbury Cemetery is that of Mercy Buel, who died in 1688 at age 22. The stones erected since then trace the history of American gravestone carving. Simsbury Cemetery looked like this before 1922 when Lemuel Stoughton Ellsworth and his wife, Ann Toy Ellsworth, commissioned the decorative red sandstone gateway and iron fence that is familiar to all who go along Hopmeadow Street in the center of Simsbury today.

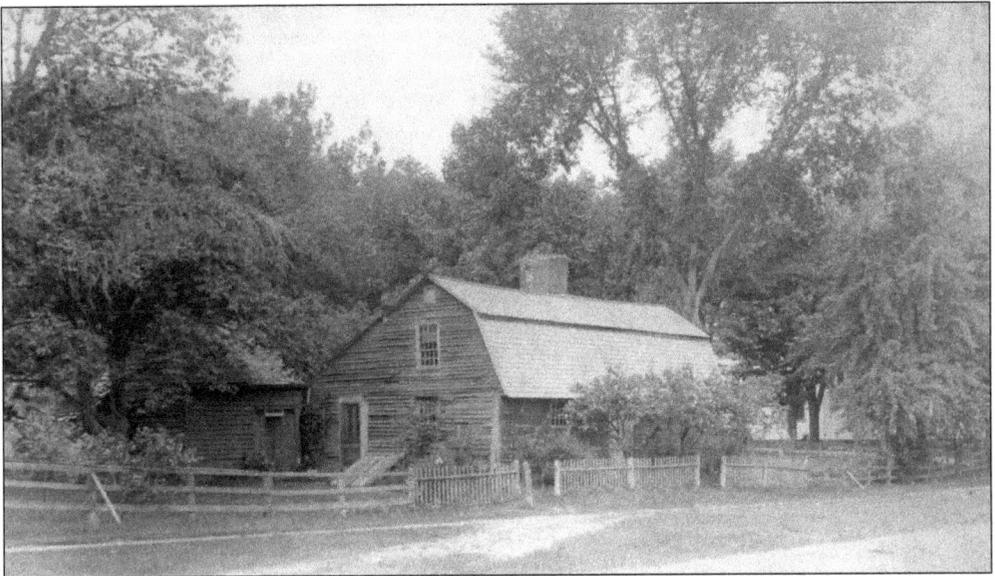

In 1770, the town granted "the Blacksmith's Lot" to Isaac Ensign (1747–1816) to lure him from Hartford. It abutted what is now the north side of Simsbury Cemetery and Hopmeadow Street. Ensign's son Moses was the father of Ralph Hart Ensign, who succeeded Joseph Toy and became president of the Ensign-Bickford Company. This is the Ensign house as it looked about 1895.

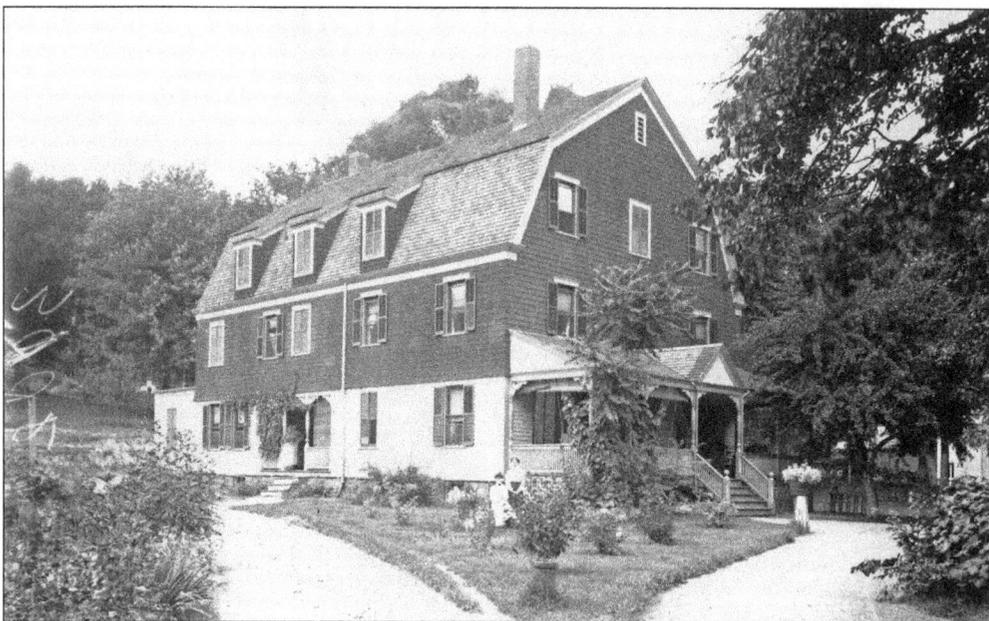

The Maple Tree Inn was built in 1895 to accommodate urban vacationers wanting to board in the fresh country air of Simsbury and to enjoy the pleasant scenery that included authentic Colonial homes. The summer visitors usually arrived by train. The *Farmington Valley Herald* often reported who was staying at the inn and if they were relatives of anyone in town. The building stands at 781 Hopmeadow Street. (Courtesy of Ashfield Historical Society.)

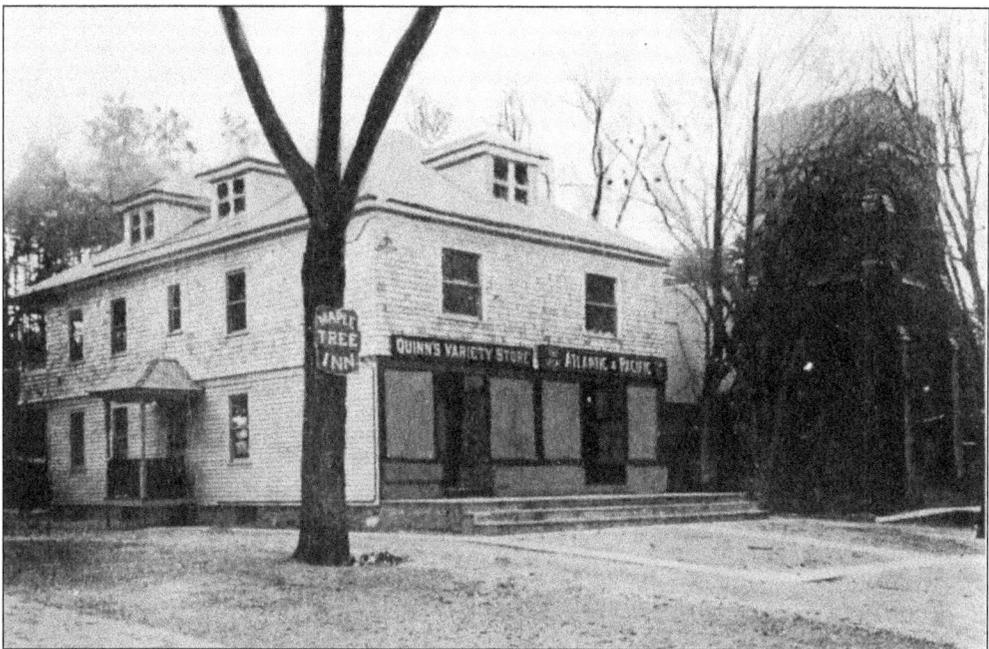

Later, this building obscured the view of the inn. It housed Quinn's Variety Store and Simsbury's first grocery store, the Great Atlantic and Pacific Tea Company, known as the A&P. The building served a succession of other stores before it was torn down. The site is now the outdoor dining area for Apollo's Family Restaurant. (Courtesy of Richard E. Curtiss.)

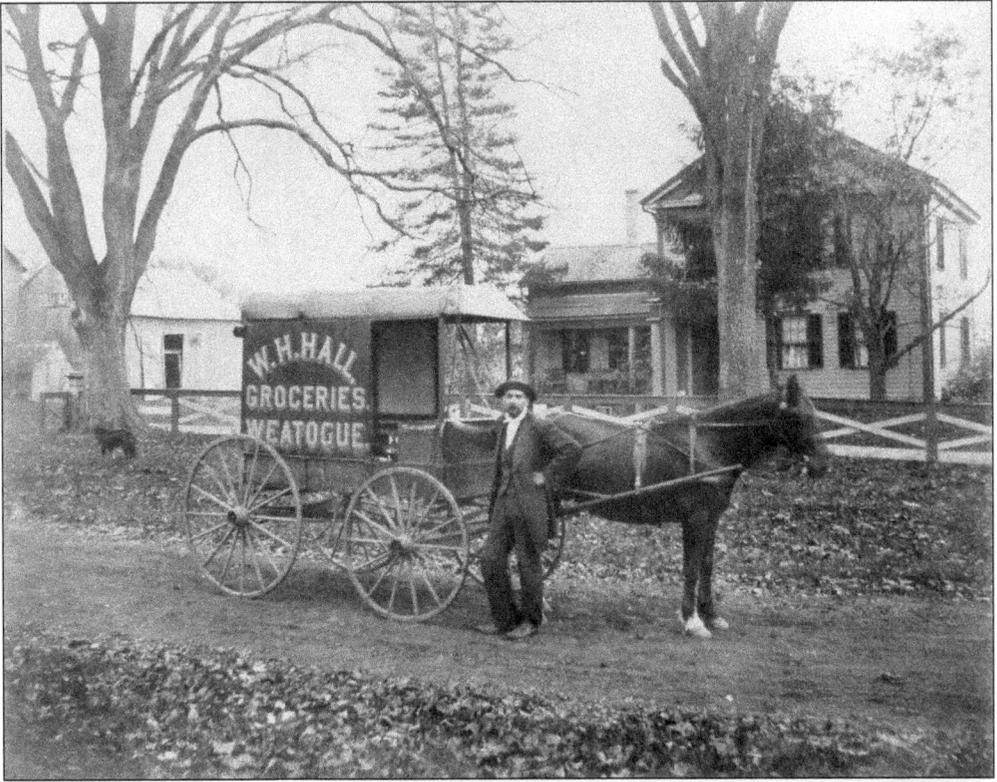

William H. Hall (1859–1929) became a grocer in 1886 and delivered groceries to his customers' doors. Eventually, he established a store on the corner of Hopmeadow and Station Streets, where he served the first ice cream soda in town. Part of that building was demolished, and part was moved behind the Simsbury Free Library in 1896 to make way for the Casino. The photograph on the right shows the north side of the store, Simsbury Cemetery across Hopmeadow Street, and a bit of the W.W. Clark Store on the other side of Station Street. (Above, courtesy of the Clark Collection, Connecticut State Library.)

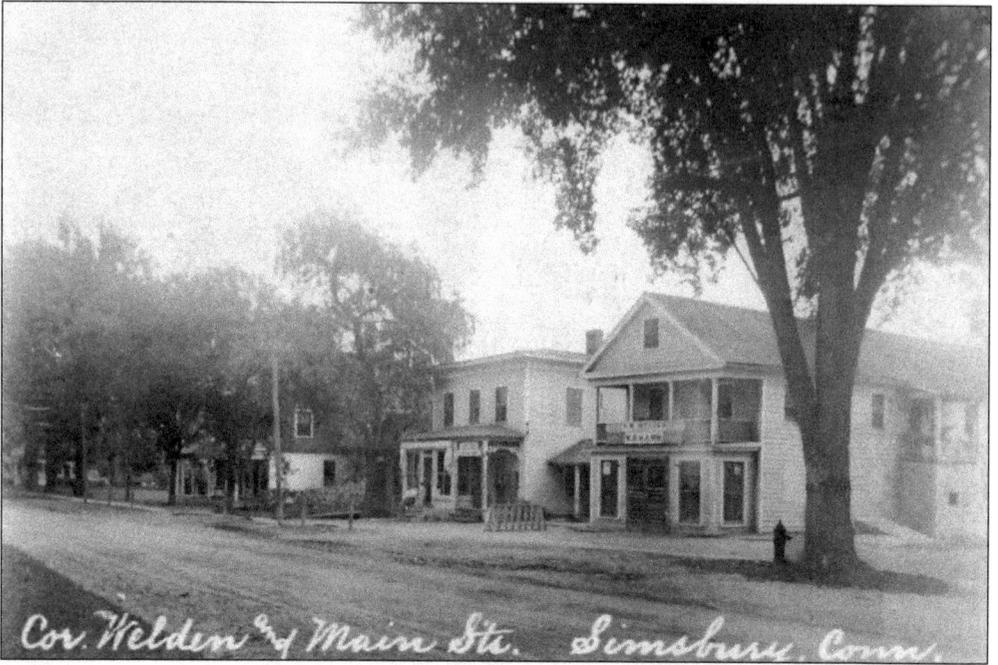

Cor. Welden & Main Sts. Simsbury, Conn.

The above view of the east side of Hopmeadow Street shows the wooden building on the northeast corner with Station Street before it was removed in 1917 to make way for the brick Simsbury Bank and Trust building. The wooden building had the Reuben Welden sporting goods store and W.R. Hamm (later Shea Brothers) meat market. The middle building had Barberi's fruit and candy store. The far left building had the Lathrop pharmacy and the post office. The photograph below looks very similar today. The Lathrop Building has become the Vincent Sport Shop, the small Andrus barbershop in the middle is gone, and the bank building, after a time as Simsbury Town Hall, now houses the offices of a new Simsbury Bank.

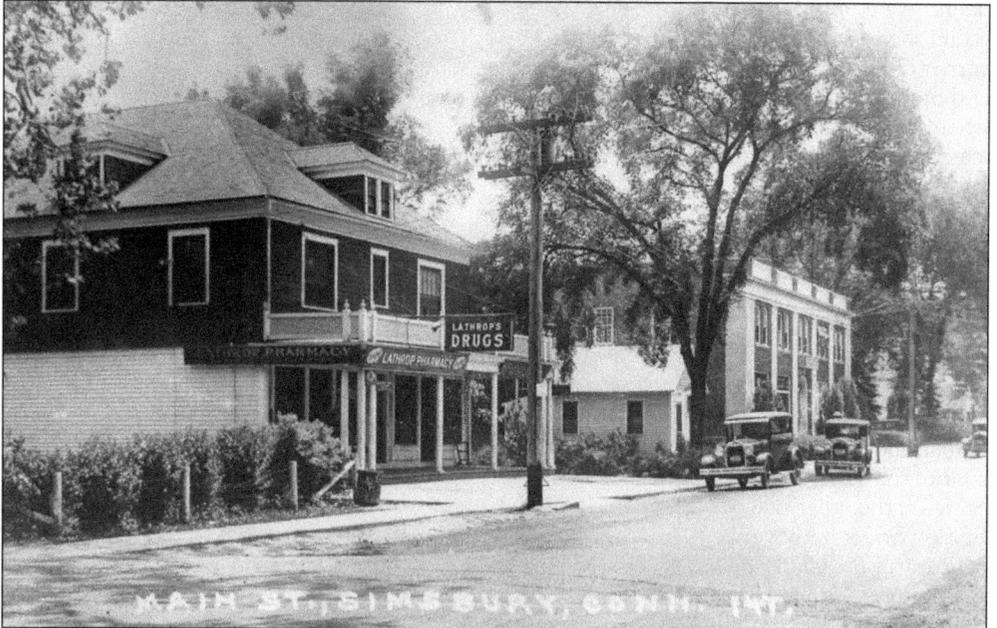

MAIN ST., SIMSBURY, CONN. 14T.

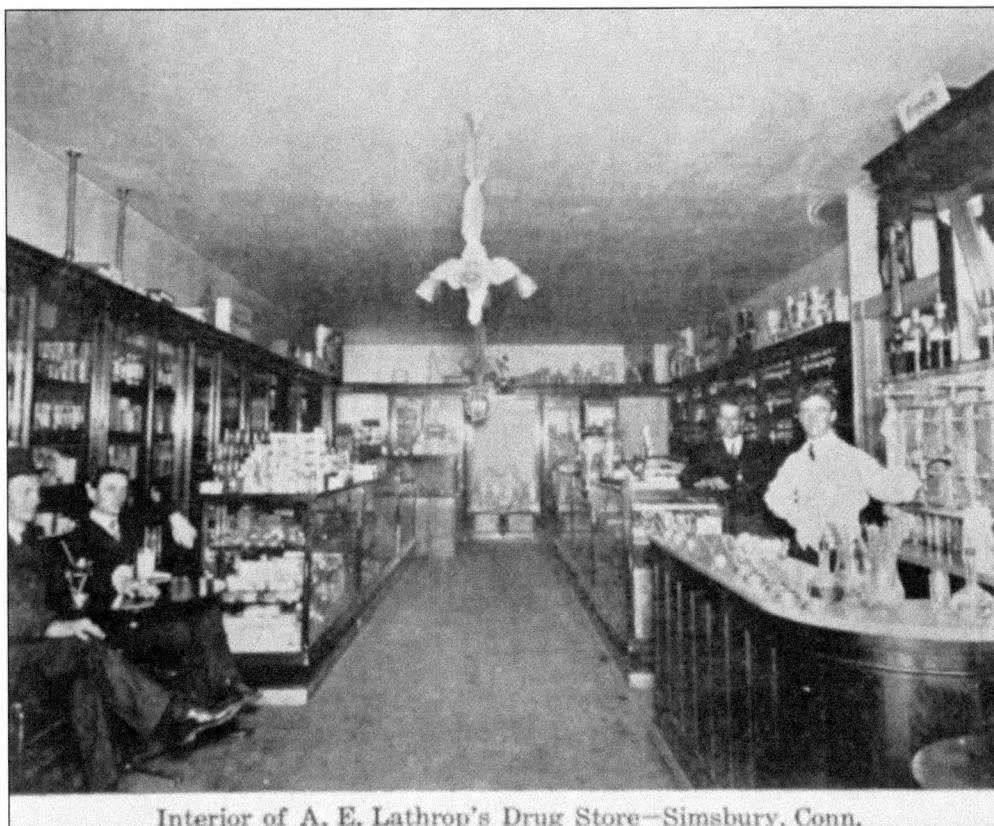

Interior of A. E. Lathrop's Drug Store—Simsbury, Conn.

Pharmacist Arthur E. Lathrop (1868–1960) operated his drugstore from 1904 until 1925. He is behind fountain attendant Jimmie Johnstone. Lucius Beeman from Granby (left) and Charles Andrus are enjoying sodas. The pharmacy later became Doyle's Drug Store. Lathrop published several series of postcards, many of which are illustrations in this book. (Courtesy of the Postcard Collection, Connecticut State Library.)

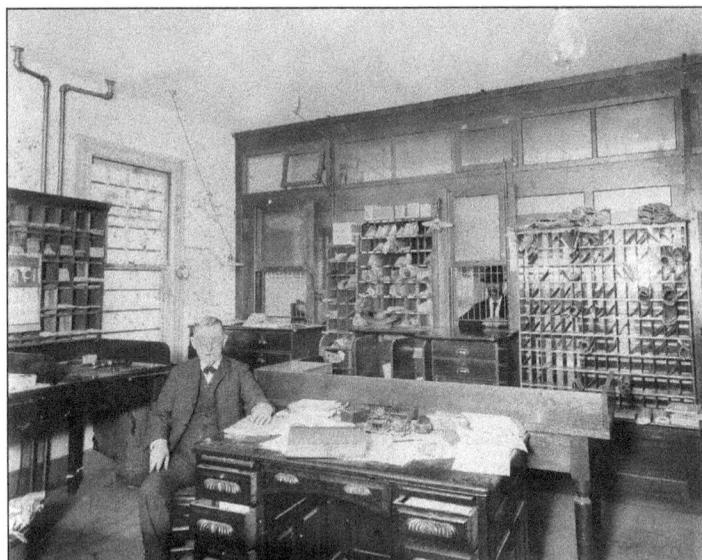

Postmaster Aaron Chapman sits beside his desk in the post office that, for about 50 years, was located in the south half of the Lathrop Building. As the calendar on the left shows, the picture was taken in 1906. The building is now the Vincent Sport Shop.

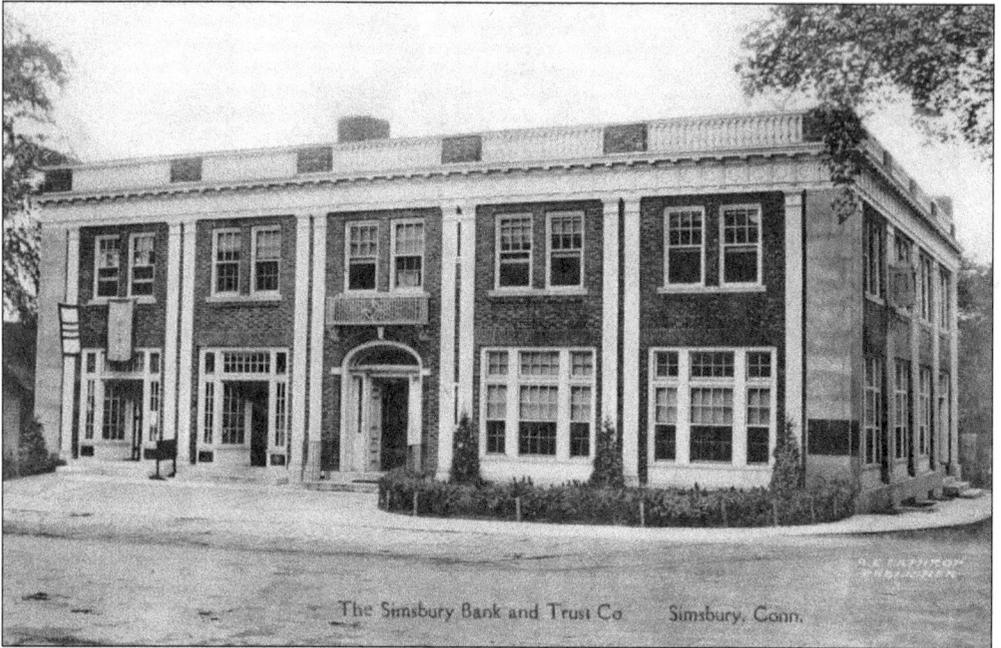

The recently incorporated Simsbury Bank and Trust opened its offices in this new building in December 1917. It occupied the first floor on the right. Upstairs, the "hello girls" of the telephone company operated party-line switchboards. Hall Brothers, an electrical contractor, ran its business on the left side of the first floor, with a lawyer upstairs. The town purchased the building in 1969 to use as Simsbury's third town hall.

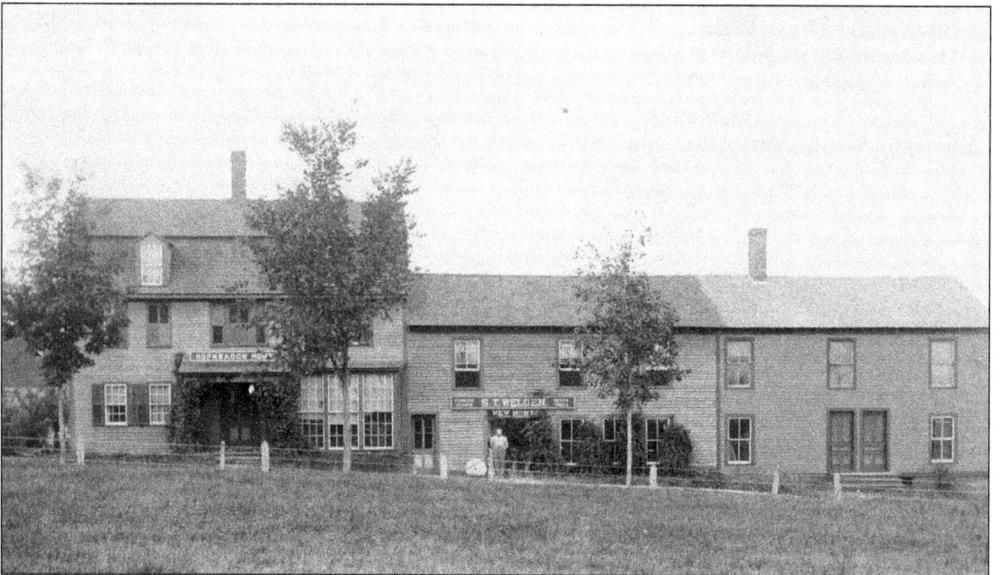

Along the north side of Station Street were the Hopmeadow House (left), a hotel conveniently near the train station; Samuel T. Welden's hardware store, with the family residence upstairs; and Dr. Arnold Eberg's office, with the Masonic Hall upstairs. Samuel Welden owned the whole block, which burned in June 1900. He rebuilt the two buildings on the right in brick. Today, they house Welden Hardware and the Second Chance Shop.

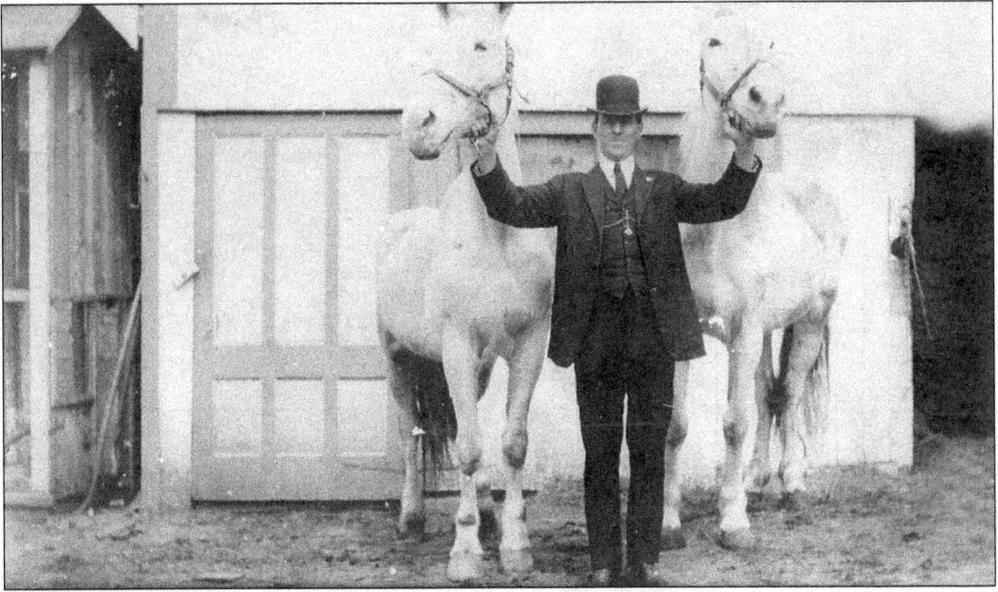

Charles Henry Vincent started his undertaking business in 1902. He kept this matched pair of horses in the barn behind his home at 70 Plank Hill Road. In that era, horses were used to pull the hearse and many funeral services were held in the deceased person's home. (Courtesy of Richard E. Curtiss.)

A pair of oxen is shown taking a drink on North Main Street (the present Hopmeadow Street north of West Street). The watering trough is on the east side just south of Station Street and the one-story Hall store, which was removed in 1896 to make way for the social club called the Casino. In 1932, Eno Memorial Hall replaced the Casino.

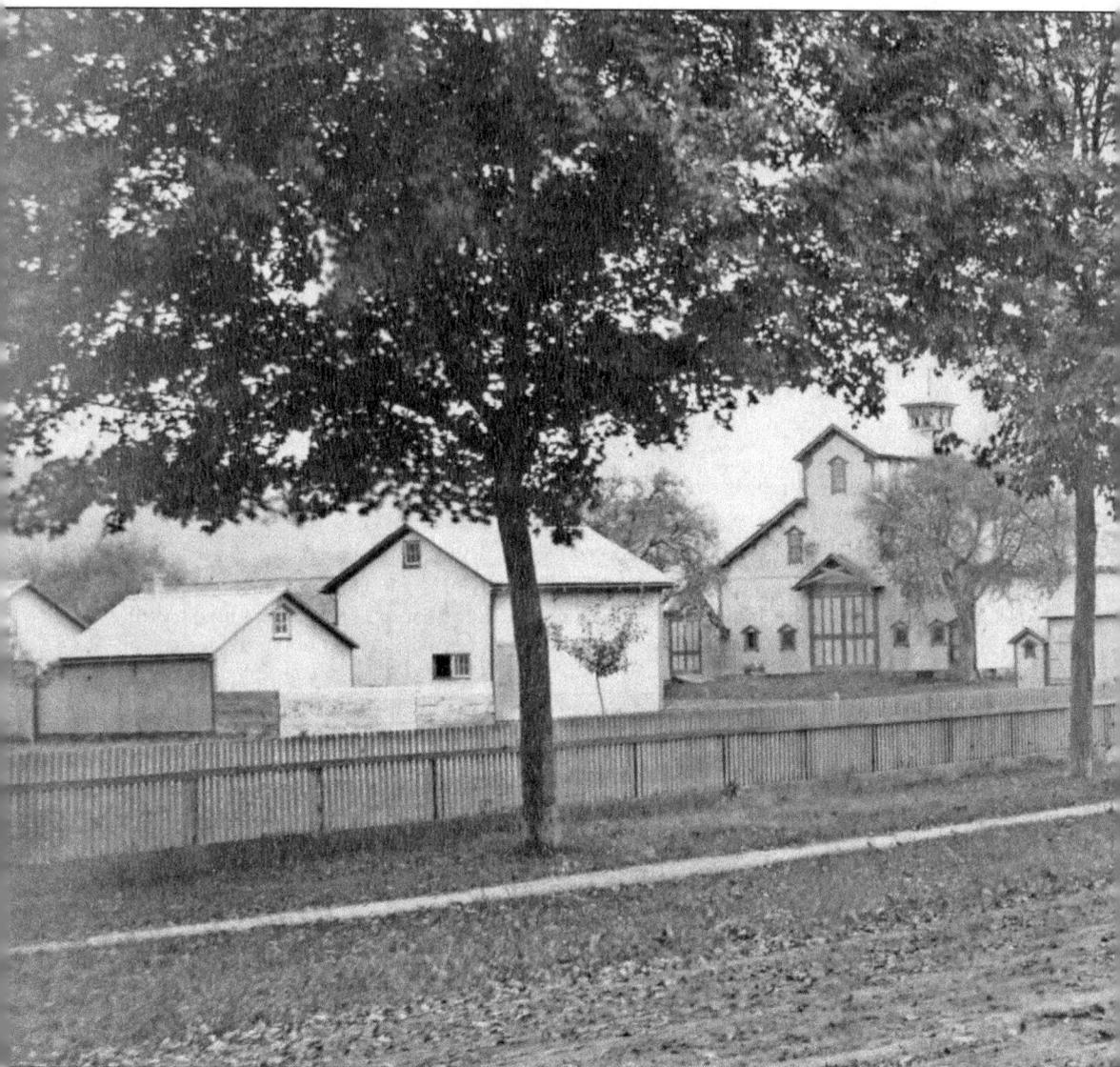

The gambrel-roofed main house on the Phelps homestead was built for Elisha Phelps in 1771 and remained in the family for five generations, nearly 200 years. It was strictly a residence until Noah Phelps acquired a tavern license in 1786 and opened a tavern room. For years, the ballroom on the second story was the largest place of assembly in town after the meetinghouse. In 1792, the Village Lodge of Free and Accepted Masons was organized there. When the Farmington Canal

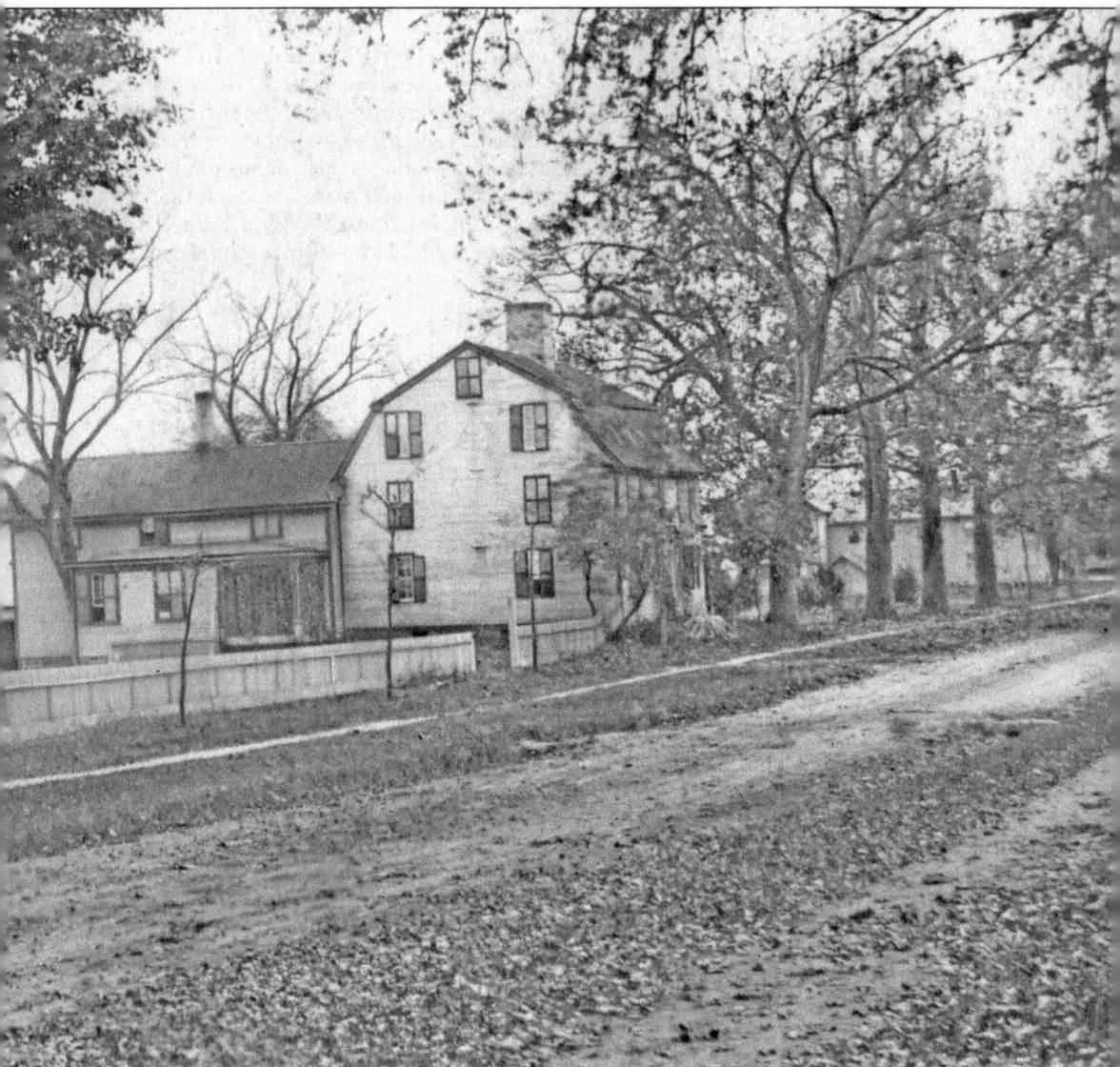

ran just across the street, the house became the Canal Hotel. Lodging was as little as 12.5¢ per night. After being the tavern keeper for 29 years, Judge Jeffrey Orson Phelps closed the business in 1849, and the house resumed being simply a residence. Now, it is home to the Simsbury Historical Society.

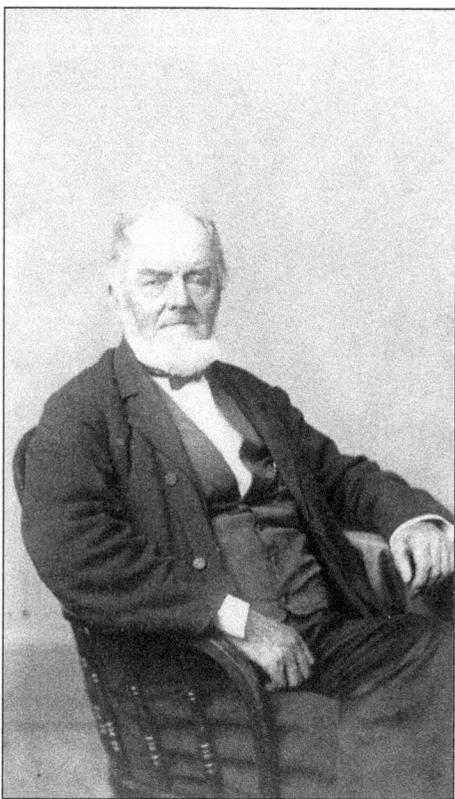

Judge Jeffrey Orson Phelps (1791–1879) was a paymaster in the War of 1812. In 1820, he bought his family homestead. He constructed three-quarters of a mile of the Farmington Canal. A sheriff, he studied law and was admitted to the bar. He and his son Jeffrey Jr. bred cattle and farmed on lands that, in 1865, amounted to 2,500 acres. All this he accomplished with a district school education.

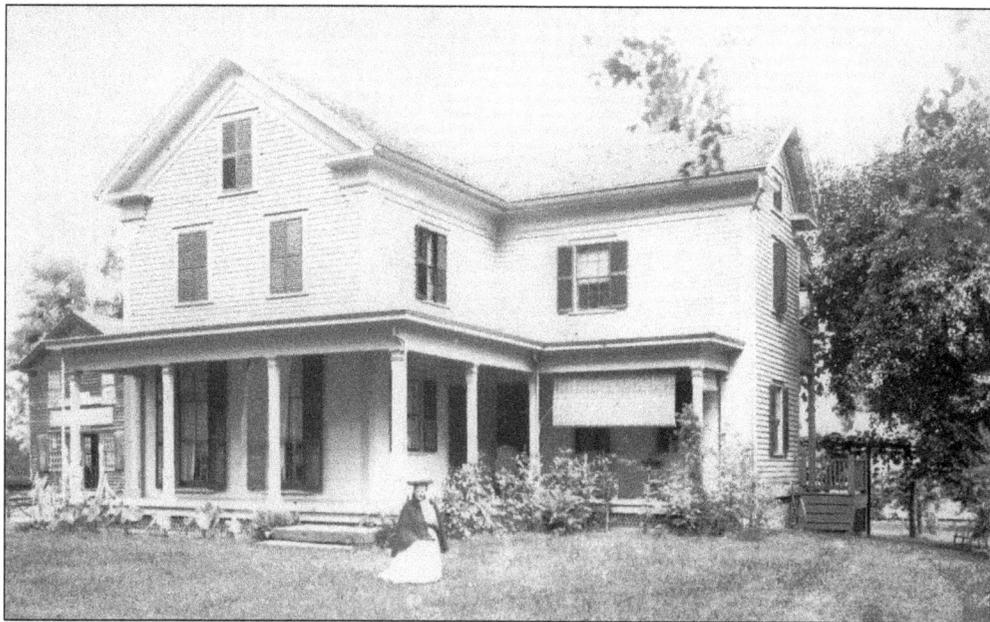

This house, which no longer exists, was the home of the Weed family. Their blacksmith shop is on the left. The shop stood where a service station is now at 850 Hopmeadow Street. The house, built about 1871 and pictured about 1890, stood where Andy's Plaza is today. (Courtesy of Ashfield Historical Society.)

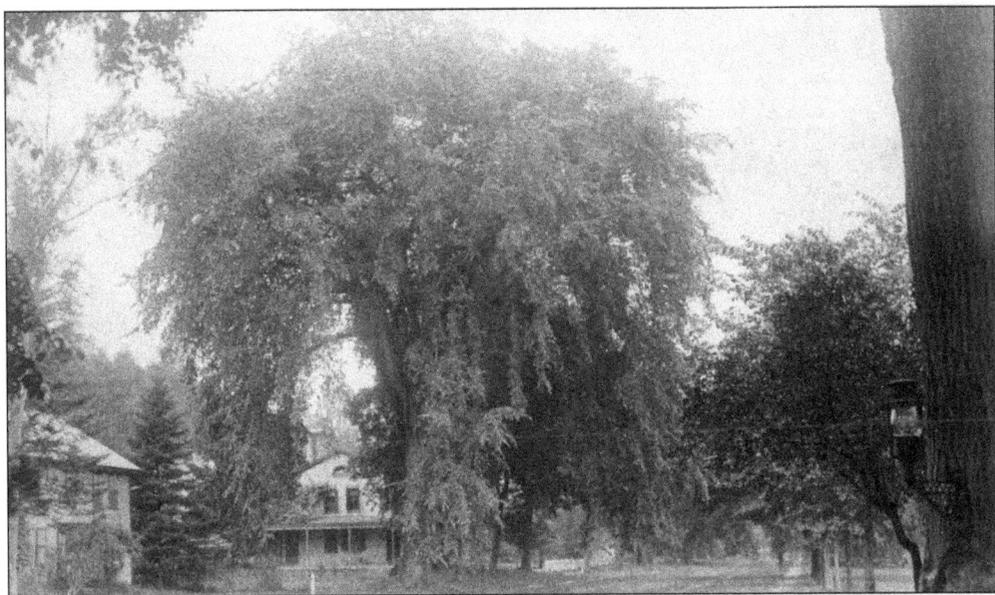

One of the sights to see at the turn of the 20th century in Simsbury was this enormous elm, called King Ulmus (Latin for elm). Until it blew down, it stood between the houses of James and Charlotte Phelps Crofut (left) and George and Nellie Goodrich Eno. The houses are now the Methodist church annex and the A Better Chance (ABC) House. Notice the street lantern on the tree to the right.

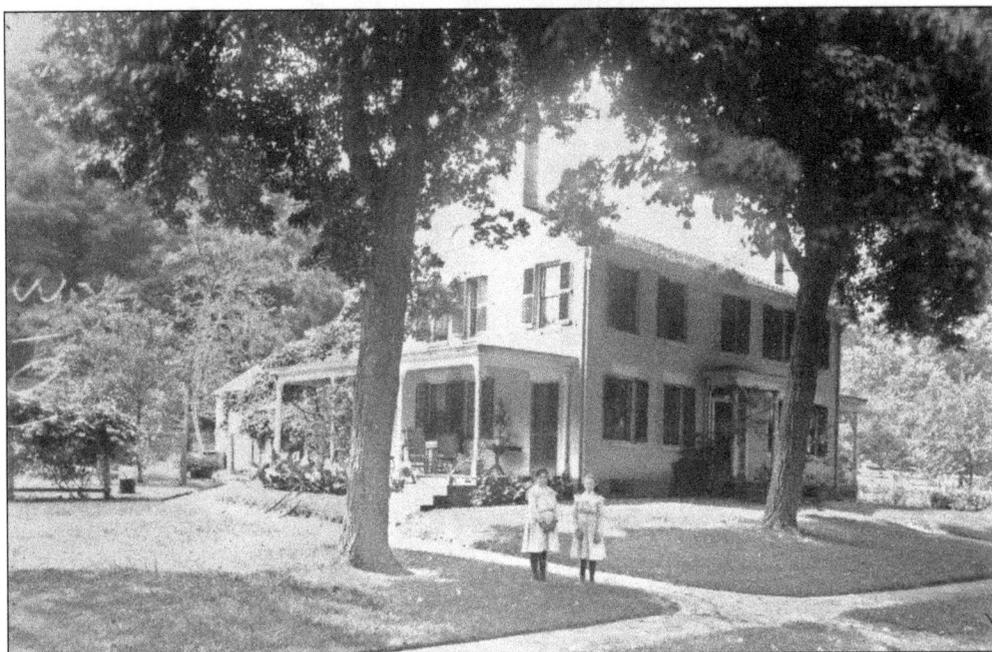

The house at 835 Hopmeadow Street, which currently serves as home during the school year for high school students in the Simsbury ABC program, was built in 1812 by Ariel Ensign. This photograph was taken about 1902 on a glass negative by the Howes Brothers, who were traveling photographers. (Courtesy of Ashfield Historical Society.)

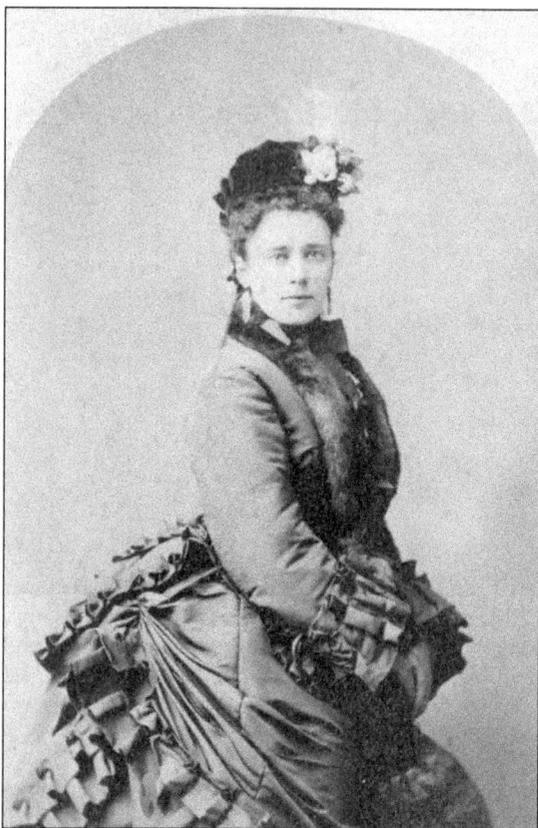

As a young man, Watson Wilcox (1802–1879) went to the South, where he established a business selling Yankee wares. With his fortune made, he returned to Simsbury, where he increased his wealth though financial investment. He married Cordelia Eno. Their son, Louis Watson Wilcox, died at 11, so their daughter Adelaide Eno Wilcox (1841–1914) became their only child. They built a large brownstone house about 1857, which passed to their daughter. She added the front portico and other Italianate-style features. Adelaide (left) has been described as reclusive during her later years. A romantic story evolved that, on a trip to Europe, she was wooed by an Italian count, but her parents refused to allow a marriage. From that time, it is said, she withdrew from society. Today, the house is the Vincent Funeral Home, located at 880 Hopmeadow Street.

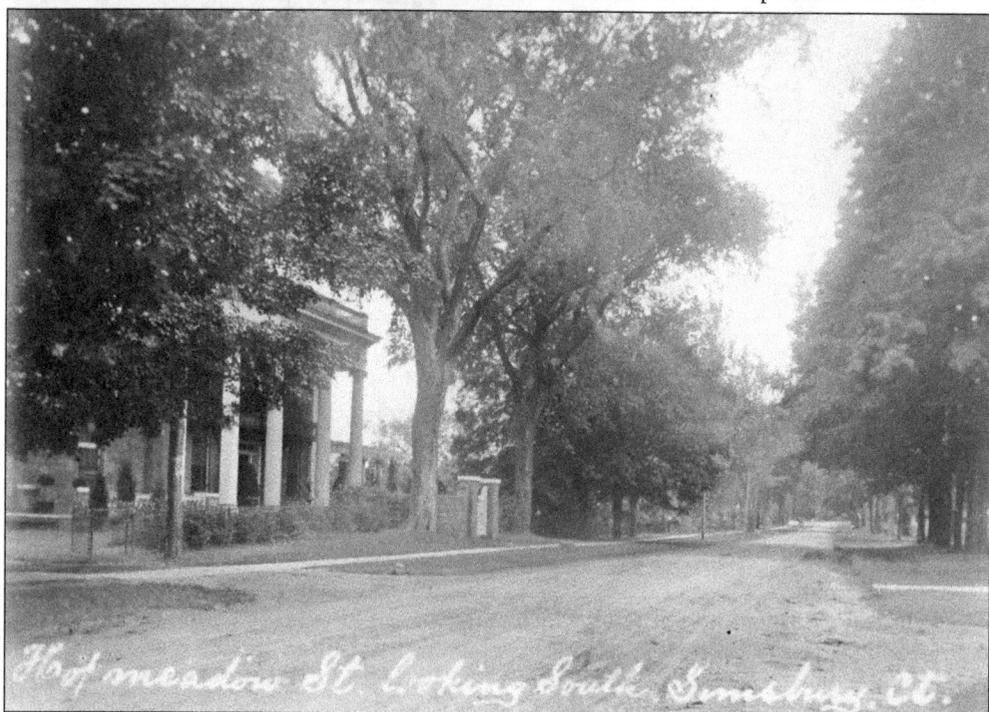

Hopmeadow St. Looking South, Simsbury, Ct.

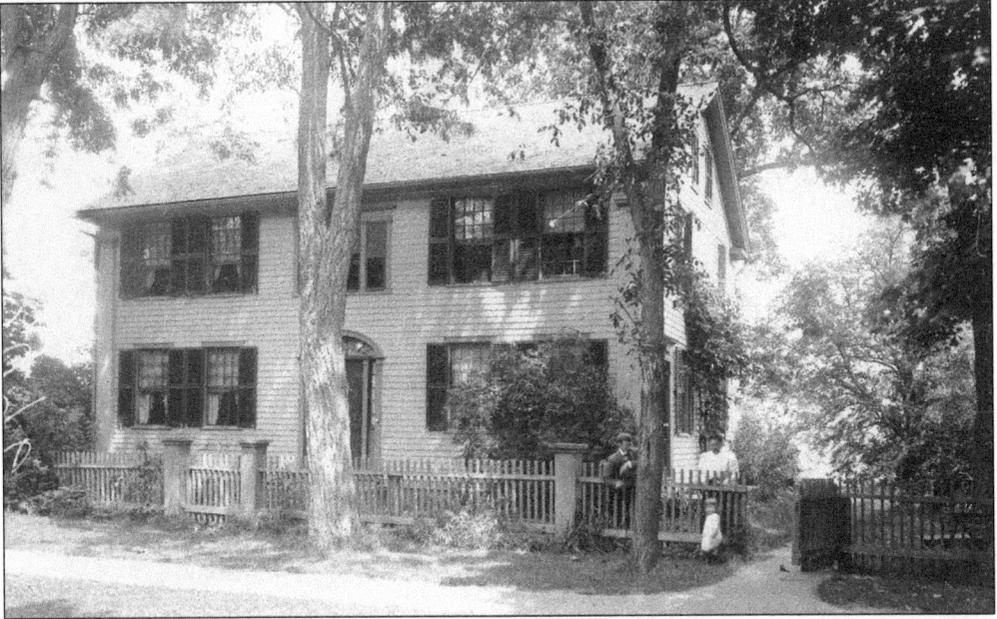

Built by Titus Barber in 1812, the ell on the rear is a portion of John Slater's 1690 house. Barber, who died in 1835 at age 60, was a leading manufacturer of tinware. He employed many workmen and sent itinerant peddlers to the South to make sales. This photograph was taken between 1886 and 1907. The house, now an office, stands at 920 Hopmeadow Street. (Courtesy of Ashfield Historical Society.)

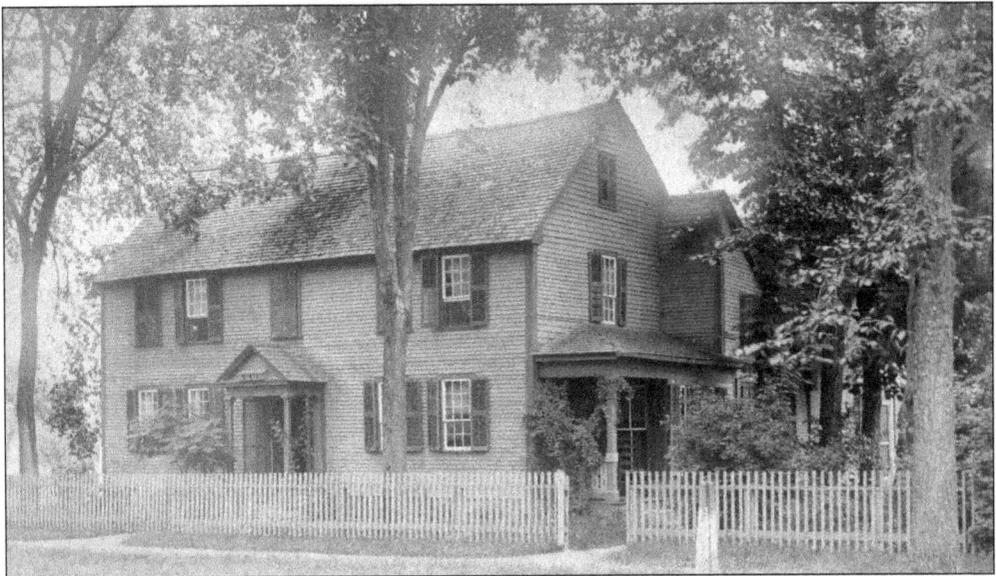

Rev. Benajah Roots built this house in 1762. It became the home of Maj. Elihu Humphrey, who died here after being wounded and imprisoned during the Revolutionary War. Simsbury historian Dr. Lucius I. Barber also lived here. This photograph was taken about 1887. Like the Titus Barber house, this house at 930 Hopmeadow Street is now part of the Simsburytown Shops.

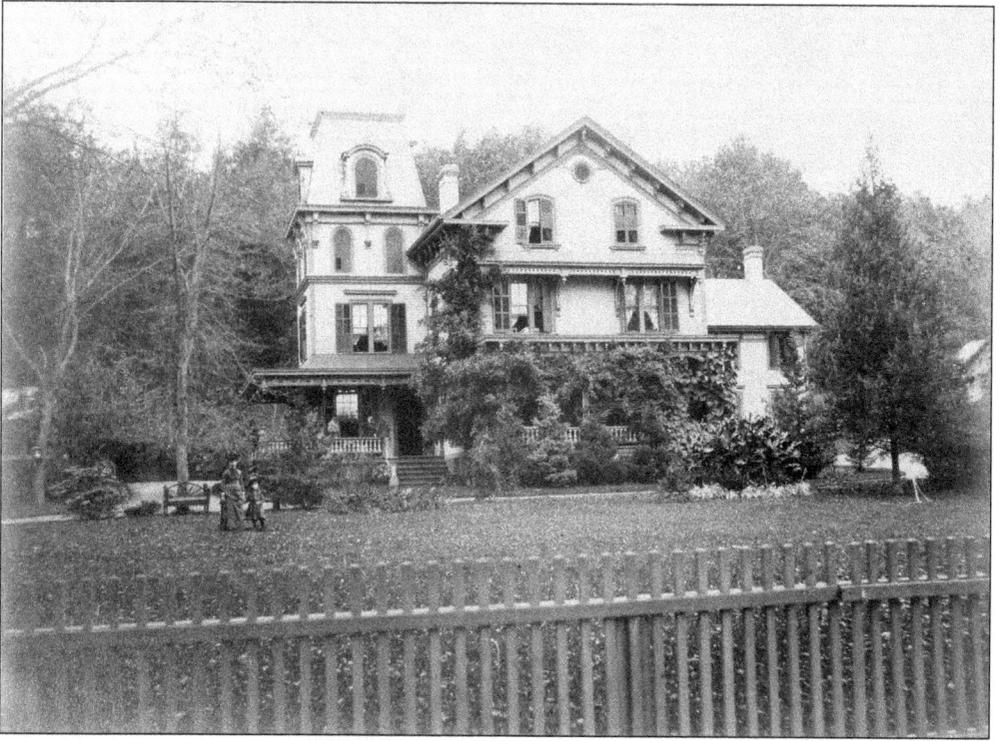

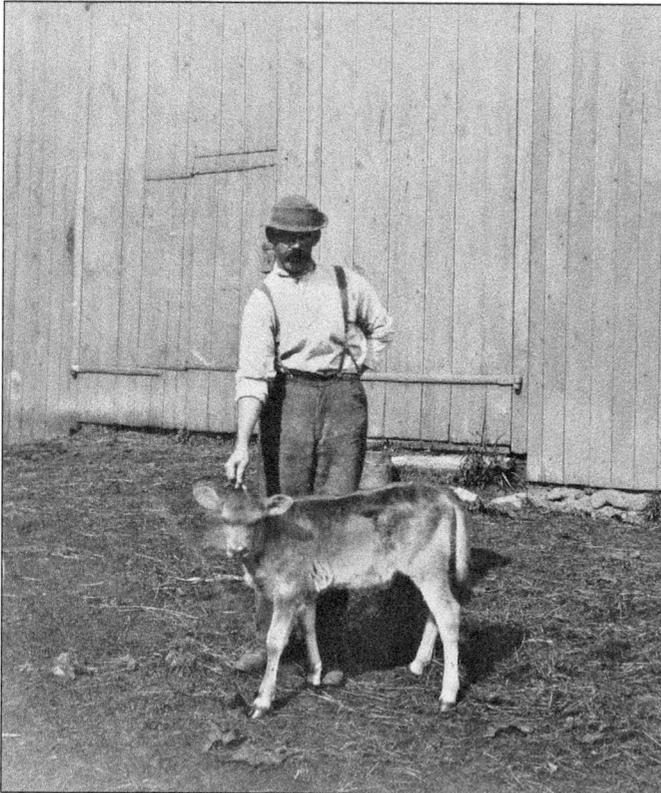

George Dwight Phelps (1804–1872), brother of historian Noah A. Phelps and Guy Rowland Phelps, went to New York at a young age, succeeded in the wholesale drug business and became the president of the Lackawanna & Western Railroad Company. He built this house on Hopmeadow Street in 1870 as a second home. The property passed to his daughter Mary, whose husband was landscape artist Horace Wolcott Robbins. It included a working farm, as the picture of the workman and calf demonstrates. In 1922, Annie Ellsworth Schultz purchased the house and transformed it into the Simsbury Community Club. (Both, courtesy of the Clark Collection, Connecticut State Library.)

The message behind these photographs says, "THE MISSES ELIZA AND HARRIETT STOWE, the twin daughters of HARRIET BEECHER STOWE, when they were young ladies. 'Given by the Misses Stowe to Mrs. Curtiss when they lived in Simsbury.' Gift of Mrs. C. Edson Curtiss." Rev. Charles Stowe provided the house at 965 Hopmeadow Street for his sisters after he became the minister of the First Church of Christ in 1891.

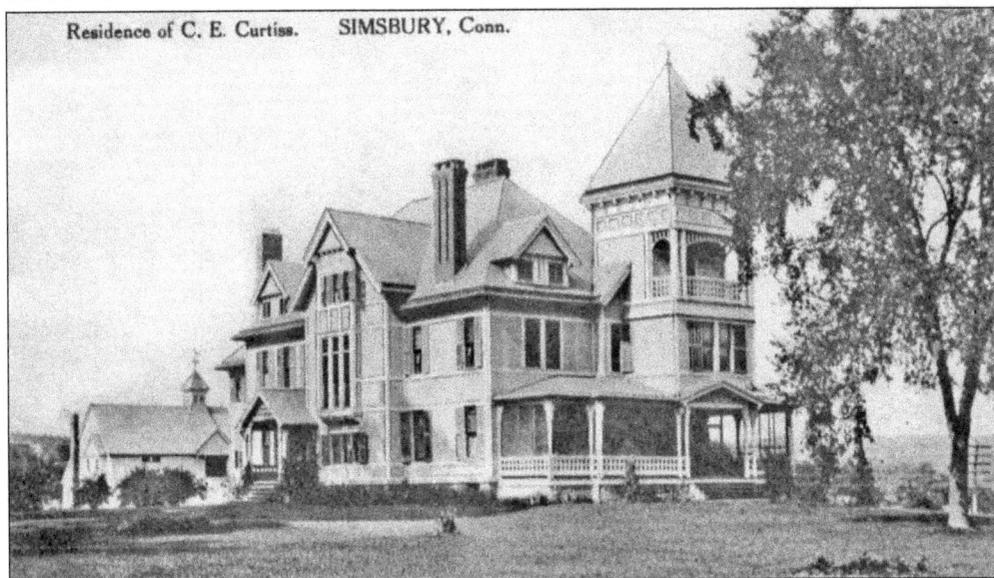

Residence of C. E. Curtiss. SIMSBURY, Conn.

Near the Stowe twins' relatively modest home stood Seven Elms, with its carriage house, built in 1888 by Charles Edson Curtiss, whose first wife was Joseph Toy's daughter Jennette. Curtiss was a vice president of the Ensign-Bickford Company. The parish of St. Mary's Roman Catholic Church purchased the property in July 1922 and built its present church just south of the house. (Courtesy of Richard E. Curtiss.)

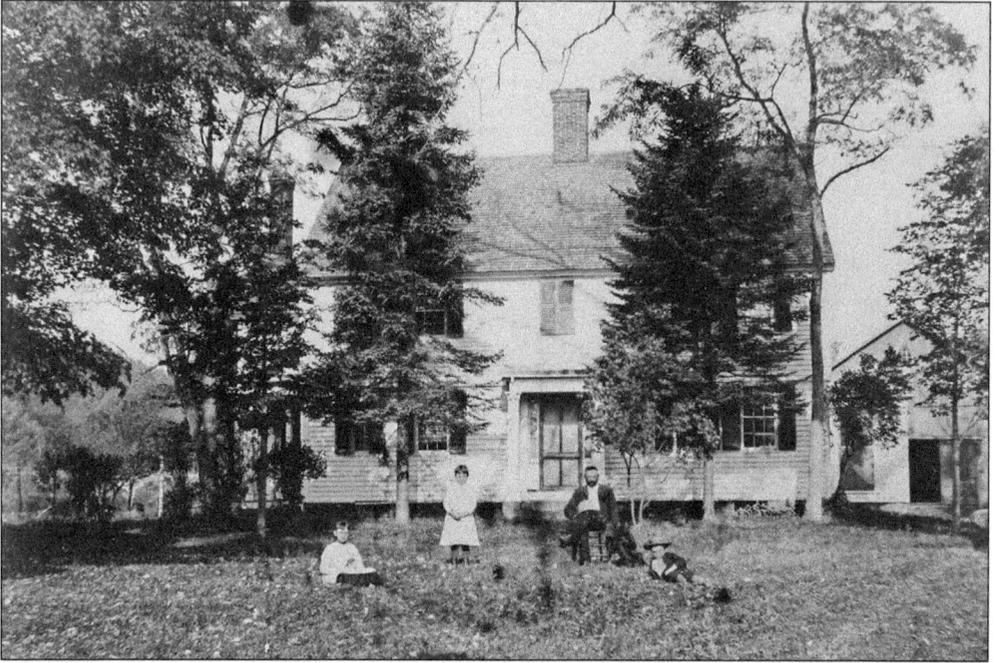

This house was built by Joseph Humphrey in 1800. Salmon Eno purchased it in 1818 and left it to his son Salmon Chester Eno. When this picture was taken about 1885, Chester's son Aaron Lewis Eno (1846–1908) lived there with his wife, the former Harriette Humphrey Phelps, their daughters, Jane and Sarah, and their son, Harry. (Courtesy of the Clark Collection, Connecticut State Library.)

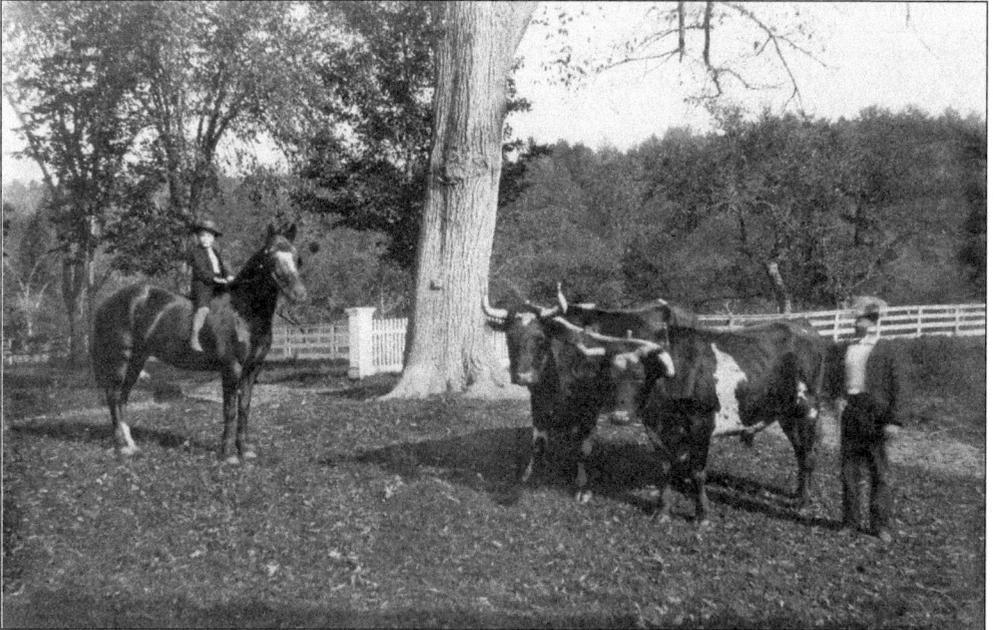

Like most men in town, Aaron Lewis Eno was a farmer. This view shows Williams Hill, now the site of the Westminster School. The residences on Winterset Lane, Somerset Lane, and Owens Place are on his land. The law offices of Dowling & Dowling occupy his house at 987 Hopmeadow Street. (Courtesy of the Clark Collection, Connecticut State Library.)

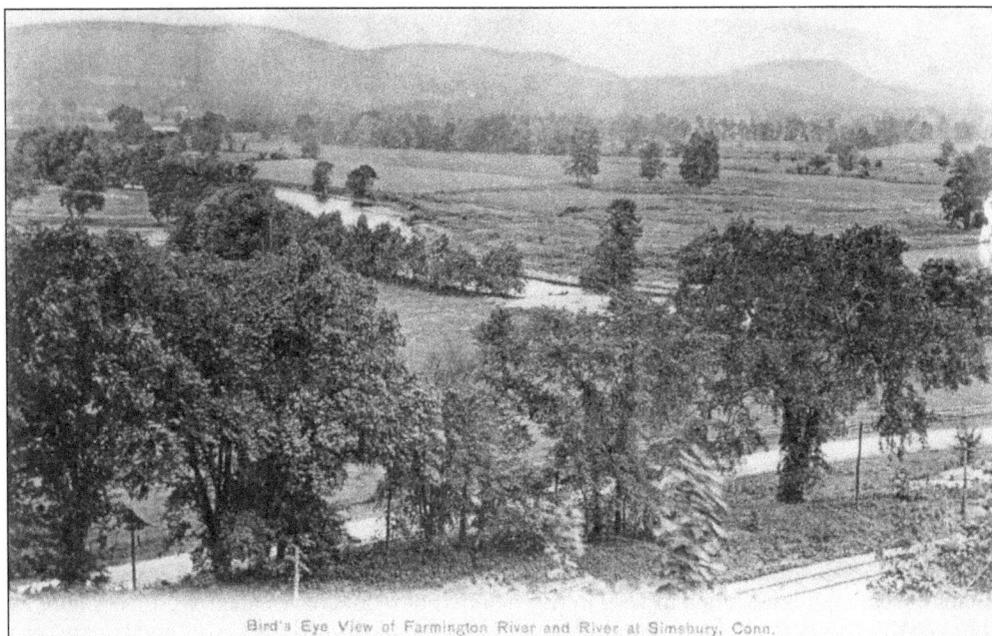

Bird's Eye View of Farmington River and River at Simsbury, Conn.

This scenic view of the Talcott ridgeline and the Farmington River shows a small beach that used to be a favorite swimming place. It also shows Hopmeadow Street, formerly Main Street, east of the railroad tracks. The stone underpass that the road went through to cross under the tracks is filled in, but the stone blocks at the east entrance under Williams Hill are still visible today.

Located on the main street until it was diverted west, this two-story home was built in 1756 at 12 Eno Place by John Case. Jonathan Eno bought it in 1774 and kept a tavern. Marching to Boston after their defeat at Saratoga, some of Burgoyne's Hessian troops dined there. Two officers, having a violent quarrel, gashed the wood paneling with a carving knife. The house remained in the Eno family until 1960.

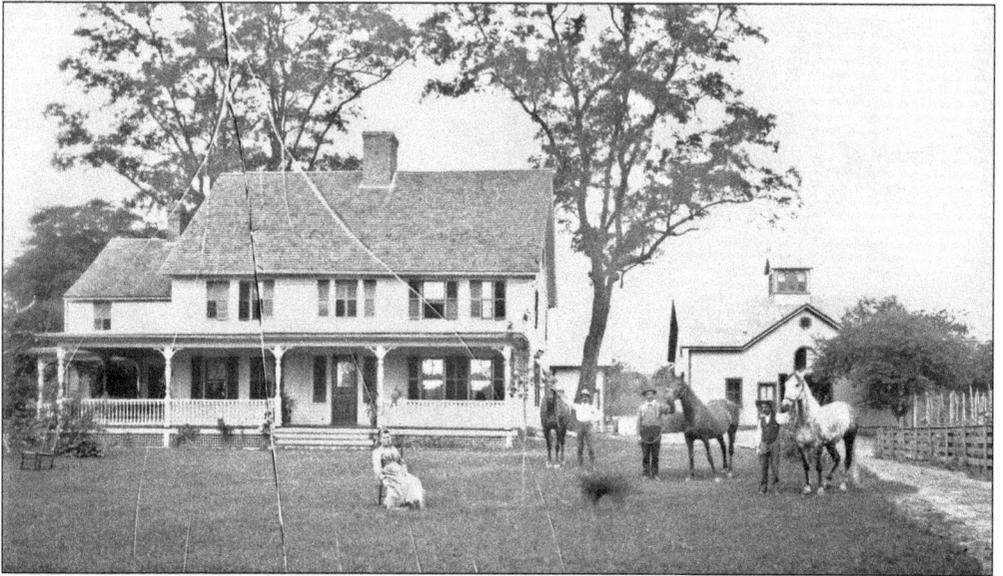

Eliakim Colton built his home in 1790 in the area that he would have called Westover Plain. By the time this picture was taken around 1902, the Noble family owned the house, and the area was called Hoskins Station for the nearby station on the Central New England Railway. The house, once located at 1243 Hopmeadow Street, is now gone. (Courtesy of Ashfield Historical Society.)

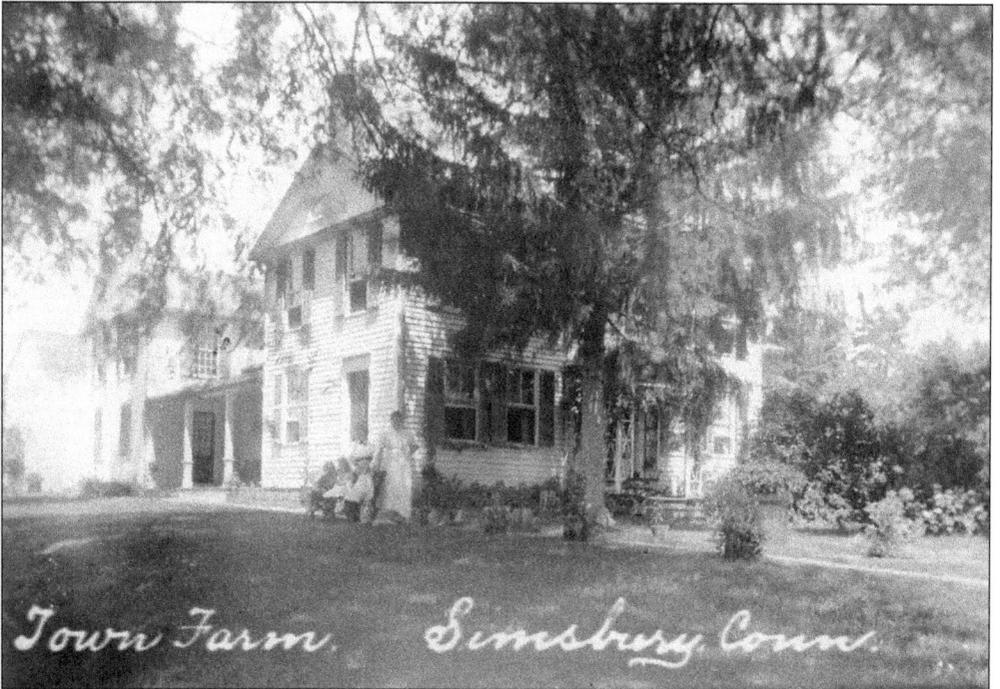

This house sits on Westover Plain land granted in 1653 by the general court to Simon Wolcott. He held the first tavern license in Simsbury. In 1883, Amos R. Eno donated this farm "to be used for the occupation and maintenance of the town poor," a function it served until 1981. Today, Community Farm of Simsbury, Inc., carries on educational and charitable work here at 73 Wolcott Road.

Two

THE WEATOGUES

AND NEIGHBORS

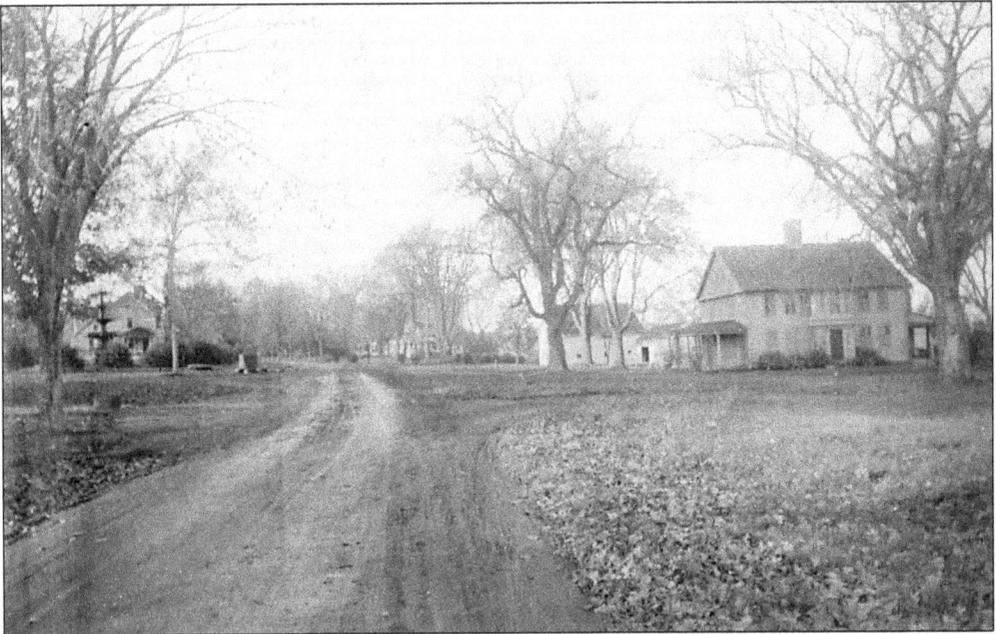

Revolutionary War veteran Jonathan Pettibone Jr. built the Pettibone Tavern (right) in 1801 to replicate a house that had burned. Shown about 1910, it was Dotha and Appelton Robbins Hillyer's country house. He founded Hillyer Institute, and she built Hartford's Bushnell Memorial Hall to honor her father, Horace Bushnell. On the left are White Memorial Fountain and the 1730 home of Civil War veteran and tin peddler Lucius Bigelow.

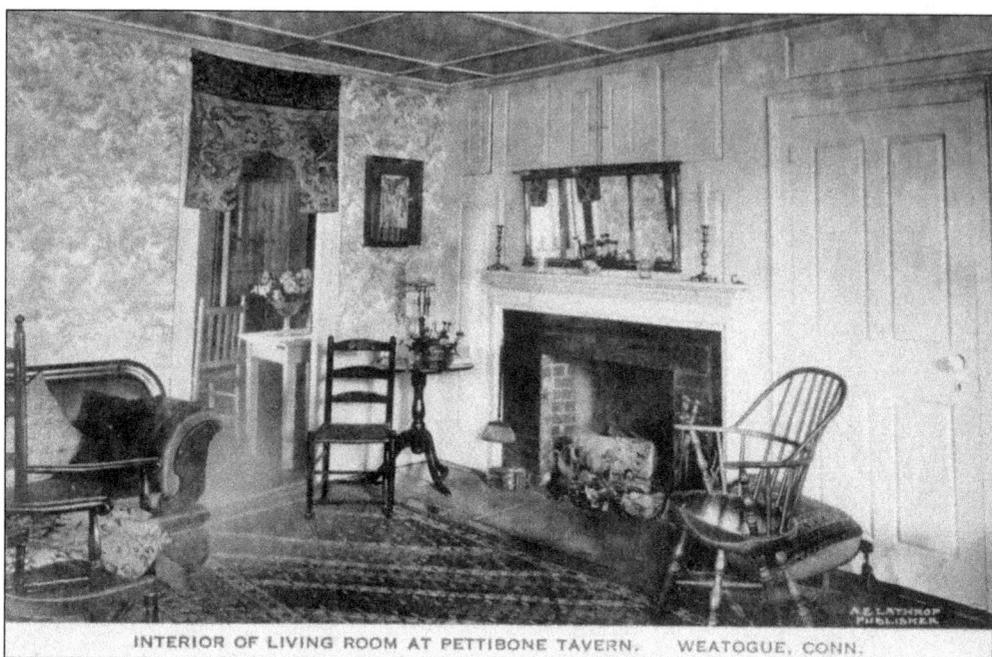

INTERIOR OF LIVING ROOM AT PETTIBONE TAVERN. WEATOGUE, CONN.

After a hiatus as a private residence, the Pettibone Tavern opened again to the public in the fall of 1919. This postcard, dated "December 23, 1919," by the sender, shows one of the 20 rooms with antique furniture that made the inn notable. She wrote that she had stayed at the inn.

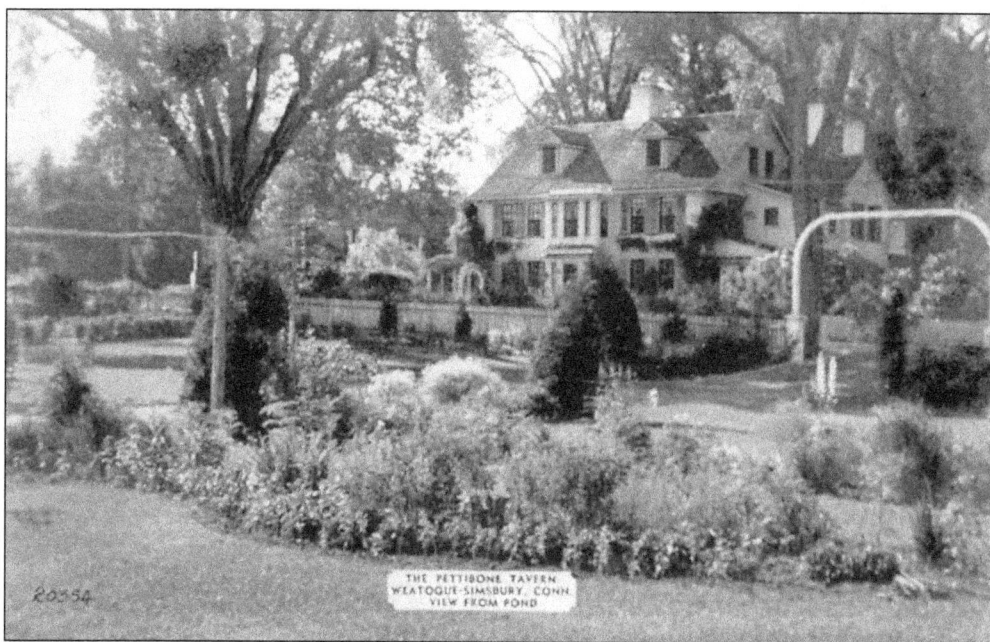

THE PETTIBONE TAVERN
WEATOGUE-SIMSBURY, CONN.
VIEW FROM POND

By the 1930s, the proprietress, Rhoda Tilney, had made a showplace of the Pettibone Tavern. She advertised that patrons would be served luncheon, tea, and dinner every day. The building, which no longer has overnight accommodations, is now occupied by Abigail's Grille & Wine Bar at 4 Hartford Road.

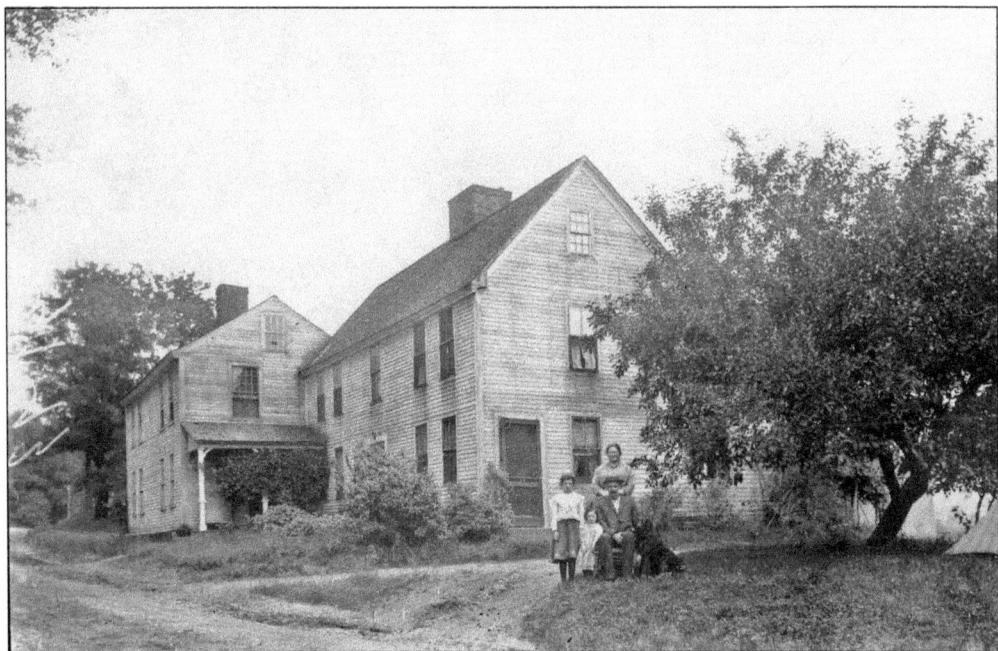

Built by Thomas Barber before 1765, this house eventually became the home of the Congregational minister Rev. Samuel Stebbins, who died in 1821. Stebbins added a wing that he used for a school. The picture at right shows Daniel Clement and his neighbor Sarah Smith in the 1920s when he had an ice cream parlor in one section. After Clement died in 1925, the house, which stood at approximately 570 Hopmeadow Street, was dismantled. Winterthur Museum in Delaware displays parts of it, including wood paneling, a summer beam, and decorative fireplace tiles, in the museum's Simsbury Room.

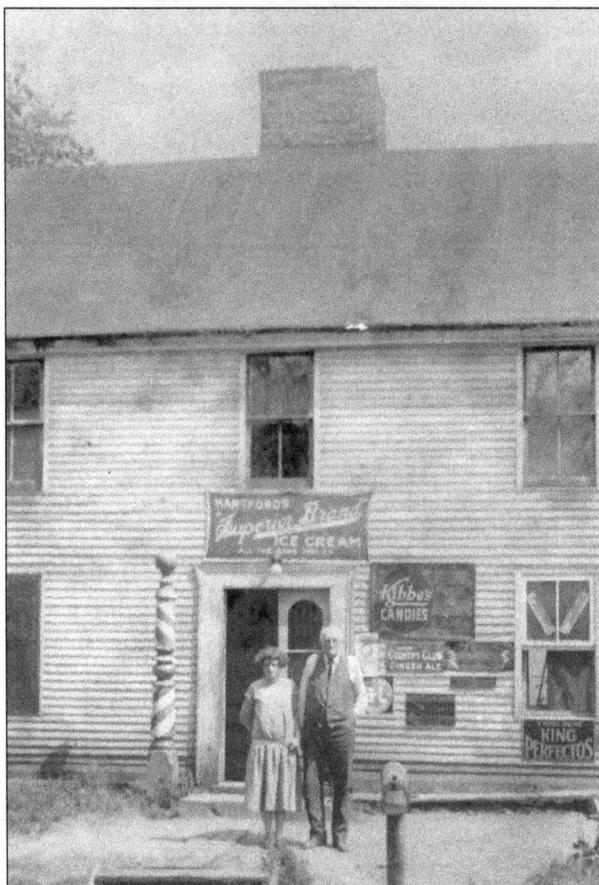

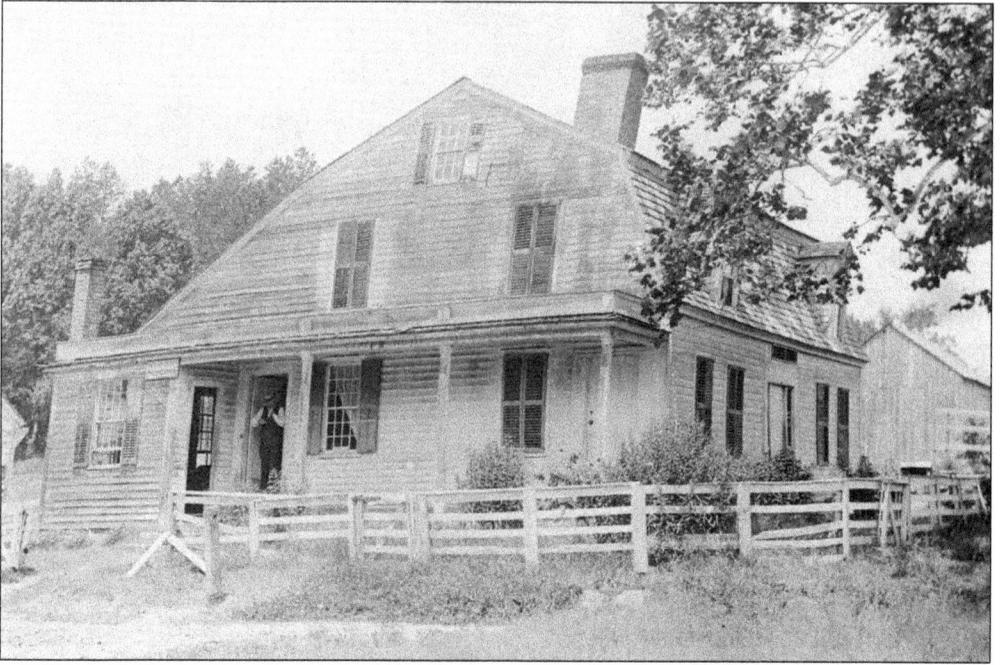

The house in the photograph above was built about 1787, but the photograph is from around 1885. At that time, it was the home of Seymour Pettibone, who was the Weatogue postmaster from when the position was established in 1861 until a few years before his death. He kept the post office in his house on Hopmeadow Street near Stratton Brook Road. He also was a judge of probate. When he died in 1892 at the age of 83, his obituary in the *Hartford Courant* said, although Pettibones had once been numerous, he was the last of that name in Simsbury. The picture below shows that the Pettibone house, now gone, was just across the street from the post office that succeeded it.

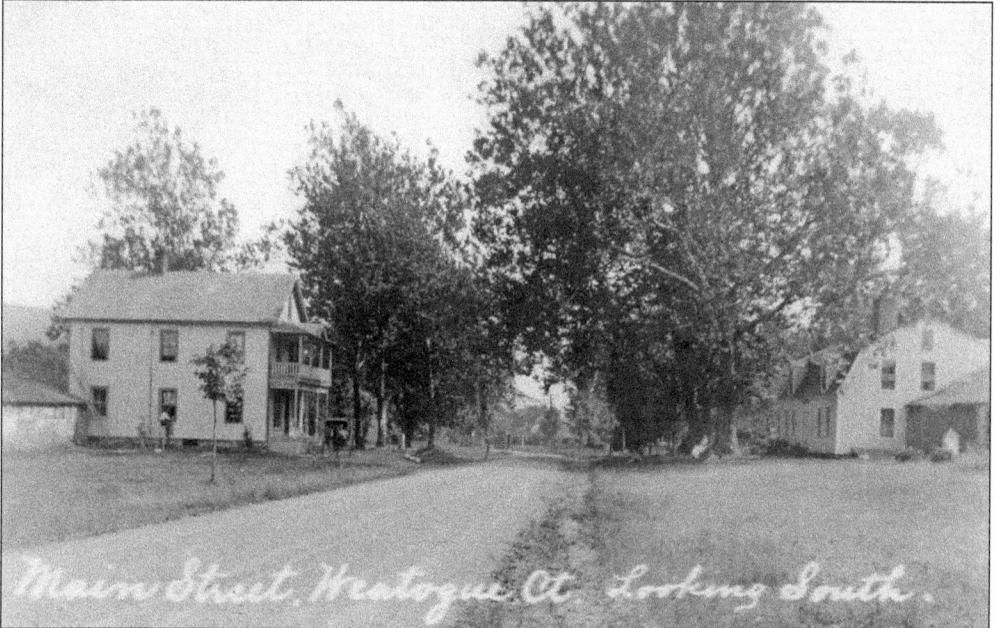

Main Street, Weatogue, Ct. Looking South.

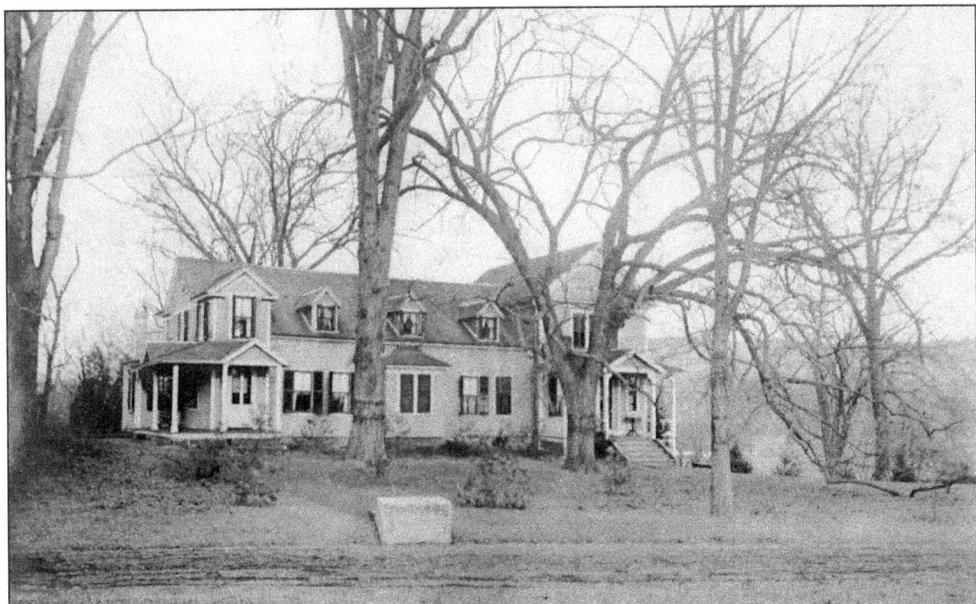

The central part of this home at 332 Hopmeadow Street was built by the widow Bathsheba Pettibone Merrill about 1779. Deacon William Mather bought it, and his granddaughter Julia Mather and her husband, Rev. Charles Pitman Croft, altered and extended it. Mrs. Croft was the first regent of Simsbury's Abigail Phelps Chapter of the Daughters of the American Revolution. Among other things, Reverend Croft developed the Phelps-Croft neighborhood.

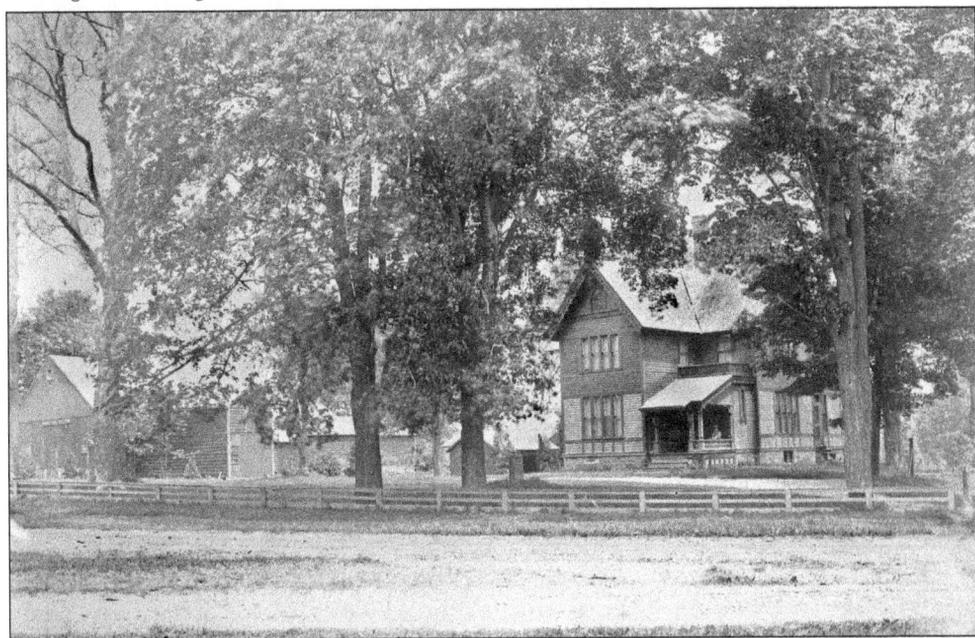

Built in 1879, this house at 348 Hopmeadow Street replaced one constructed about 1679 by John Pettibone. His descendant Charlotte Pettibone, the wife of Rev. Horace Winslow, apparently built it for their retirement. Reverend Winslow was the pastor of several Congregational churches and was chaplain of the 5th Connecticut Volunteers during the Civil War. From 1888 to 1890, he came out of retirement to be pastor of Simsbury's First Church of Christ.

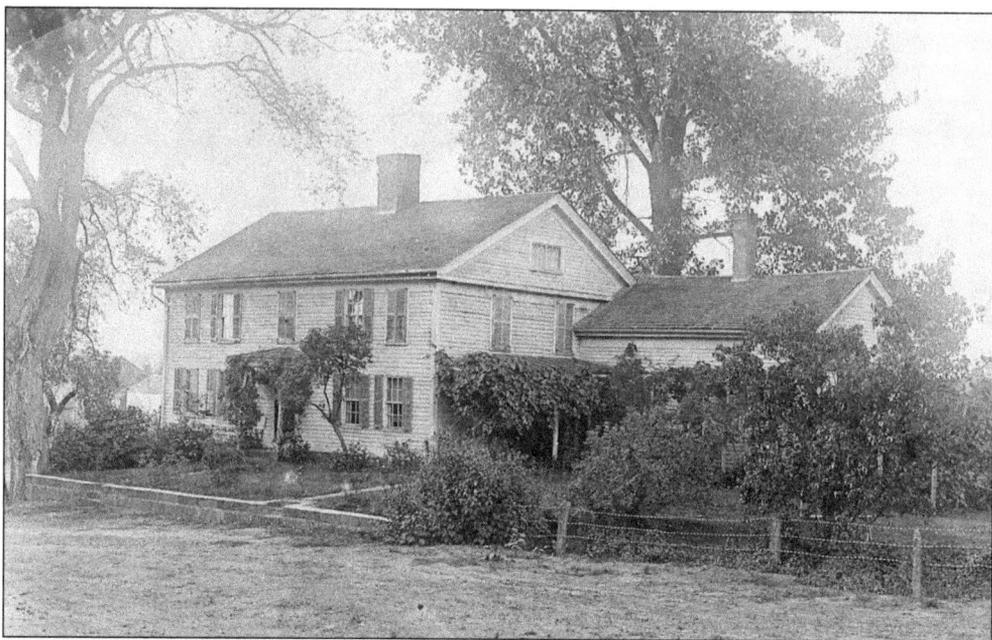

Tradition holds that this house in East Weatogue was built about 1790 by David Phelps as a wedding present for his son Roswell and his bride, Dorcas Pettibone. Joseph Toy, founder of Toy, Bickford & Company, bought it in 1841. His daughter Ann was born there, and when her son John Stoughton Ellsworth became the owner, he called it the Ann Toy house. It stands at 76 Hartford Road.

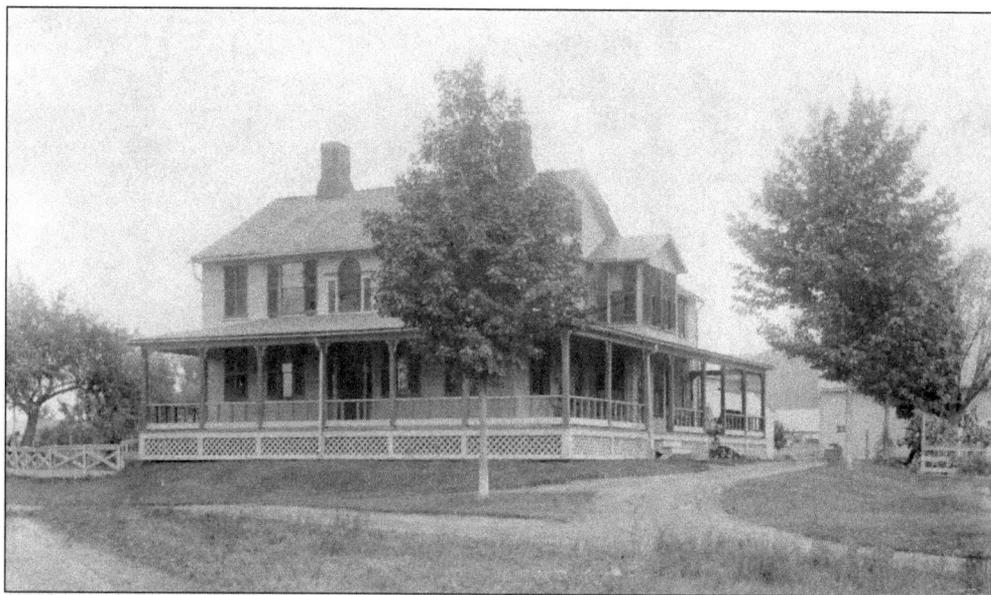

Built about 1800, this house, located at 2 East Weatogue Street on the northeast corner with Hartford Road, was the Phelps Tavern. It catered to travelers on the stagecoach route from Hartford. Originally Colonial in style, the house had these handsome verandas in 1910 when it was owned by C.F. Poindexter, a roofing contractor. John S. Ellsworth restored it to its present look.

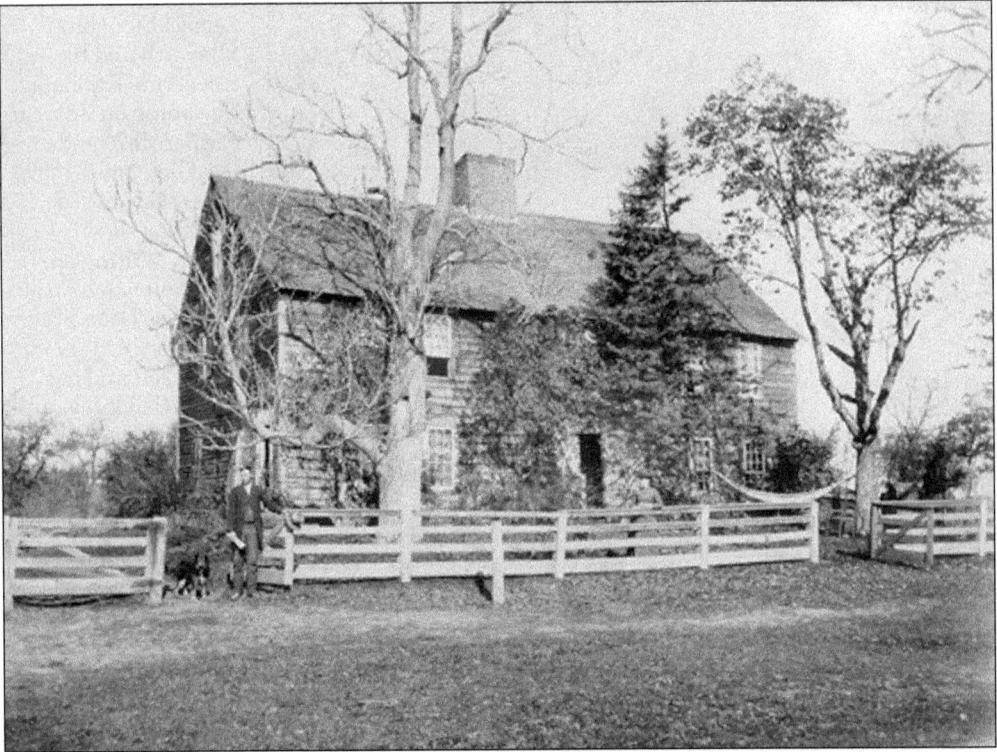

This house, built about 1717 by Joseph Phelps, is believed to be the oldest home in Simsbury now. Tradition holds that it was built on the site of a blockhouse that burned. Revolutionary War soldier Noah Phelps, known as "the Spy at Ticonderoga," was born here. By the time these photographs were taken (sometime between 1885 and 1890), Maria Bacon Eno, the wife of Chauncey E. Eno, had obtained the house through inheritance from her mother, Laura Humphrey Bacon, and purchase from the other heirs. The couple lived here with their children, Richard Bacon Eno and Mary C. Eno. Their fine cattle (below) were worth recording, too. The house is at 11 East Weatogue Street. (Both, courtesy of the Clark Collection, Connecticut State Library.)

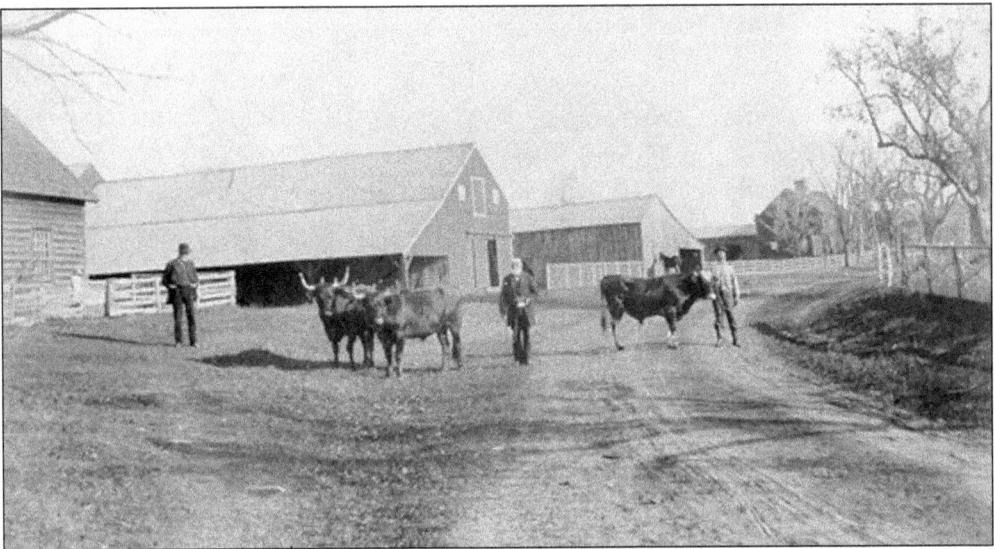

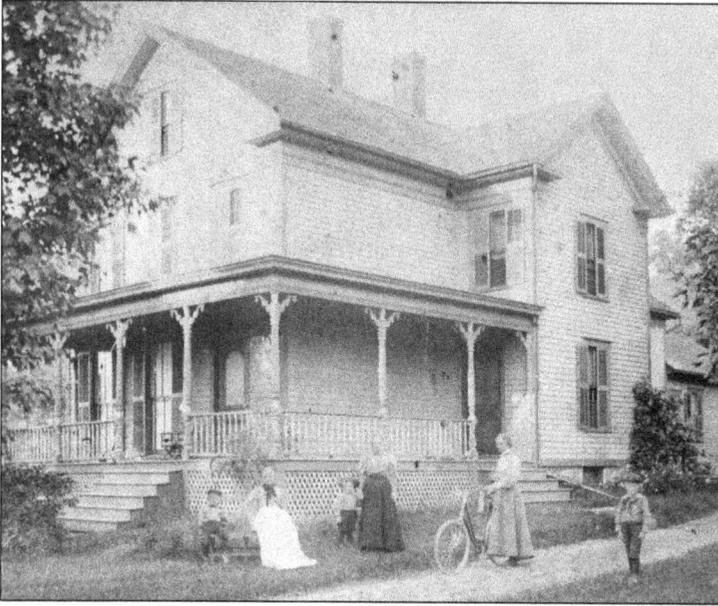

Lemuel Stoughton Ellsworth and his wife, Ann Toy, built this house on Roskear Farm in 1876 and lived here until 1889, when they moved to Hopmeadow Street. Writing on the photograph's mat identifies Delia Sceery Pattison (1838–1928) on the left and her daughters Jennie Pattison Washburn and Caroline Pattison Eddy. Now without the porch, the house stands at 80 East Weatogue Street.

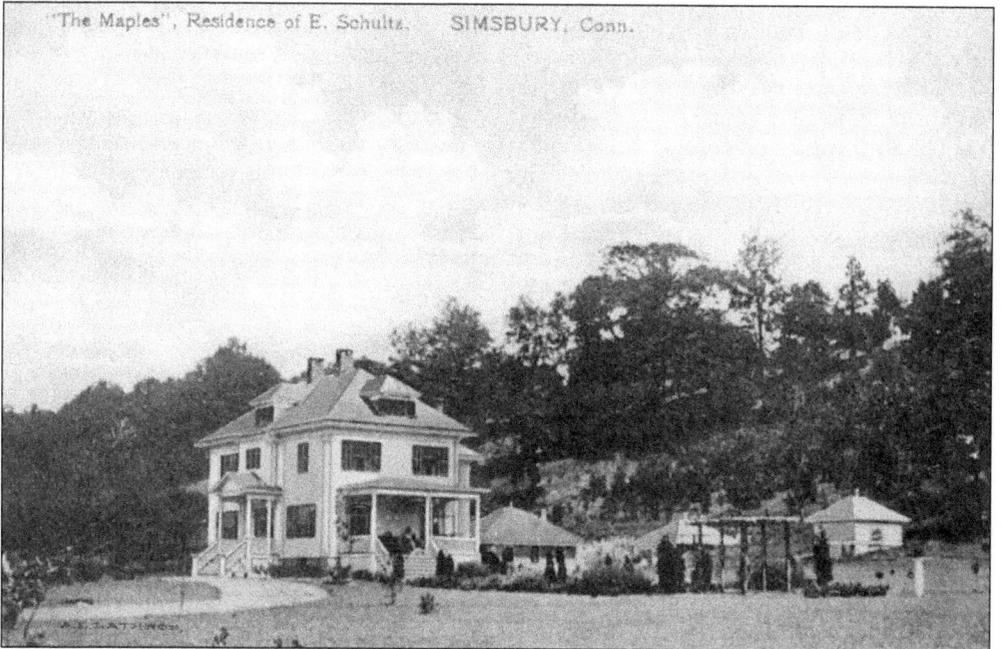

"The Maples", Residence of E. Schultz. SIMSBURY, Conn.

Emmett Schultz and his wife, Ann Ellsworth, daughter of Lemuel Stoughton Ellsworth and Ann Toy, built this stately house "The Maples" at 72 East Weatogue Street in 1913. Emmett died in 1916, and Ann founded the Simsbury Community Club in his honor. She supported numerous civic organizations, including the Simsbury Visiting Nurse Association, Red Cross, and Scouts, and she was instrumental in founding Camp Alice Merritt in Hartland.

A good horse and a brisk winter day make an invigorating ride. This scene is in front of 45 East Weatogue Street. The house was built in 1826 by George Cornish. It is one of eight along this road built by members of the Cornish family, beginning in the early 1700s.

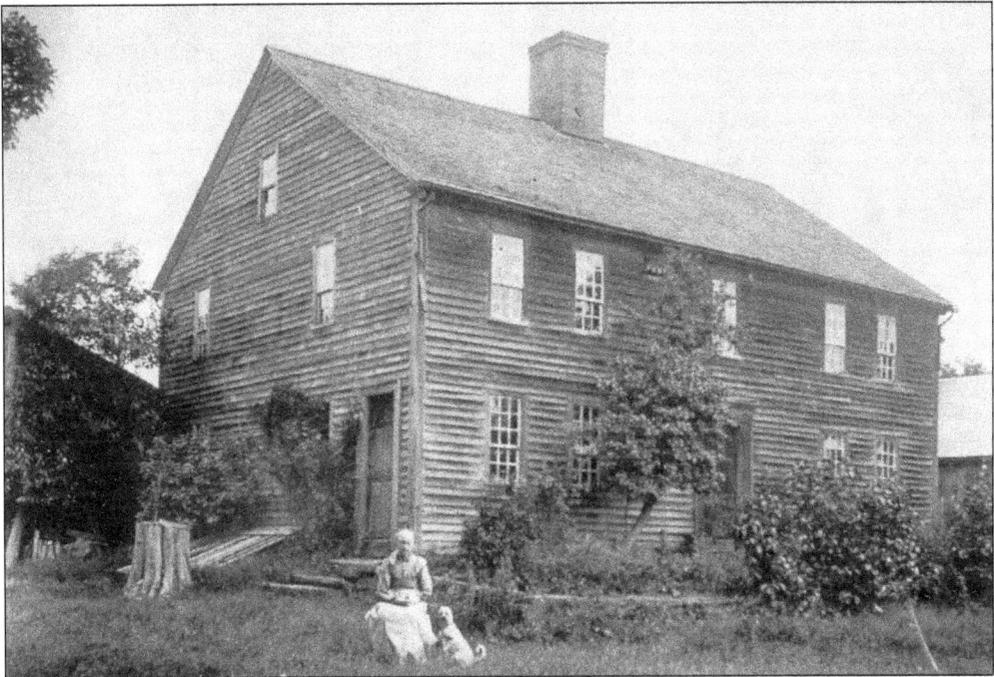

Known as the Goodrich Farm, 21 Goodrich Road was built about 1780 by John Terry on land his grandfather, also named John Terry, was granted in 1677 in payment for his surveying services. Stephen Goodrich of Wethersfield came to Simsbury to help build the house and met and married Terry's daughter Lydia, and the couple inherited the property in 1797. The original farm remained in the family for 210 years until 1887.

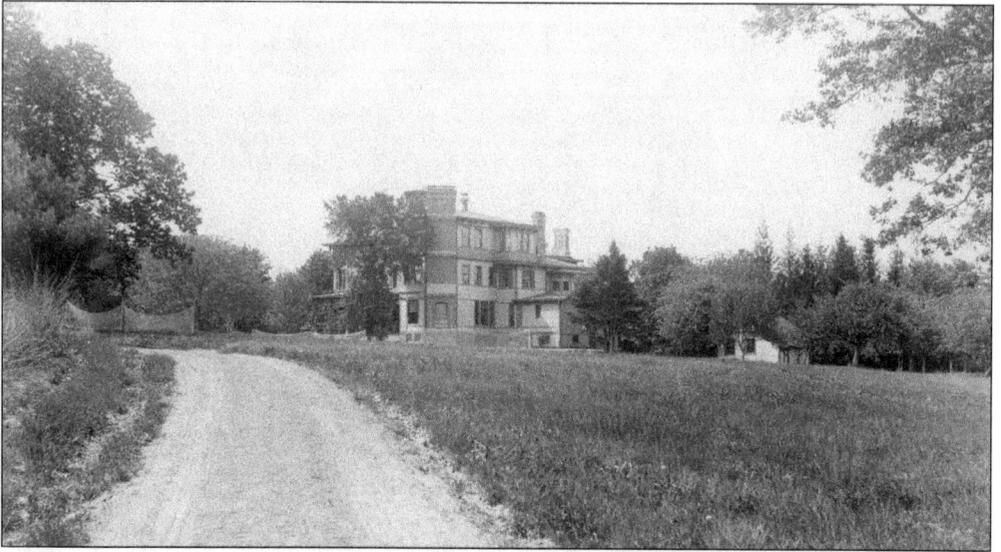

John Jay Phelps (1810–1869), one of New York's merchant princes and an early business partner of Amos R. Eno, bought his family homestead and other land on Bushy Hill and built this summer home. Eventually, it passed to his daughter Ellen Ada Phelps and her husband, Rev. D. Stuart Dodge. An heir to the Phelps-Dodge fortune, he was a missionary, educator, and a founder of the American University of Beirut.

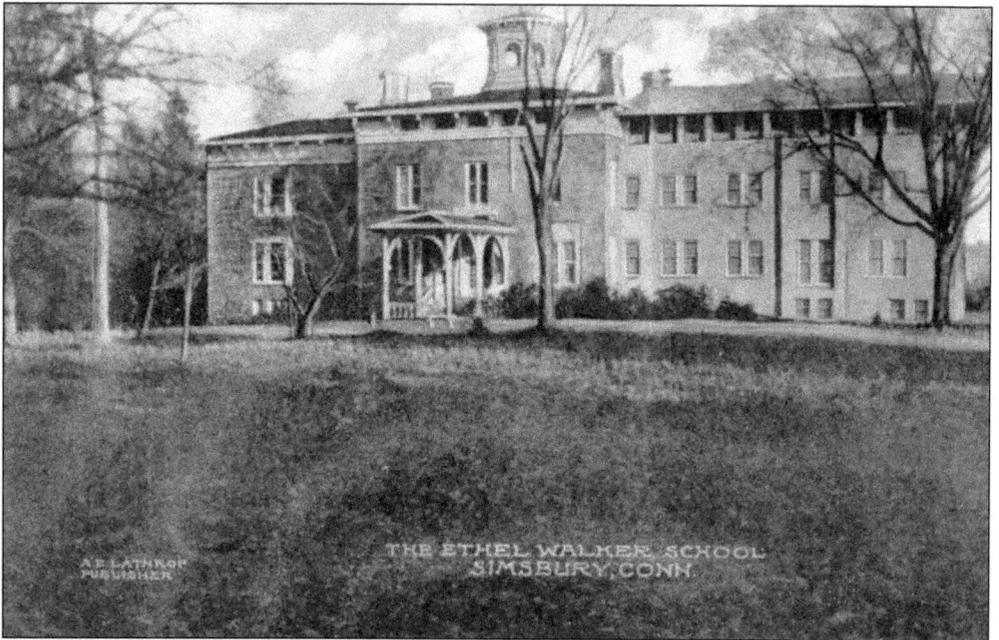

In 1917, Ethel Walker purchased the 400-acre estate from Reverend Dodge and moved her school for girls from Lakewood, New Jersey, to Simsbury. She expanded and remodeled the house in the Italianate style. The native brownstone was covered with pink stucco. Called Beaver Brook Hall, it burned to the ground in 1933. The school replaced the structure with the present Beaver Brook Academic Building. (Courtesy of Richard E. Curtiss.)

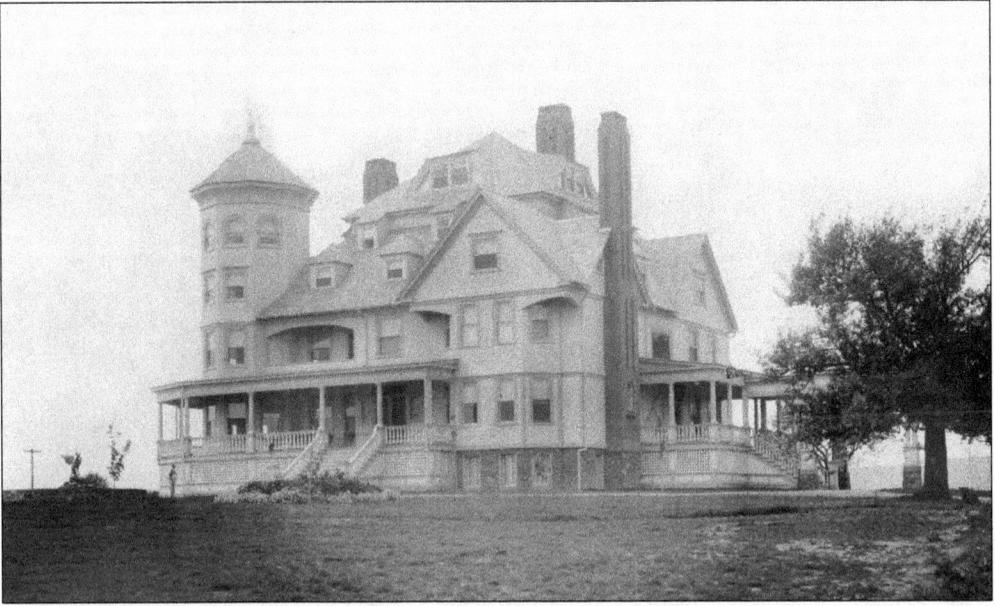

Norman White Dodge (1846–1907) built his 32-room Queen Anne summer home, "Nassahegan," northwest of his brother Stuart's place. Ethel Walker's sister Evangeline Andrews bought the house and 130 acres of land in 1917 for faculty accommodations and an infirmary. Renamed "Four Corners" after the intersection of Bushy Hill and Stratton Brook Roads, it was destroyed by fire five days after Beaver Brook Hall. Authorities suspected arson.

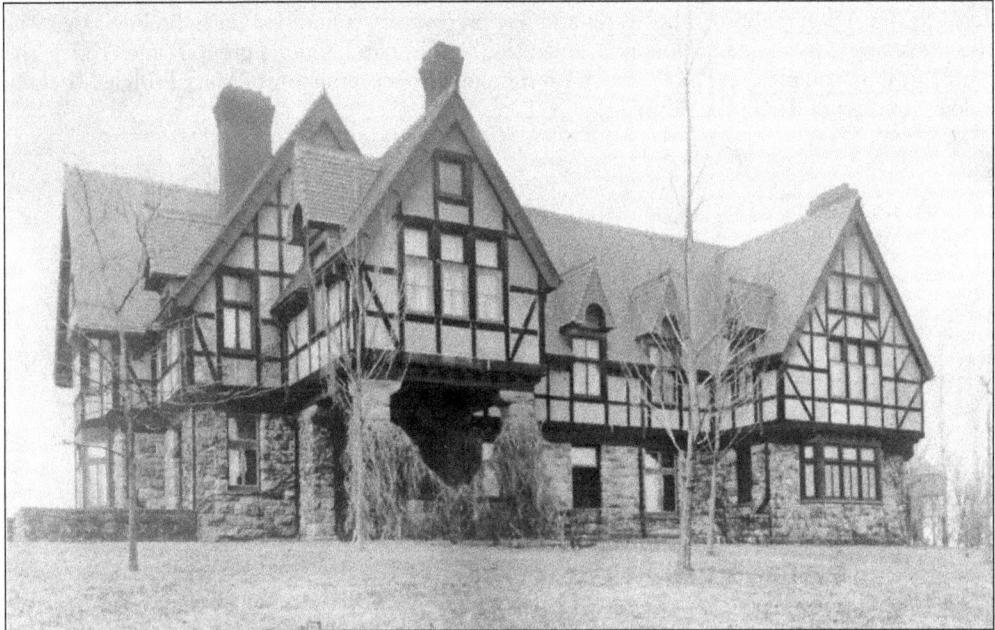

In 1893, the Boston firm Cram, Wentworth & Goodhue designed this Tudor summer home for Reverend Dodge's son Walter Phelps Dodge. "The Grange" stood on a rise across the road south of his father's house. In 1919, the Cluetts of Troy, New York, purchased the property for the Ethel Walker School in memory of their daughter, who had died in the influenza epidemic. The Emily Cluett house was demolished in 1969. (Courtesy of Richard E. Curtiss.)

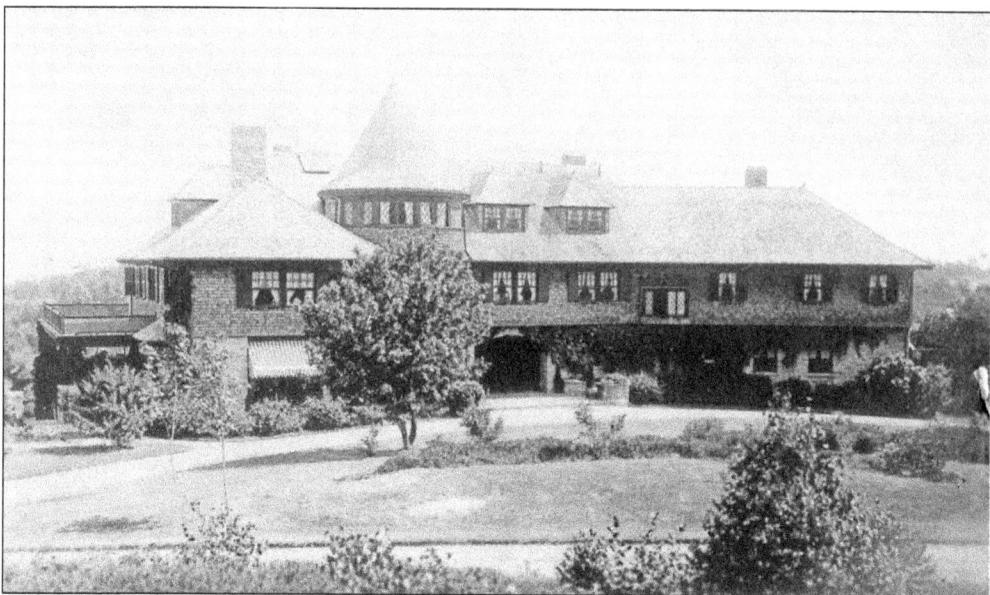

Arthur Murray Dodge (1852–1896) was the youngest brother of D. Stuart Dodge. His wife, Josephine Marshall Jewell (1855–1928), was the daughter of Marshall Jewell, a governor of Connecticut. Their property on Sand Hill with this summerhouse abutted his brother's estate. Mrs. Dodge's rose gardens were compared to those in Hartford's Elizabeth Park. Gladys J. Rugg bought the estate in 1928 and opened Simsbury Manor, remembered for luncheons, banquets, and special functions, like the 1936 Trinity College Senior Ball. In 1944, Rugg sold the house, outbuildings, and 135 acres to the Abbey School, a boarding and day preparatory school for Catholic boys. By 1953, the Simsbury Convalescent Home occupied the building and, later, a group home. Today, the condominium complex on Knoll Lane is on the site. (Above, courtesy of Mary Pringle Mitchell; below, courtesy of Richard E. Curtiss.)

Three

WEST SIMSBURY

AND VICINITY

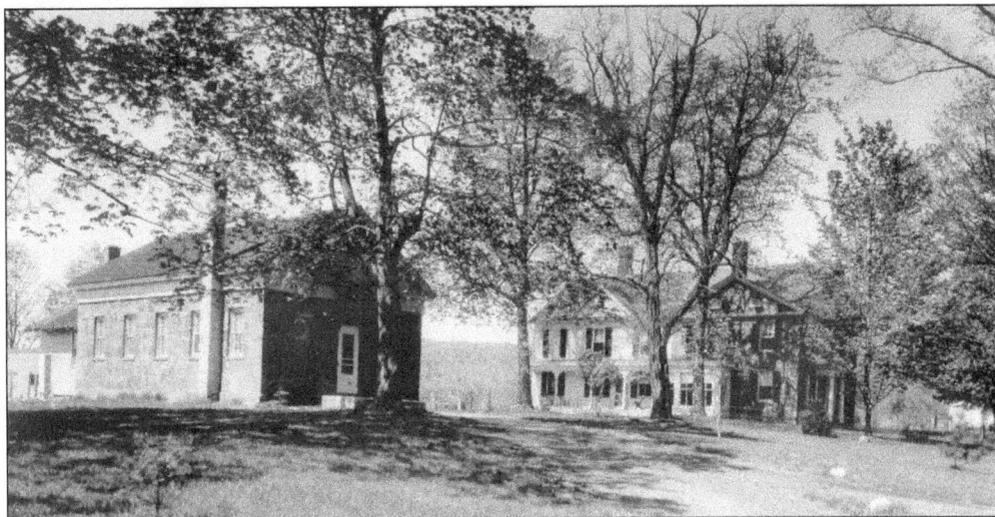

Built in 1830 by Whiting Shepard, this house (right) was the first stone house in West Simsbury. The Tuller family home for generations, it is on Tulmeadow Farm. The Tullers deeded land to the town for the stone schoolhouse (left), which was once a practice school for girls training to be teachers at New Britain Normal School. In 1915, schoolteacher Theona Holcomb of East Weatogue became the bride of Oliver Dibble Tuller.

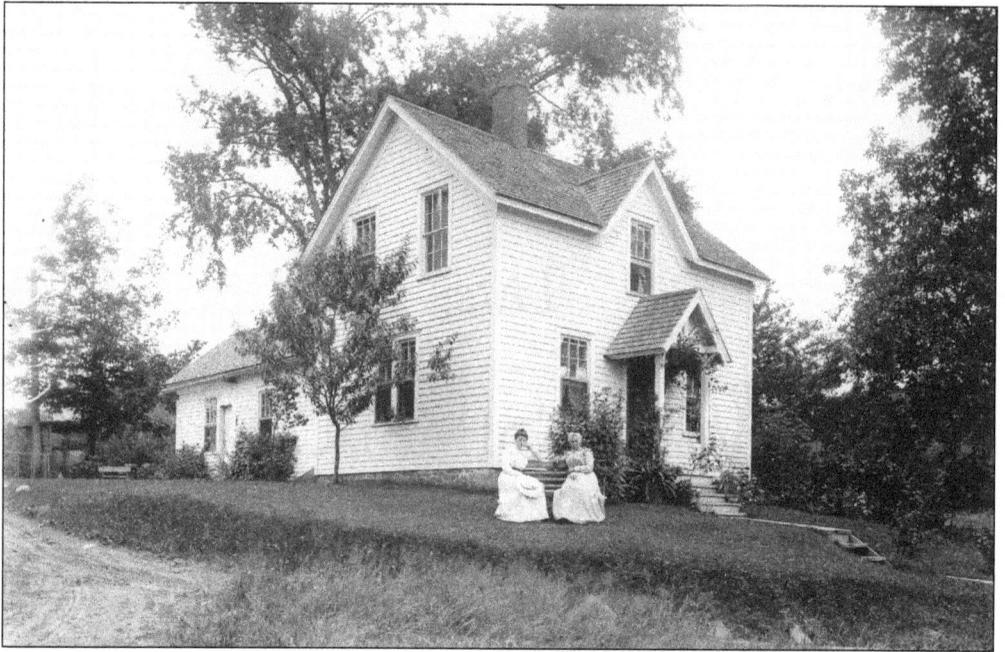

Driving along West Street toward West Simsbury, one passes more than 20 houses built between 1817 and 1918 by the Ensign-Bickford Company as worker housing. This is 70 West Street around 1902. These and other houses grouped in small communities were often the first homes in America for immigrants from Italy, Poland, and all over Europe. All the former company houses are now in private hands. (Courtesy of Ashfield Historical Society.)

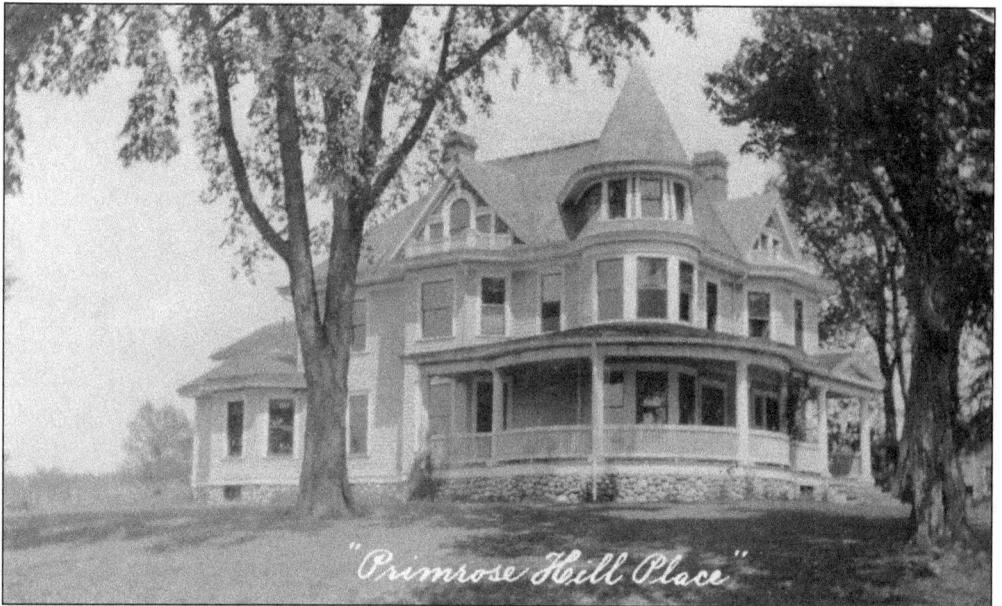

"Primrose Hill Place"

This house, built about 1890, stands on the northwest corner of West Street and Old Mill Lane. It was the home of Ensign-Bickford Company vice president J. Frank Byrne Sr. from 1929 to 1970. Later, it was converted to offices. The now defunct *Farmington Valley Herald* newspaper was published from here.

George Payne McLean (1857–1932) was born in Simsbury in the family homestead on Firetown Road. He later built the elegant Holly Hill (below) across from his childhood home. He studied in district schools and was valedictorian of the Hartford High School class of 1877. Lacking the money to attend college, he apprenticed in the law firm of Henry C. Robinson in Hartford and was admitted to the bar. Entering politics, he eventually became governor of Connecticut (1901–1903) and served three terms as a US senator (1911–1929). An inheritance from an aunt eased financial concerns. In 1907, he married his lifelong friend Juliette Goodrich. In his will, he established funds that provided for the McLean Game Refuge and for constructing a home for the elderly and impoverished that has grown into the present McLean Home residential and medical facility in Simsbury.

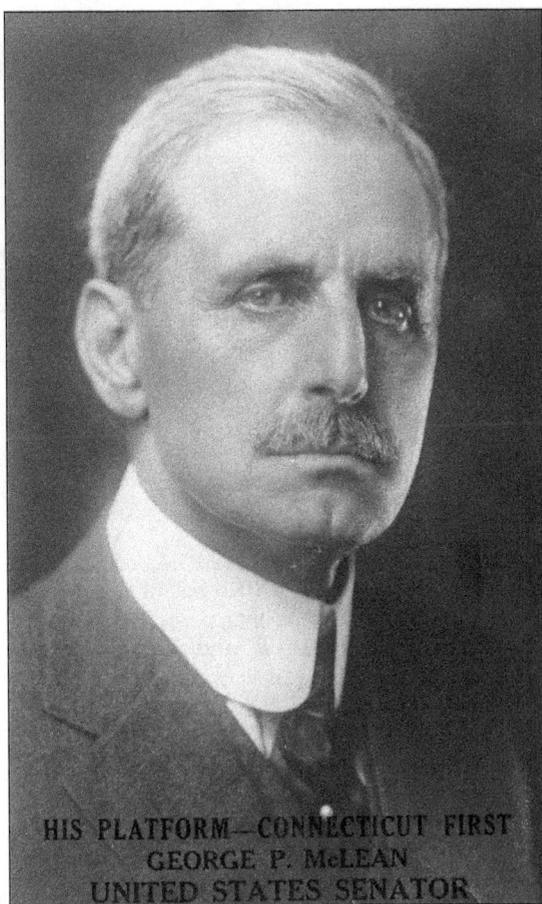

HIS PLATFORM—CONNECTICUT FIRST
GEORGE P. McLEAN
UNITED STATES SENATOR

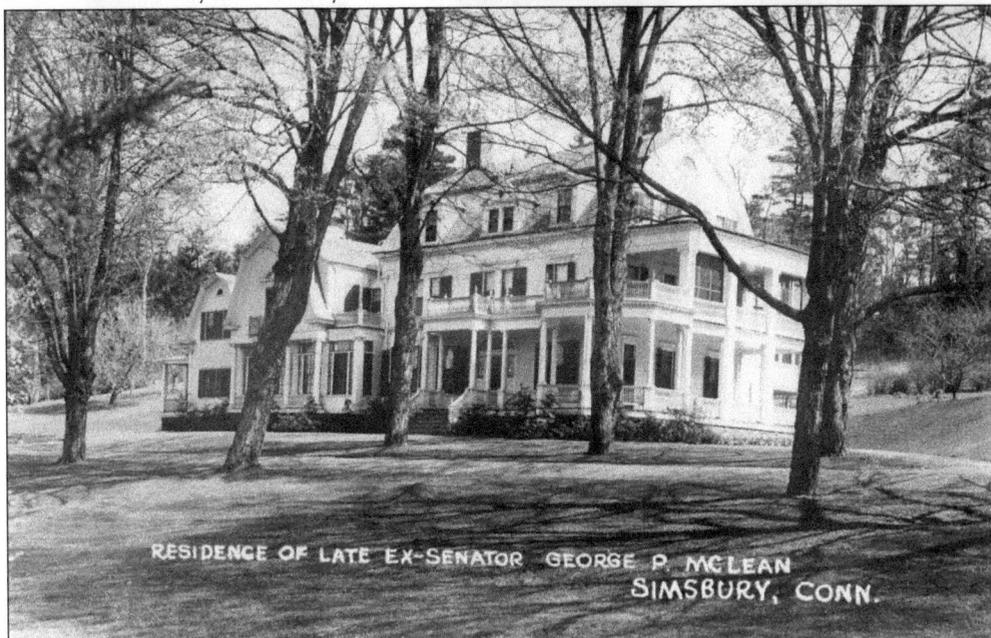

RESIDENCE OF LATE EX-SENATOR GEORGE P. McLEAN
SIMSBURY, CONN.

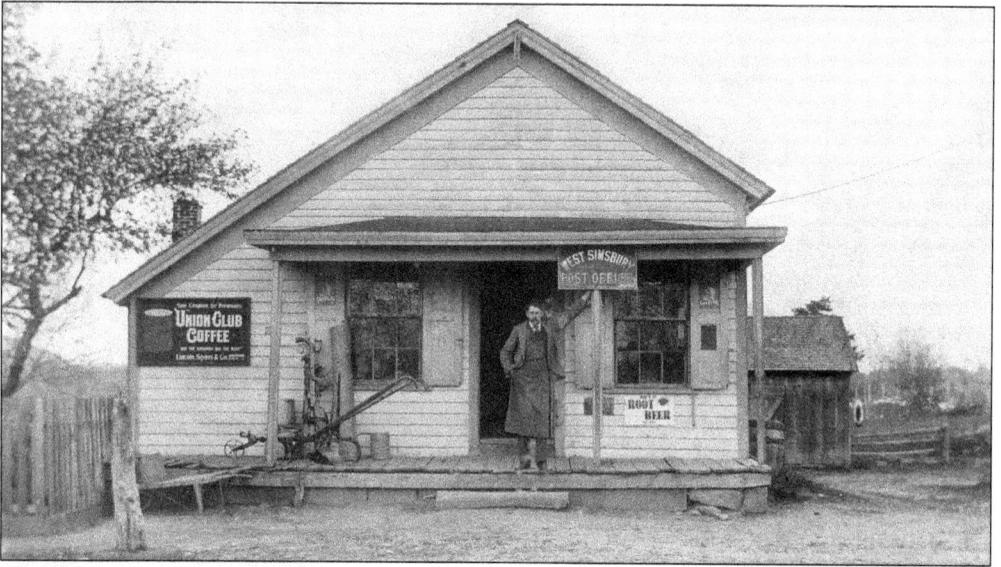

The West Simsbury Post Office was in this general store on Farms Village Road. Leon Rowley, the postmaster and storekeeper, poses in front. A 1913 advertisement says that he sold "a general line of country store goods" and that "fine teas and coffees are our specialties." Open from 6:00 a.m. to 10:00 p.m., it was a place where people congregated to talk and play checkers. (Courtesy of Catherine J. Behrens.)

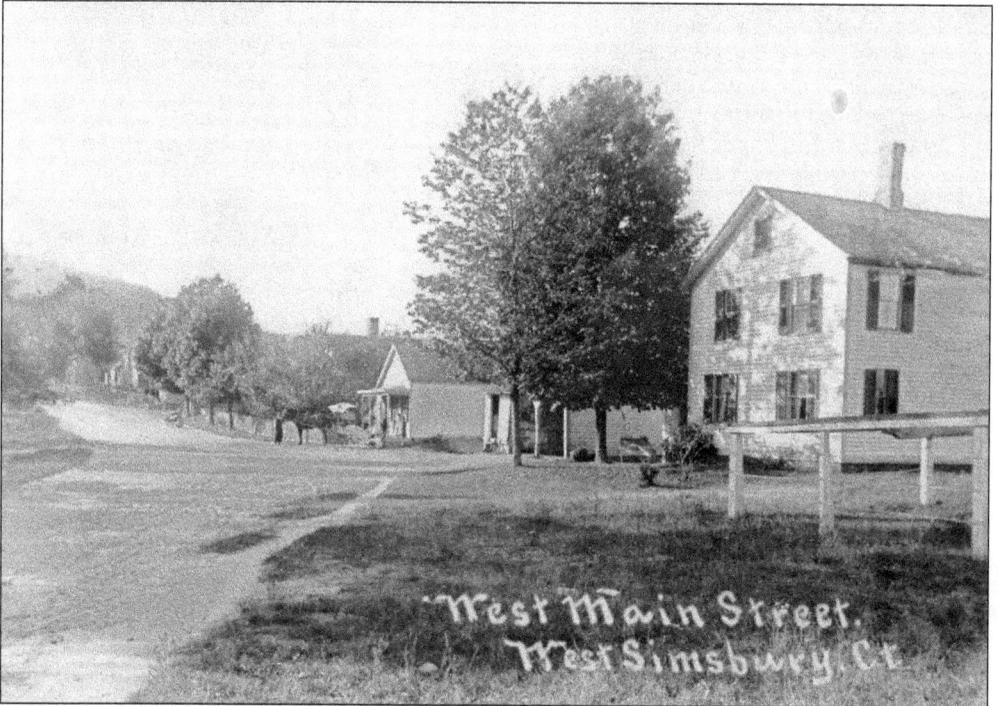

This scene, looking west along what was called West Main Street (now Farms Village Road) would have been familiar to Leon Rowley. The house on the right is 248 Farms Village Road. Rowley's store, which burned down in 1922, is the smaller building with the porch. It was rebuilt in brick in similar style.

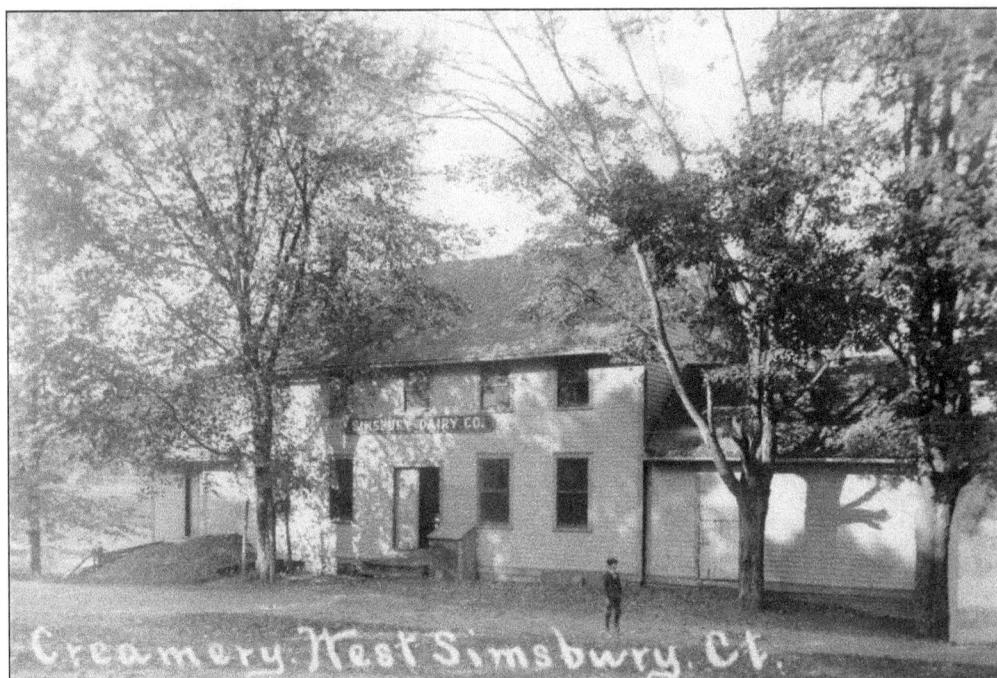

"The Simsbury creamery located at Farms Village starts off with a large amount of business. About 200–300 pounds of butter are made here daily, which finds a ready sale at the highest rates. Also a large amount of cream is furnished for the confectioners trade of New Haven," stated a newspaper clipping, dated June 8, 1883, in the Theona Tuller collection.

When the creamery closed in 1923, the *Hartford Courant* reported that local farmers were sending their milk to Hartford to get a better price rather than selling their cream for butter. The newspaper predicted that soon all butter would come in packages from Midwestern dairies. The creamery is shown here being moved back from the road to become the residence at 260–262 Farms Village Road. (Courtesy of Barbara Sweeton Tuller.)

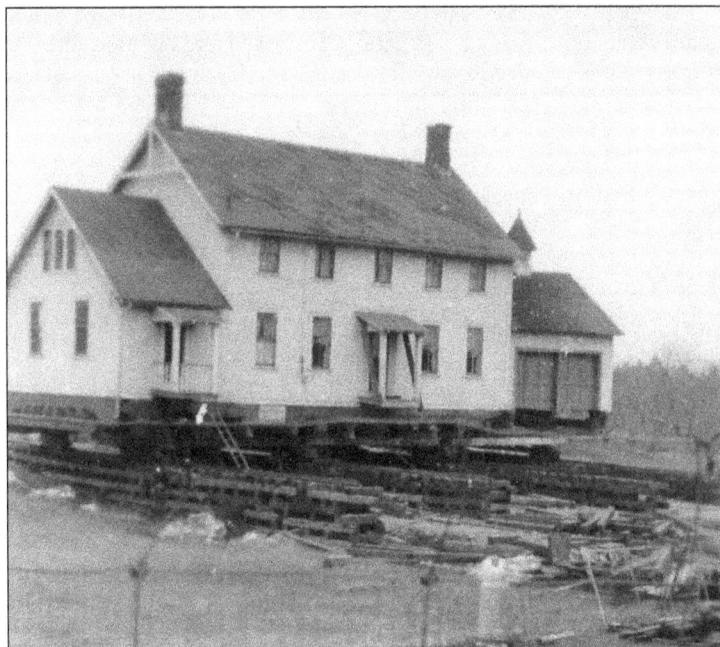

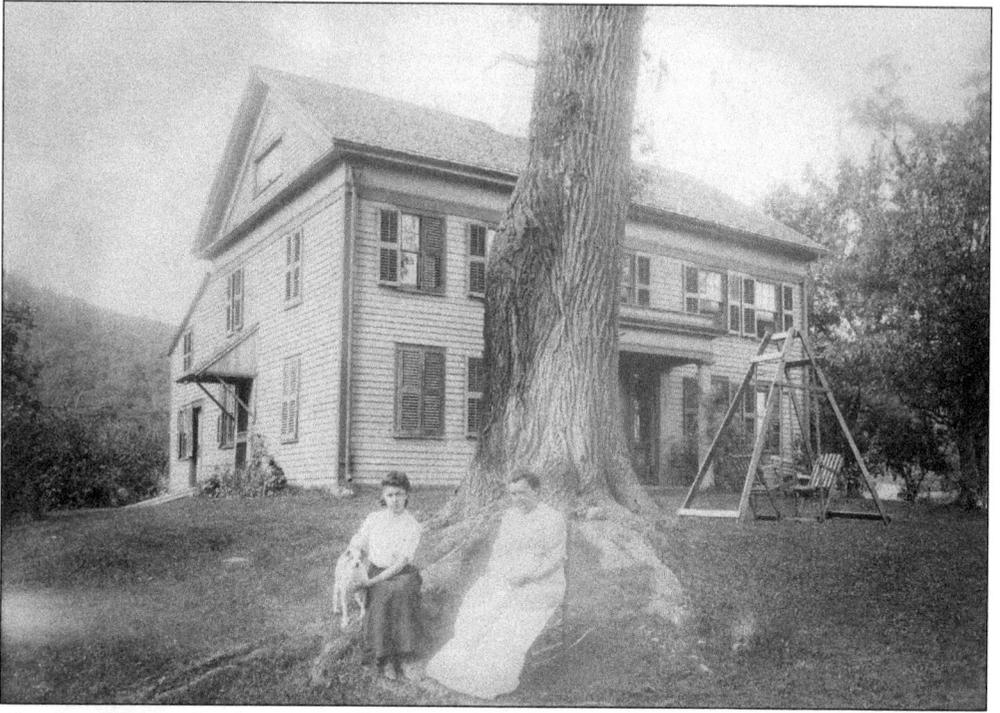

The date 1777 on the chimney is taken as proof of the year that Elijah Tuller built this house. It has 11 rooms, including one running the width of the second floor that was used as a ballroom and meeting room. The first Simsbury Grange was organized there. The tavern room at the back provided refreshment for stagecoach travelers. Elijah's granddaughter Mary Tuller, who operated the West Simsbury store and post office, bought the property. The Stockwell family, who inherited the farm from Mary, passed down through four generations the memory of the stage bringing supplies of hooks and eyes to be sewn onto cards, a local cottage industry. The photograph above, taken about 1901, shows Lucy Frances Stockwell and her mother, Addie Denison Stockwell. The address is 1 Westledge Road, West Simsbury. (Courtesy of Lois M. Comstock.)

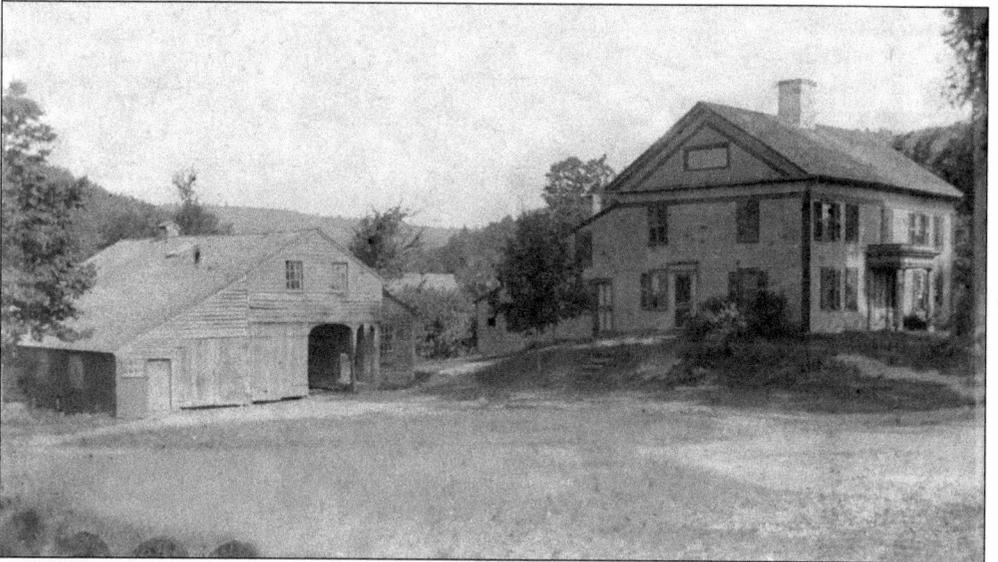

This house at 82 Westledge Road stands on land that was once part of Canton, and an 1855 Canton map shows a house here. But in 1879, the Simsbury town boundary was moved westward, increasing the size of Simsbury by about 4.5 square miles. Dr. N. Webster Holcomb lived in this house, then five generations of the same family—Shepards, Rowleys, Stromgrens, and Behrens—until the late 1980s.

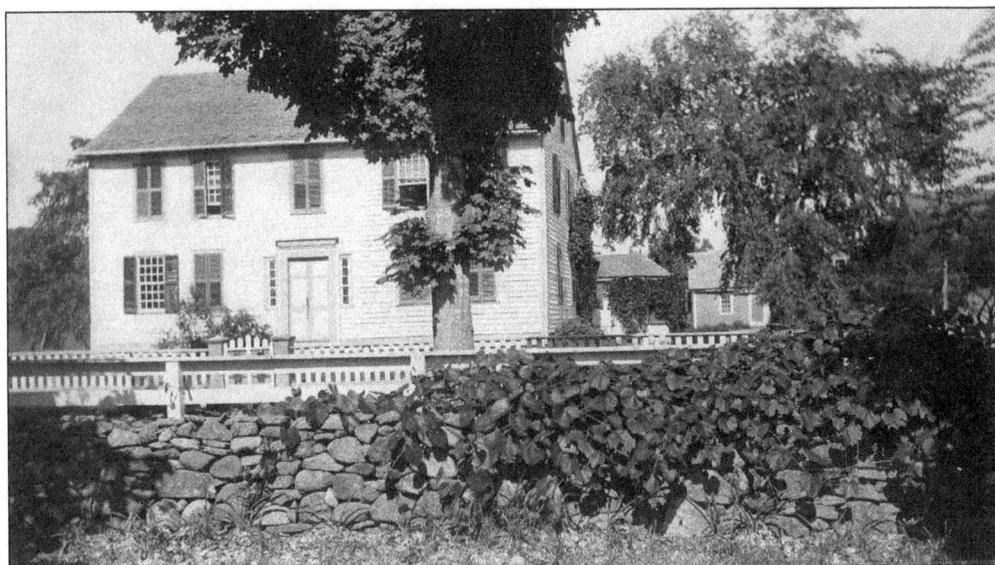

Built in 1781 by S. Buell, this is the house at 82 Old Farms Road as it looked about 1890. Over the years, it has been called the Holcomb place, Holcomb-Butler house, Orrin Kilbourn house, and Twin Oaks Farm. The ell is believed to be the Butler house, which was moved and added to the rear of the Holcomb house.

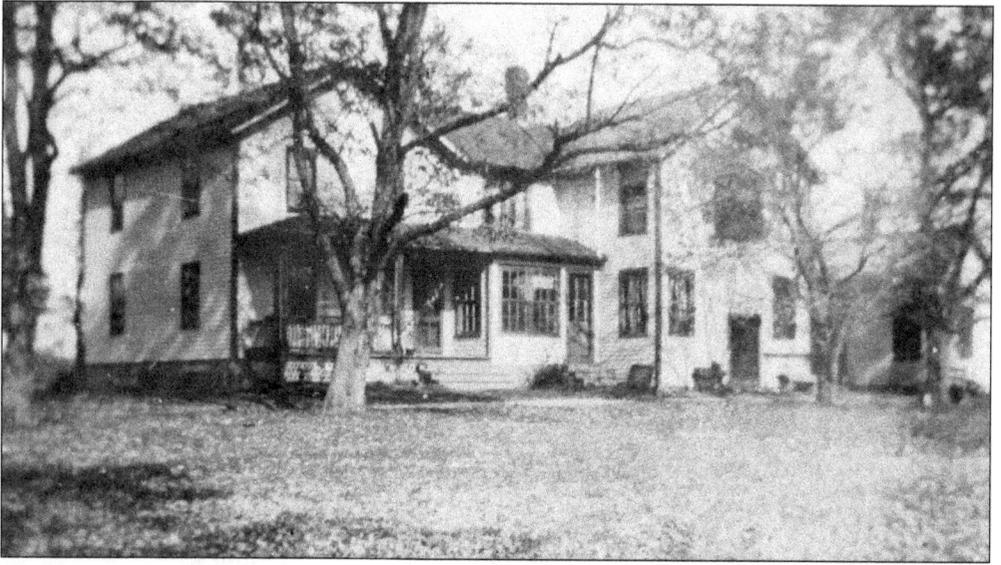

Photographer Barley Brown took this photograph of 180 Old Farms Road in 1810. Now the George Hall Farm, it is one of three family farms still active in West Simsbury, along with Tulmeadow Dairy Farm and Flamig Farm. Family farms east of the Farmington River include the Pickin' Patch, Rosedale Farms and Vineyard, Dewey Flower Farm, and Hall Farm.

White Birch Farm was an early name for the present George Hall Farm, once owned by John T. Shaw. This photograph, taken in the late 1800s, shows the property's signature birch path under the mountain west of Old Farms Road. The image was purchased in 1991 from the Emaret Flamig estate.

Four

THE VILLAGE
OF TARIFFVILLE

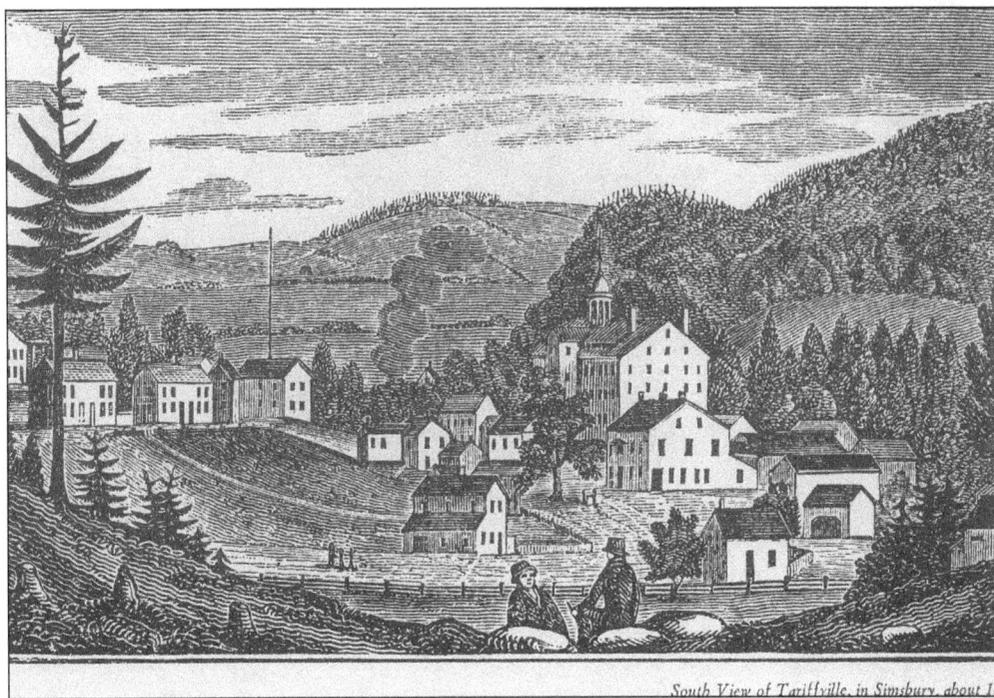

South View of Tariffville, in Simsbury, about 18

John Warner Barber made 180 engravings to illustrate his 1836 book about all the towns in Connecticut and he chose this scene of Tariffville from the south to portray Simsbury. The larger stone factory building, with the cupola, was built in 1825 by the Tariff Manufacturing Company, which recruited many skilled carpet weavers from Scotland. The factory was situated on the west bank of the Farmington River to make use of steady waterpower. The buildings to the left are worker housing.

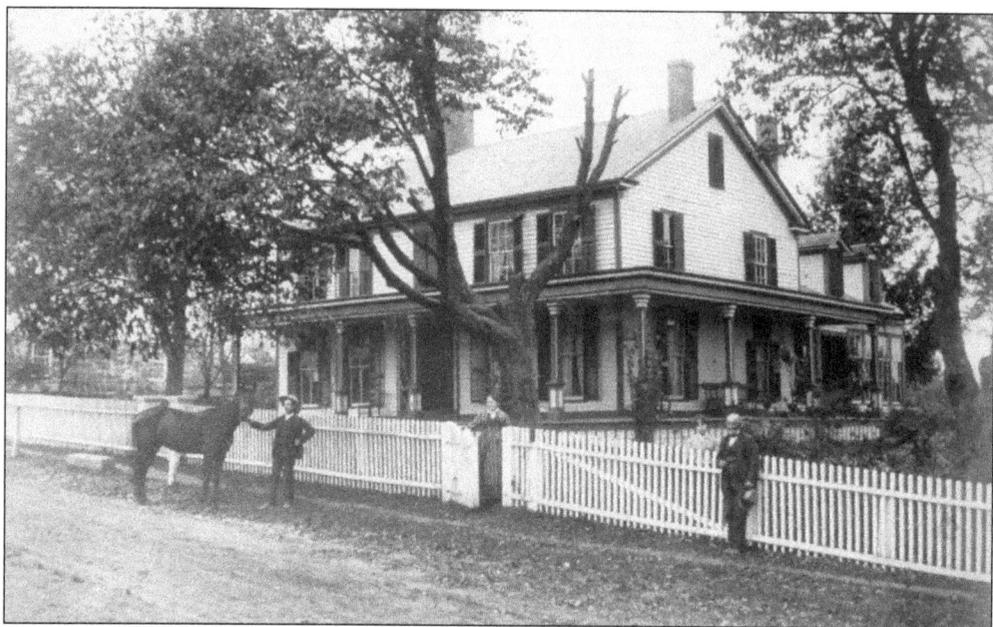

The Ariel Mitchelson residence at 48 Elm Street in Tariffville is shown here about 1890. The man on the right is probably Ariel Mitchelson Jr., a prosperous tobacco grower and one of the founders of Trinity Episcopal Church. His son, also called Ariel Mitchelson, is remembered as one of the first men in the state to successfully grow tobacco under cloth. (Courtesy of the Connecticut Historical Society, Hartford, Connecticut.)

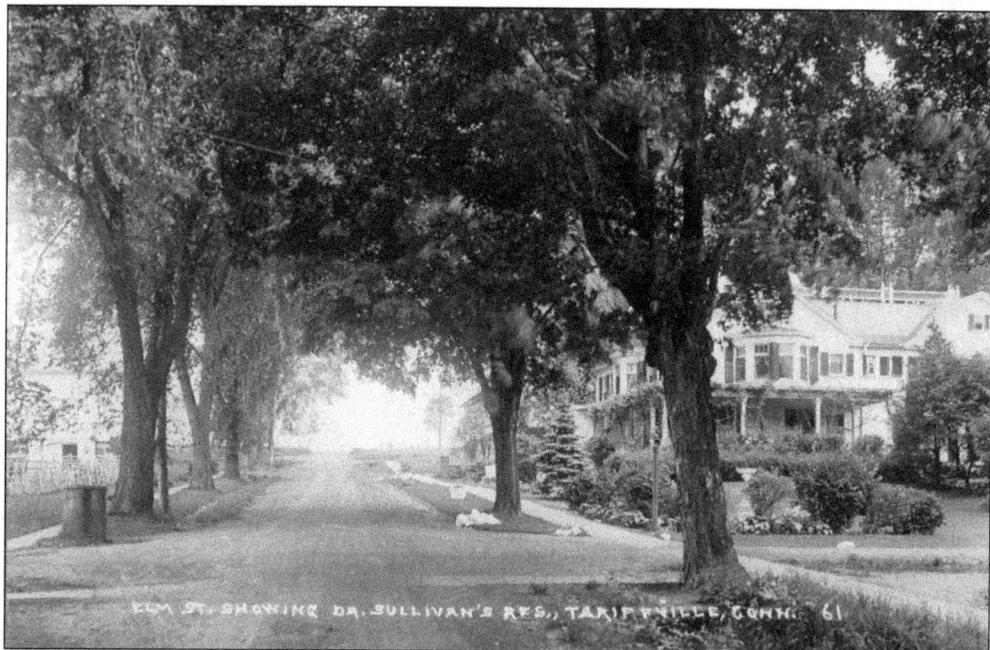

This postcard from the 1920s shows the same house when Elm Street had magnificent elms. The house was then owned by Dr. Daniel F. Sullivan, and the cross street is Church Street. The house was also owned at one time by tobacco and dairyman Arthur J. Hayes. (Courtesy of Richard E. Curtiss.)

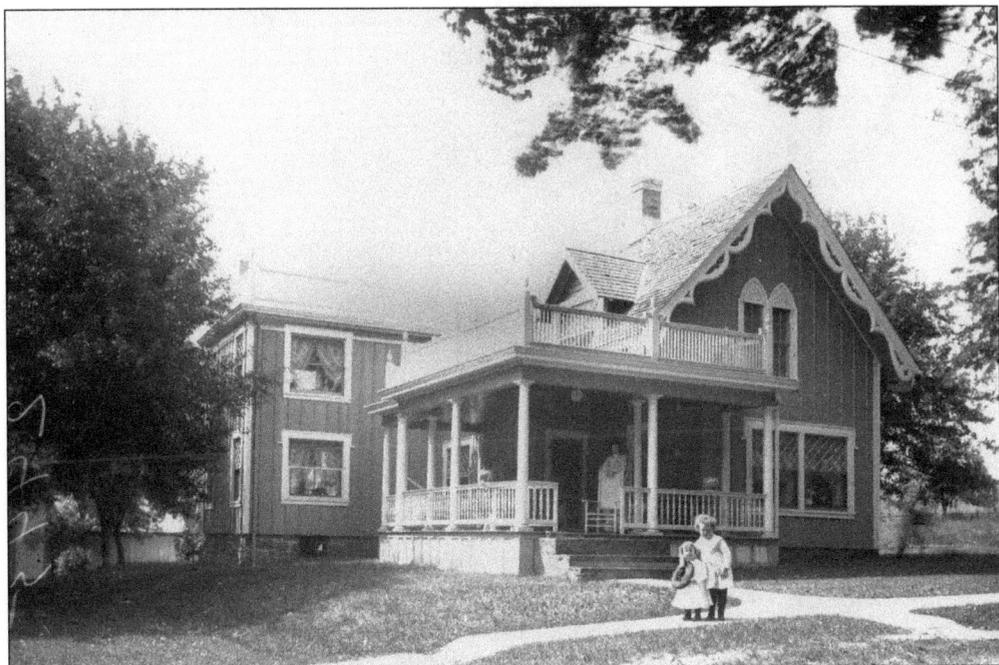

This house at 39 Elm Street was one of several Gothic Revival cottages built by Ariel Mitchelson, both for family members and as investments. This picture and the one below were taken about 1902. (Courtesy of Ashfield Historical Society.)

This Greek Revival house at 24 Elm Street in Tariffville was probably built around 1855 by Morgan Bacon, a wealthy farmer, who sold it to Thomas Lee before 1869. In more recent times it was the home of the Barwick family. Eleanor Barwick (1867–1958) was a longtime teacher in Tariffville Grammar School. She may be the younger woman in this photograph since it was taken about 1902. (Courtesy of Ashfield Historical Society.)

Sanford R. Olcott, a harness maker, lived here at 19 Elm Street at one time. Bartlett's Tower stands on the mountain ridge behind the house, dating the photograph to after 1889, which was when the tower was built. It could not have been taken later than 1907 because that is when the photographers, the Howes Brothers of Ashfield, Massachusetts, ceased business. (Courtesy of Ashfield Historical Society.)

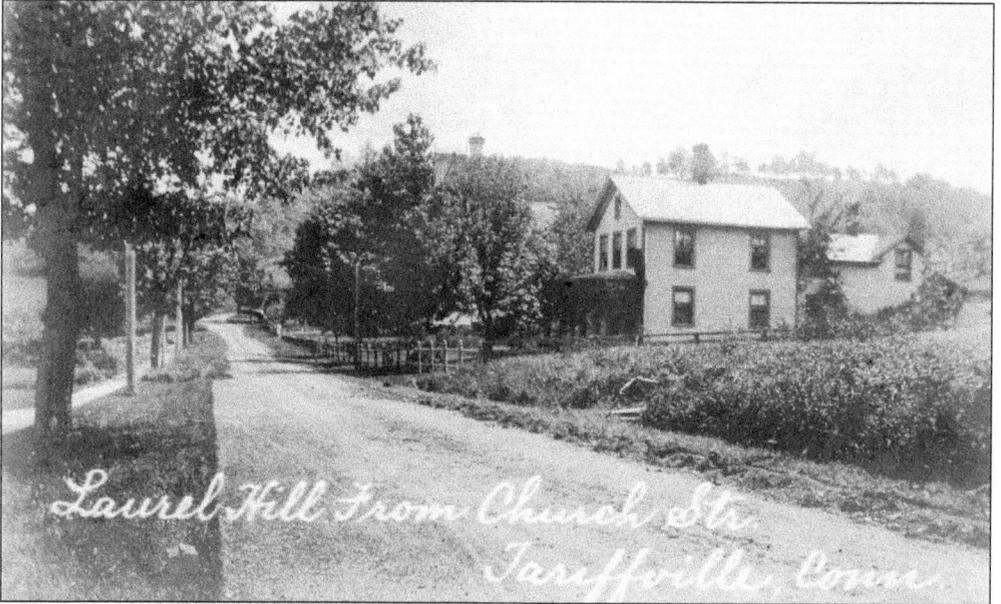

The same tower is shown here, but by the time this postcard was made, Antoinette Eno Wood owned the tower. William H. and Jennie Smith Pease bought this lot at 41 Church Street Extension from Ariel Mitchelson in 1883 to build their house. William was the postmaster and funeral director. Their daughter Nellie was a schoolteacher for many years in Tariffville. (Courtesy of Richard E. Curtiss.)

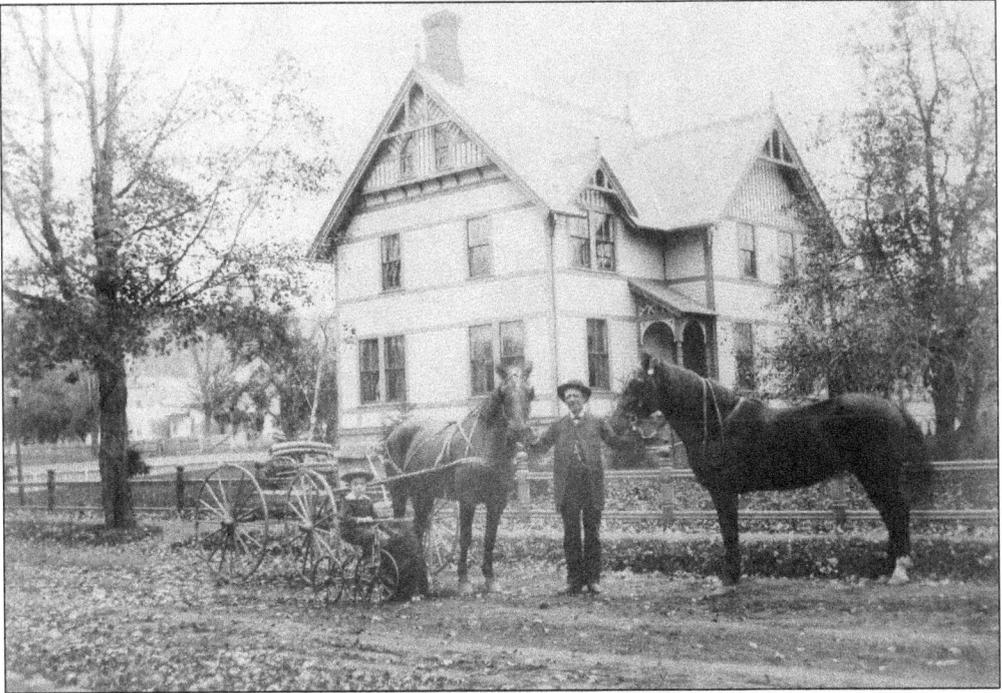

The photographer who took this picture about 1887 wrote that his client was M.H. Sanford, probably Marvin H. Sanford. His residence was 23 Center Street. His father, Dr. George W. Sanford (1807–1892), practiced medicine in Tariffville for more than 50 years and owned an almshouse that cared for state paupers. Marvin, and then his brother Morton, continued to run the almshouse until 1915. (Courtesy of the Clark Collection, Connecticut State Library.)

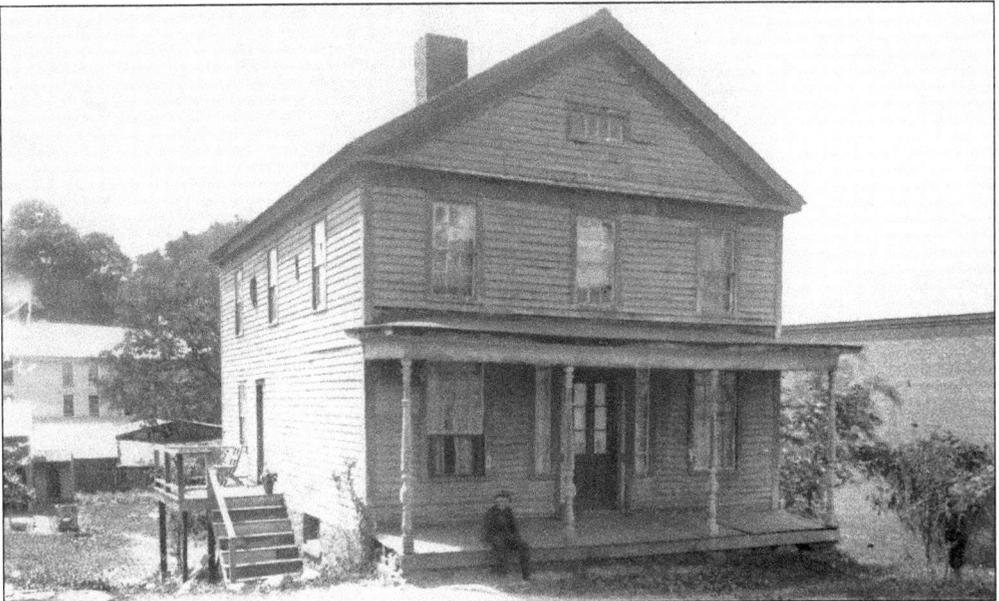

This picture of 15 Mountain Road, near the mill buildings in Tariffville, was taken about 1902. An 1869 map shows that it was one of two neighboring houses owned by an M. Congdon. The Sanford almshouse is visible in the background. (Courtesy of Ashfield Historical Society.)

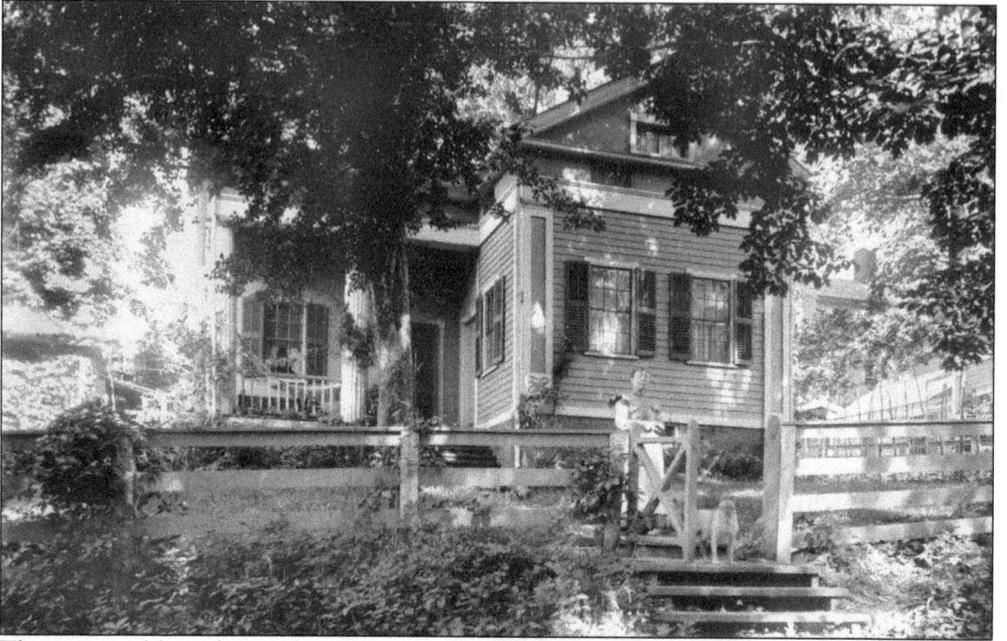

This is one of four almost identical houses on Tunxis Road built by the Tariff Manufacturing Company, probably for mill supervisors or highly skilled Scottish carpet weavers. They are the only buildings that the company owned that survived the 1867 fire. The Greek Revival cottages face the Farmington River. (Courtesy of Ashfield Historical Society.)

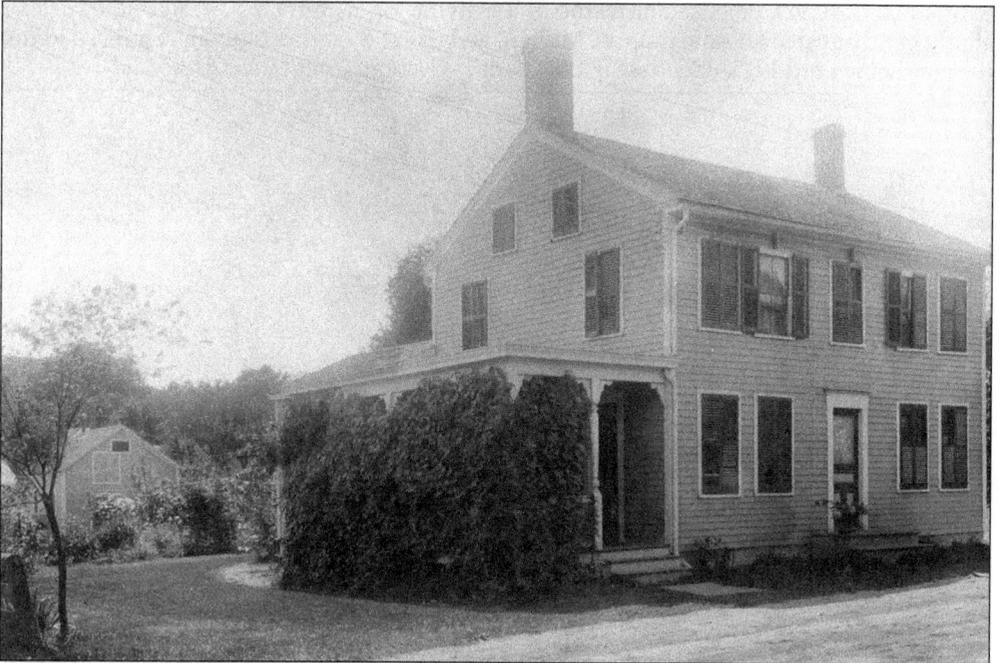

Porter White, who was in the stage business, built this house at 21 Winthrop Street about 1840 on land he had bought from the Ketchin brothers. The Pinney family purchased the house in the 1880s, and it is still in the family. At the turn of the 20th century, workers hand rolled R.L. Pinney cigars in the small building behind the house on the left. (Courtesy of Ed Pinney.)

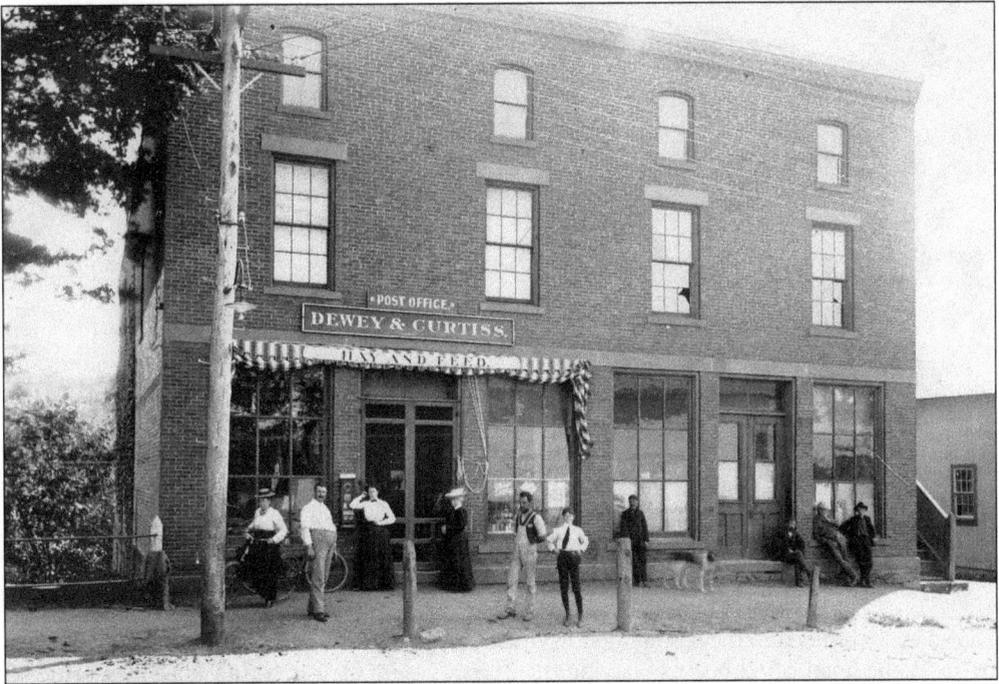

This store block was built around 1871, after the railroad came to Tariffville. On the left was a reading room, with the telegraph office above. On the right was the Tariffville Post Office, with a factory above producing hand-rolled cigars. When this photograph was taken about 1902, the Dewey & Curtiss general store (left) housed the post office. Today, the first floor is the Cracker Barrel Pub. (Courtesy of Ashfield Historical Society.)

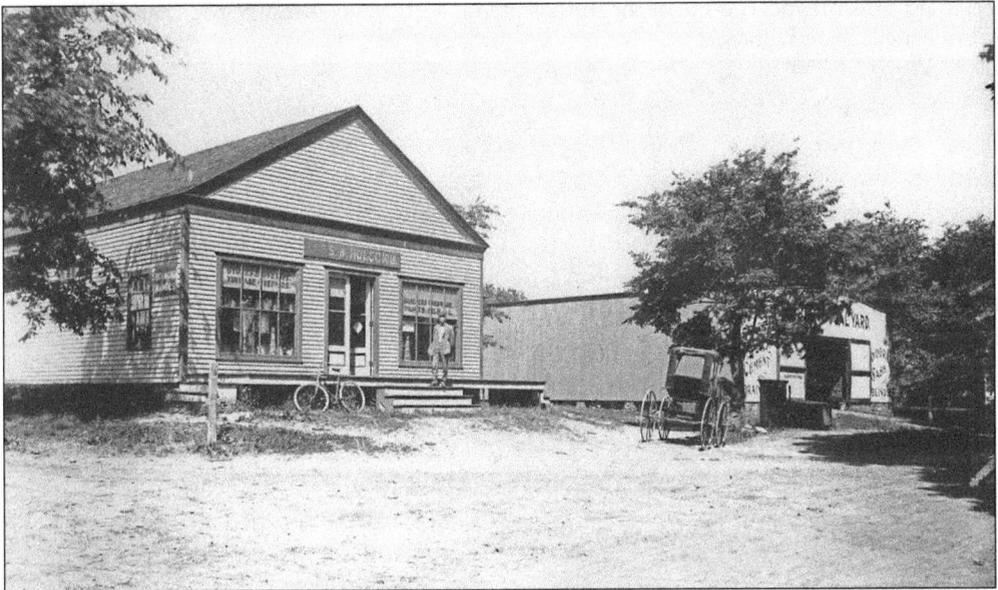

Charles B. Holcomb operated this store until it burned in the 1920s. It was at the corner of Main and Winthrop Streets. As the signs proclaim, he sold Richmond ranges, stoves and stovepipe, tinware, paints and builders' hardware, doors, sash, and blinds. (Courtesy of Ashfield Historical Society.)

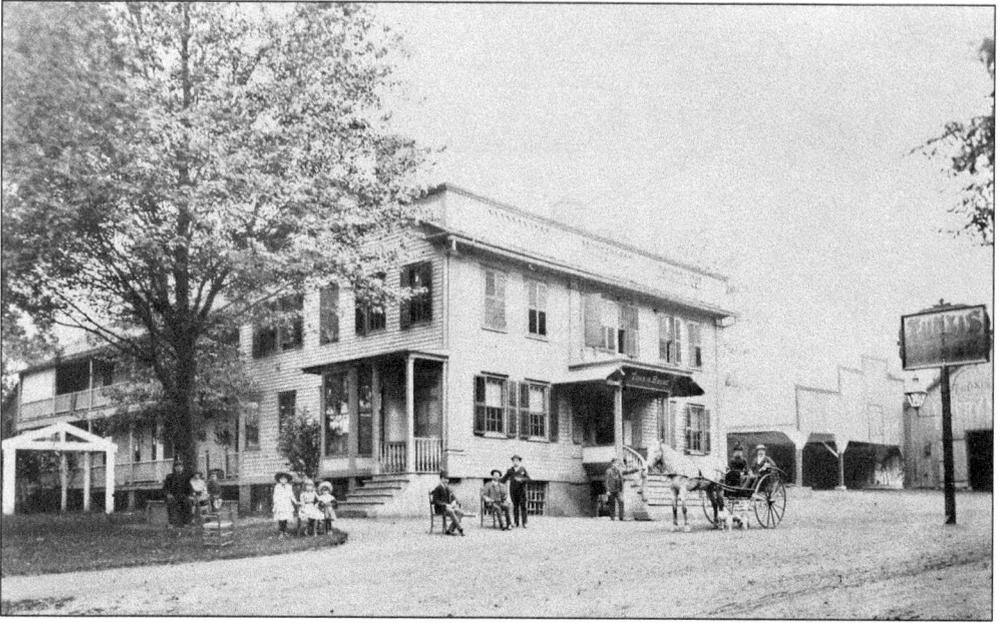

Shown above is the Tunxis House around 1885; shown below is the same house with later additions. By 1889, the hotel could boast of having the Tunxis Opera House, with a stage measuring 40 by 25 feet and 10 sets of scenery. It hosted a variety of shows, and the space was also used as a ballroom. An 1895 railroad travelers' guide said the hotel had 40 rooms. The hotel reached its peak during the height of railroad service. When passenger service dwindled and Tariffville suffered industrial reverses, the hotel's fortunes waned. It was a boardinghouse for a time but was mostly unoccupied when it was destroyed by fire on November 3, 1935. Today, Tariffville's village green on Main Street marks the site of the Tunxis House. (Above, courtesy of the Clark Collection, Connecticut State Library.)

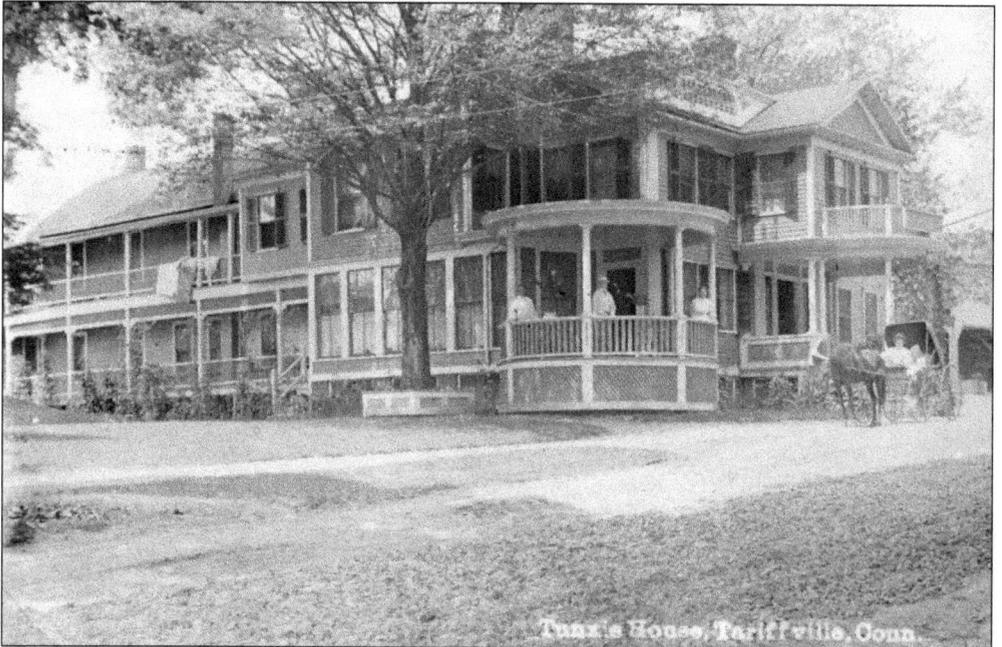

Matthew H. Bartlett built this 70-foot tower in 1889 on Laurel Hill. The spectacular view and the dance pavilion and bowling alley on the ground level drew visitors from all around, including Mark Twain, Harriett Beecher Stowe, John Greenleaf Whittier, and "Buffalo Bill" Cody. Antoinette Eno Wood later owned the tower and gave memorable socials there. Then, it became state property. It burned down one night in 1936.

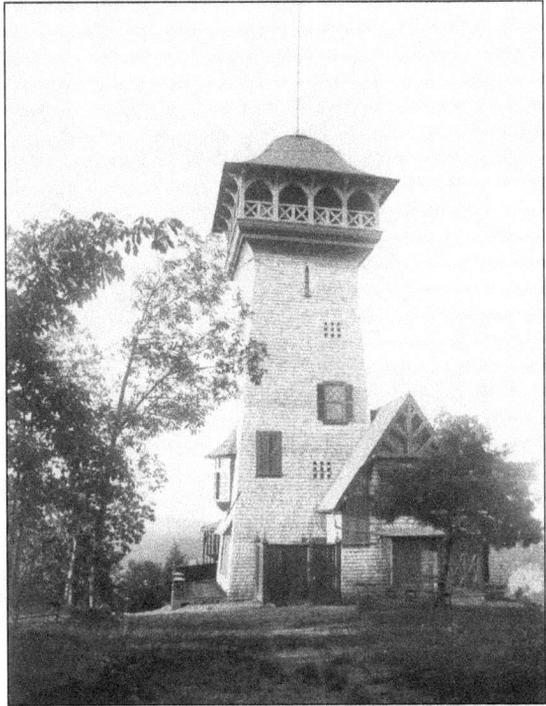

Dr. Charles M. Wooster came to Tariffville in 1879 intending to stay awhile to recover his health. He enjoyed living here so much that, in 1898, he built a fine house and stayed to become one of the two doctors in the village. Later, his house at 19 Wooster Street was converted into this hotel.

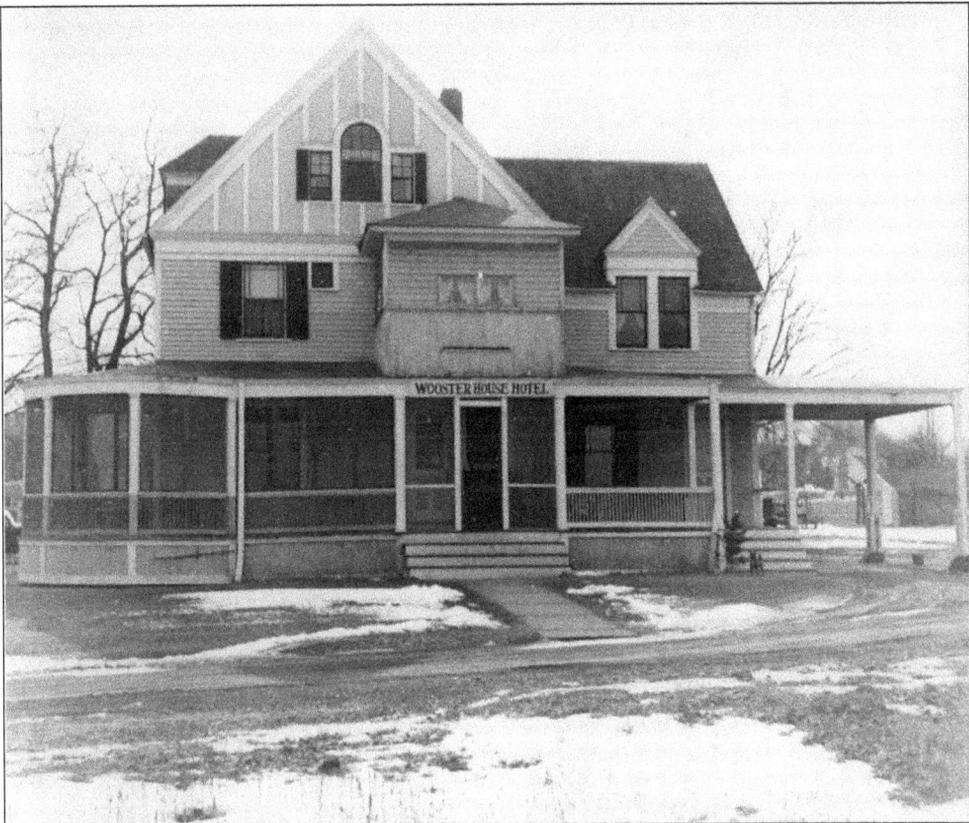

Around 1885, a traveling photographer recorded this building. Signs in the windows say, "Billiards and Pool." The sign on the wing says, "C.H. Olcott, Cigar Manufacturer." In 1886, the *Hartford Courant* reported, "Mr. Charles H. Olcott has in use in his cigar warehouse an incubator capable of holding six hundred eggs." Later, the paper reported that Olcott's poultry venture was successful. (Courtesy of the Clark Collection, Connecticut State Library.)

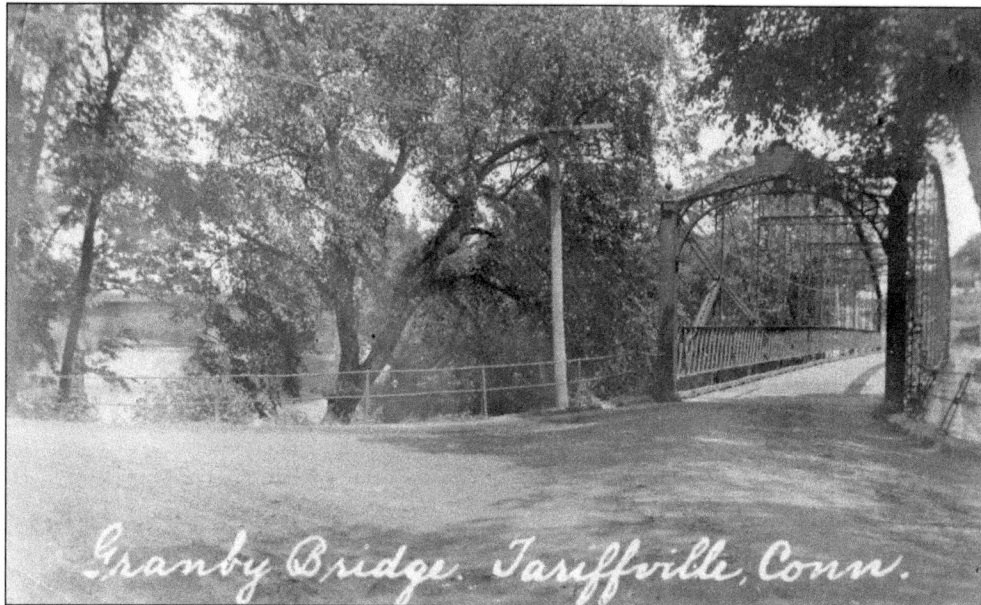

Granby Bridge. Tariffville, Conn.

This bridge at the west end of Main Street took traffic and pedestrians over the river to the cluster of homes and small businesses on the East Granby side of the Farmington River. The 1955 flood put an end to the bridge and, with it, the easy flow of people between these two neighborhoods. (Courtesy of Richard E. Curtiss.)

Five

CHURCHES AND COMMUNITY

In Colonial New England towns, the meetinghouse served both as a place of worship and a place for town meetings. Simsbury's first meetinghouse was completed in 1683 in front of the old burying ground, now Simsbury Cemetery. The building in this image, reconstructed at the original site as part of the Connecticut Tercentenary Celebration in 1935, followed the specifications of the original structure.

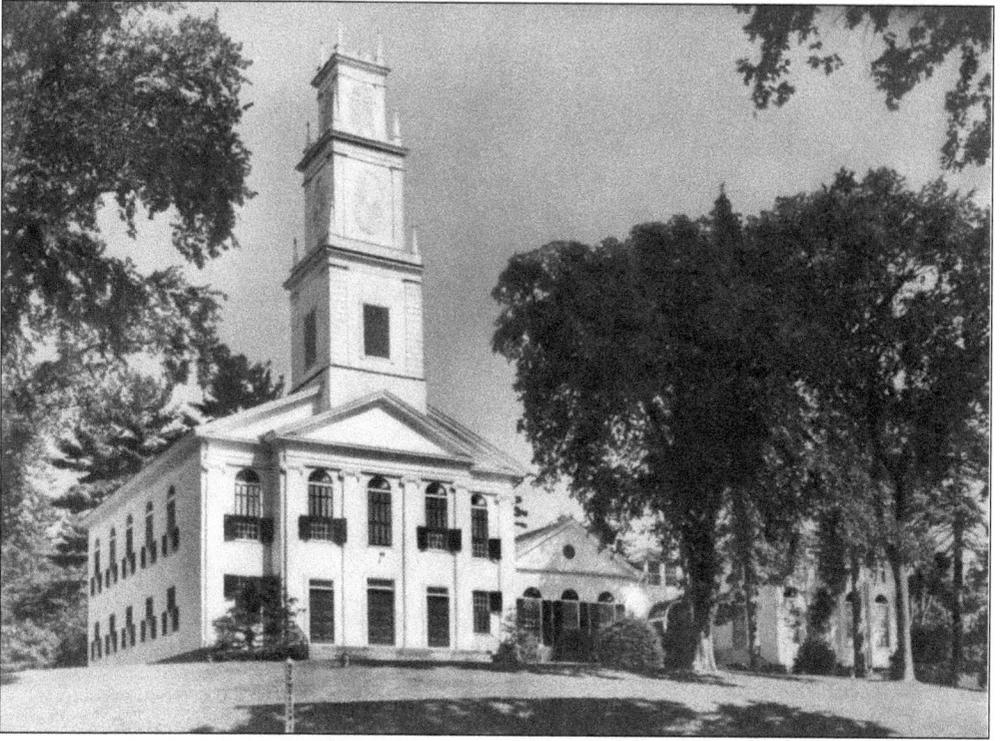

As the population grew, the town needed a larger meetinghouse and, in 1743, built one at a site on Drake Hill. In 1830, a new church, known today as the First Church of Christ, arose on the same site. A chapel was added in 1895, and a parish hall was built in 1925. They were lost to a fire in 1965.

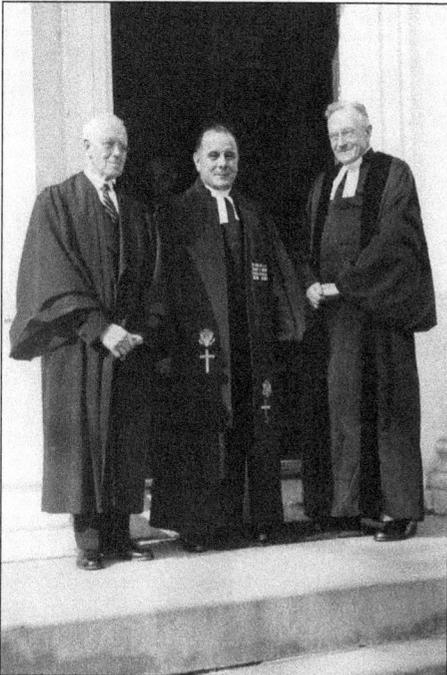

Congregational ministers were prominent in the town's history. Dudley and Timothy Woodbridge helped develop the town's copper mines. Samuel Stebbins led the congregation through the turbulent years of the Revolutionary War. Allen McLean promoted education and temperance. In 1947, the church celebrated its 250th anniversary. Symbolizing continuity, Minister William Nicolas (center) posed with two predecessors. Hugh McCallum (left) served from 1910 to 1918, and Oliver Bronson served from 1899 to 1907.

The Episcopal Church arrived in the mid-1700s when St. Andrew's Church was founded in Simsbury's Scotland District (now part of Bloomfield). In 1848, a sister parish was established in Tariffville and it held services in a church formerly used by the Presbyterians. Ariel Mitchelson gave land for a new structure in 1871, and on July 8, 1873, the present Trinity Episcopal Church Building was consecrated. (Courtesy of Trinity Episcopal Church.)

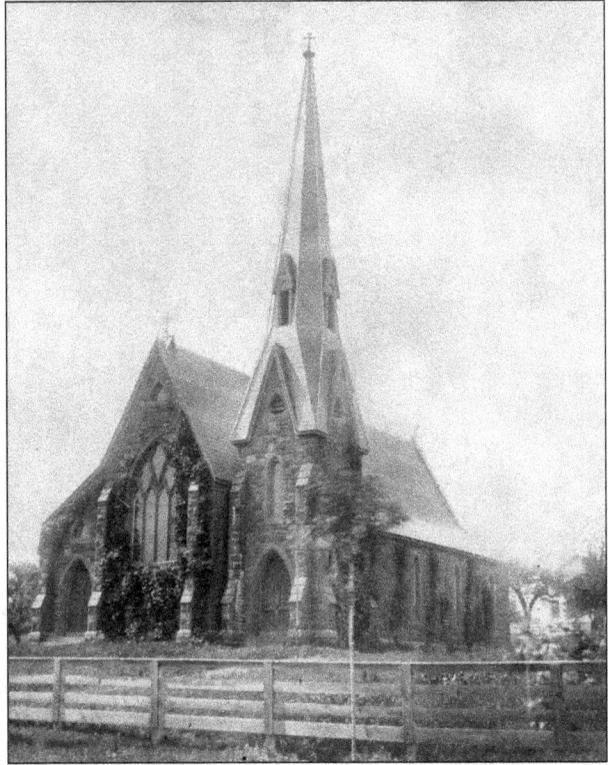

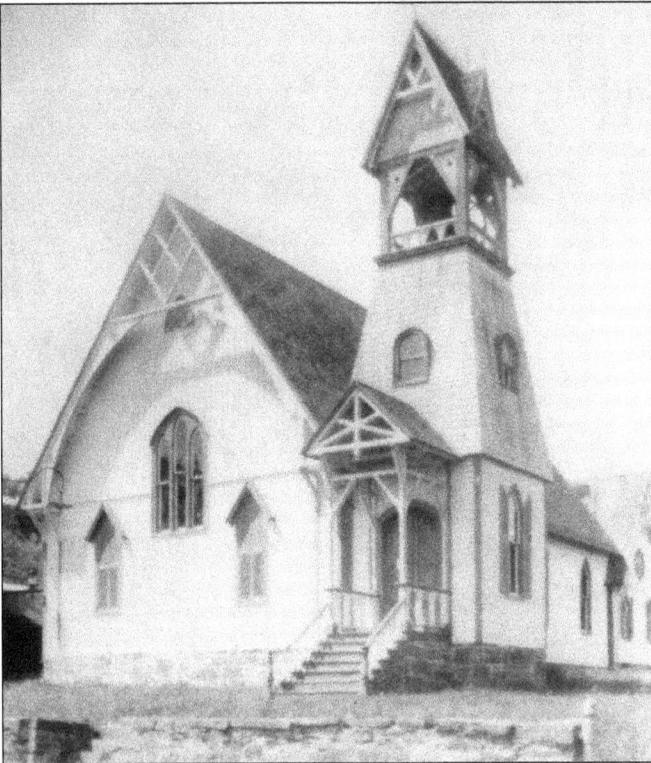

A Baptist congregation started in Tariffville in 1833 and built a church in 1843. That building burned down in 1876. It was rebuilt as it is shown in this photograph, but participation gradually faded. The former church is now a private residence on Church Street Extension.

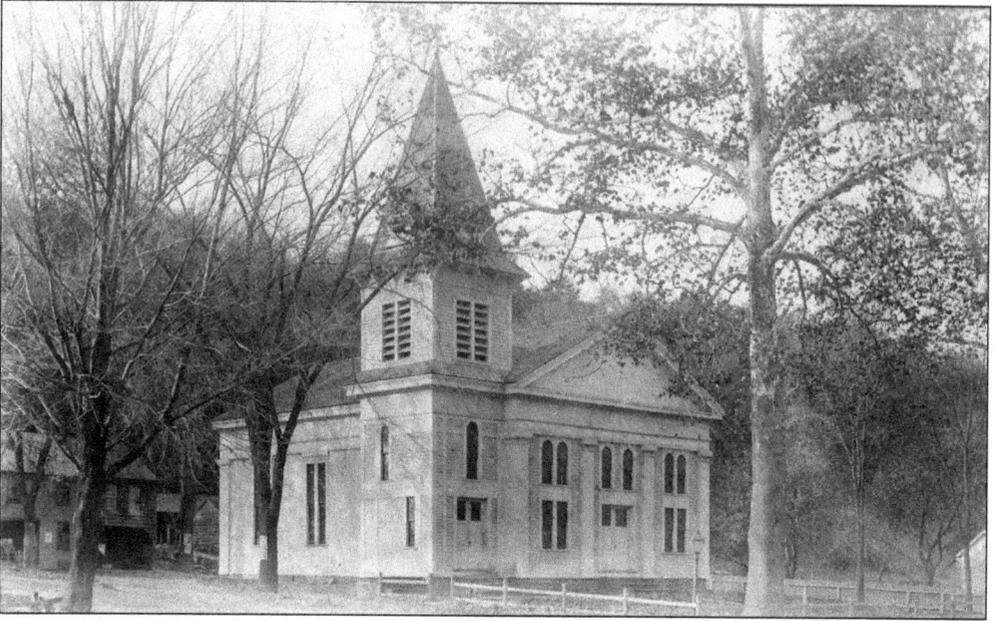

Methodists made their appearance in Simsbury around 1800, initially meeting in homes in West Simsbury. In 1840, Moses Ensign, a prominent citizen and member of the Congregational church, gave the Methodists land for a new church on Hopmeadow Street, located "easterly of Levi Brockett's shop." The congregation raised the $3,000 needed to construct this simple wooden structure.

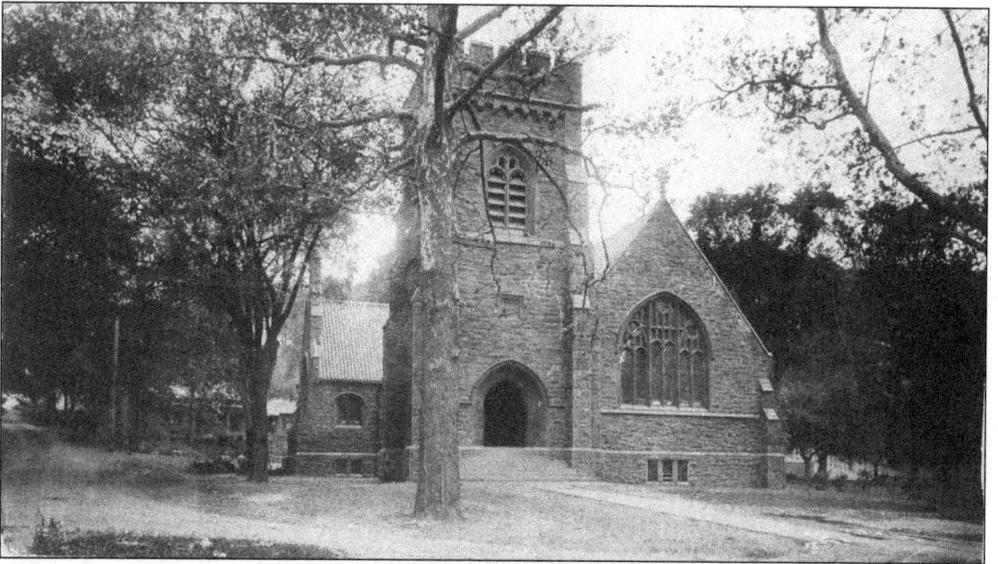

By the early 1900s, the congregation had outgrown the old building. In 1908, it was demolished. Ralph Hart Ensign, Moses Ensign's son and Joseph Toy's son-in-law, helped place the cornerstone of a new church on the same site. George Keller of Hartford designed it in late English Gothic style, and A.J. Ketchin & Son of Tariffville built it. The new church was dedicated on June 10, 1909.

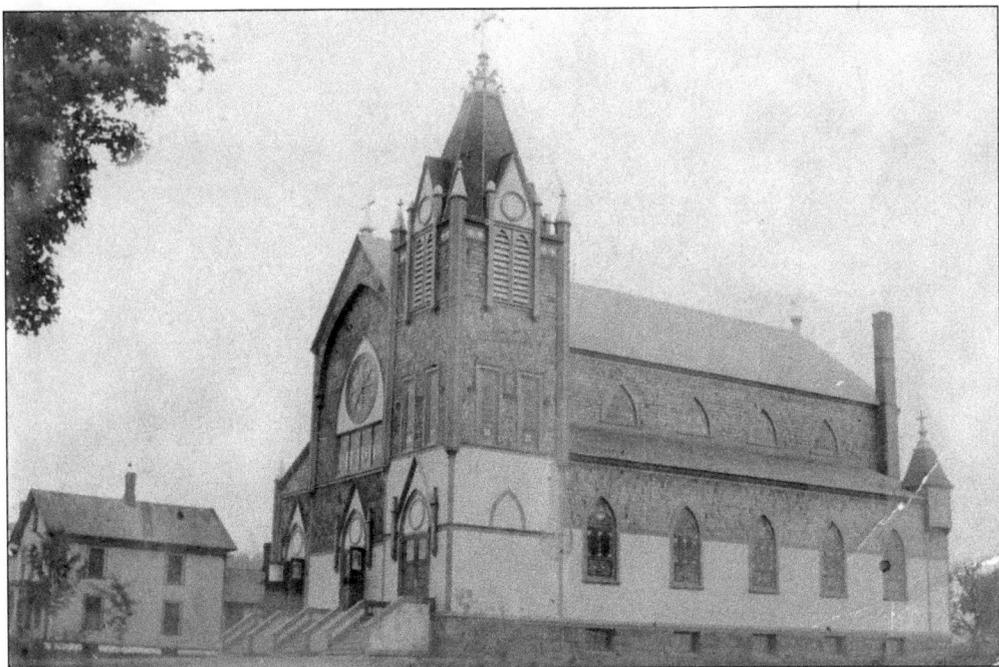

The first Catholic church in Simsbury was built on Mountain Road in Tariffville in 1850. The population quickly outgrew the original building, and its immediate successor was lost to fire. The present St. Bernard's, at the corner of Winthrop and Maples Streets in Tariffville, dates from 1895. Among its parishioners were many Irish immigrants who settled here to work in the factories. Mary Kelly and Peter Gargon, both born in Ireland, were married at St. Bernard's on October 6, 1897. The photograph below was taken at the bride's mother's home on Firetown Road.

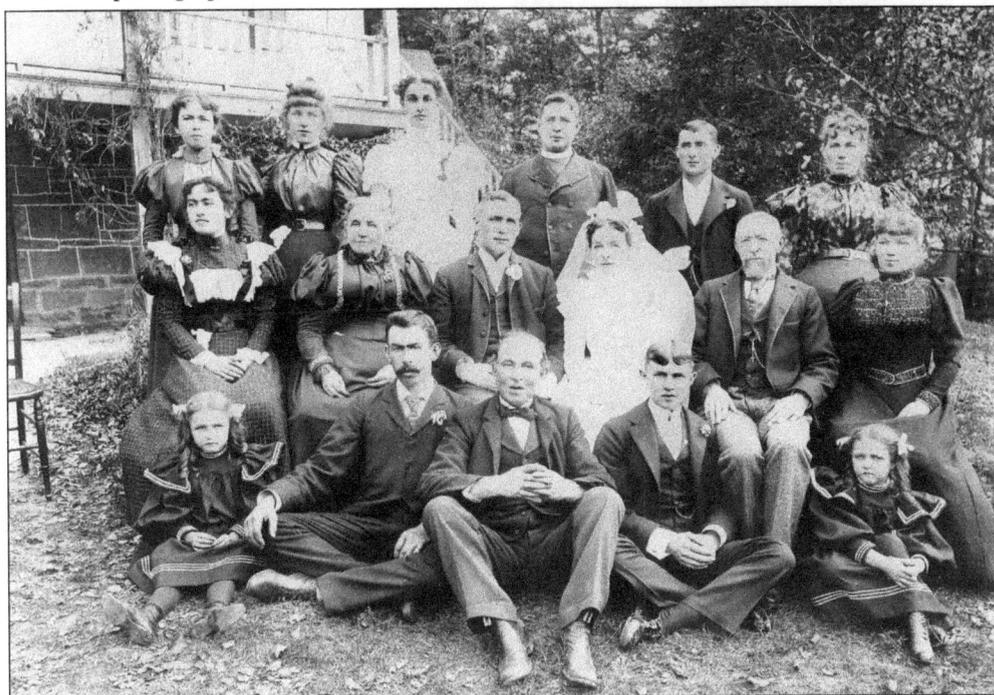

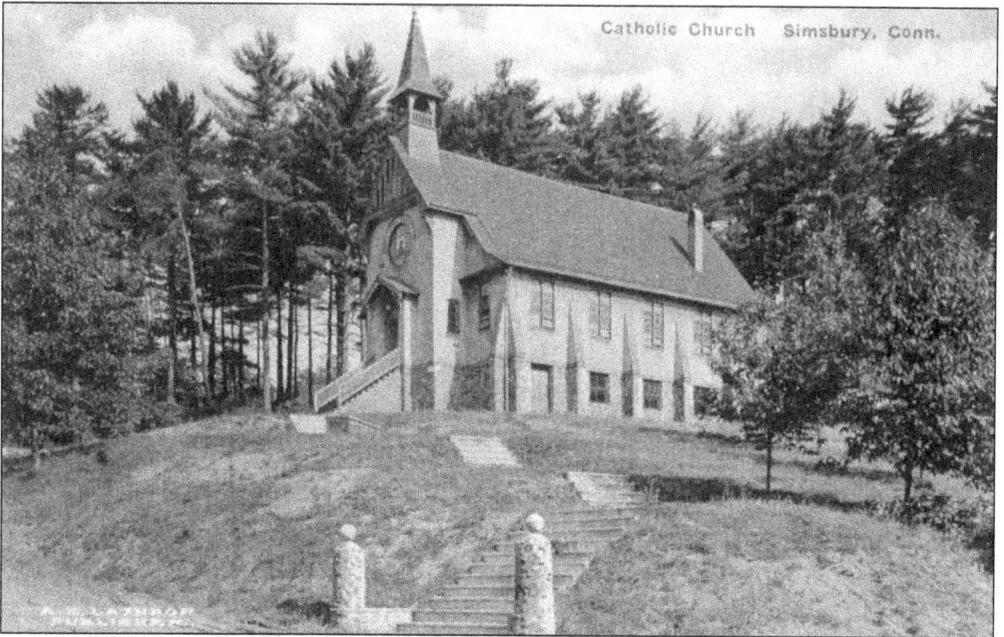

In 1903, the cornerstone for a new Catholic church, still within the Tariffville parish, was laid in Simsbury Center on Plank Hill Road. Built by Louis Fagan of Simsbury, this new Church of the Immaculate Conception was dedicated on May 29, 1904, and served the community for more than 30 years. (Courtesy of Richard E. Curtiss.)

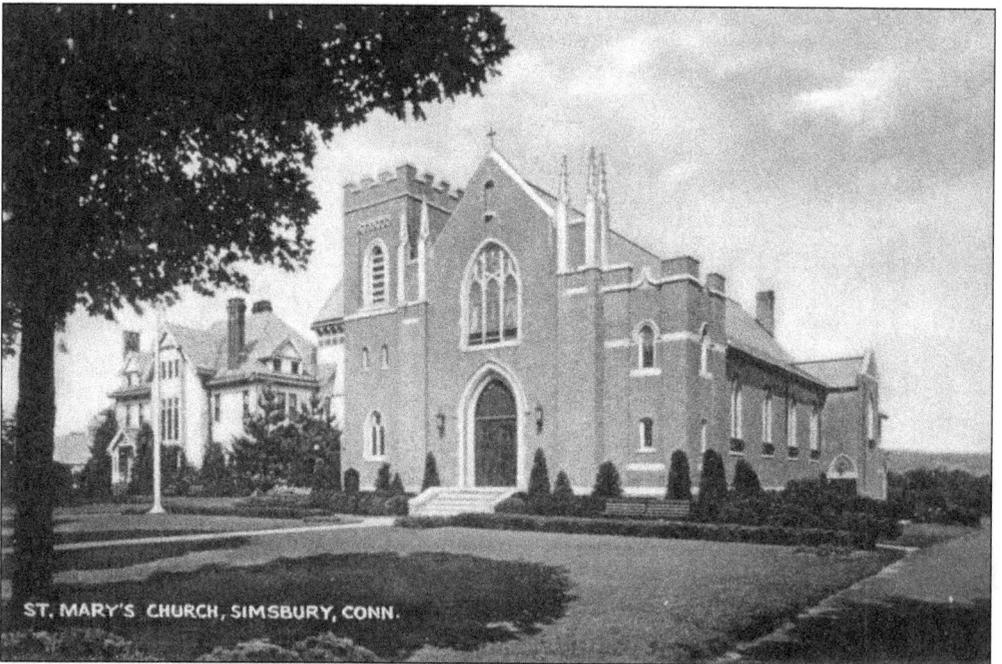

Eventually, the congregation outgrew the Plank Hill church. In 1936, the present St. Mary's Church on Hopmeadow Street replaced it. The structure just to the left of St. Mary's was originally the Victorian home of C.E. Curtiss. It served as a rectory, convent, and, later, an educational center before it was torn down in 1982. (Courtesy of Richard E. Curtiss.)

74

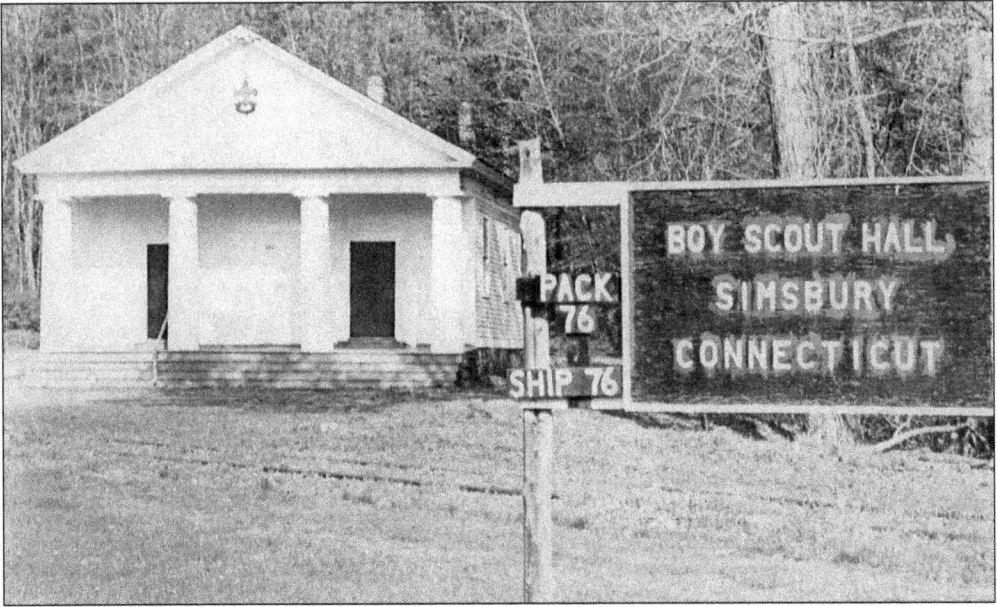

Simsbury built its first townhouse (as the town hall was then called) in 1839 on the hill just west of the Congregational church. Later, it was moved down the hill nearer to West Street. In 1871, it moved again to its present site to make room for the Connecticut Western Railroad. The hall hosted town meetings, dances, and basketball games. It became known as the Boy Scout Hall in the 1930s.

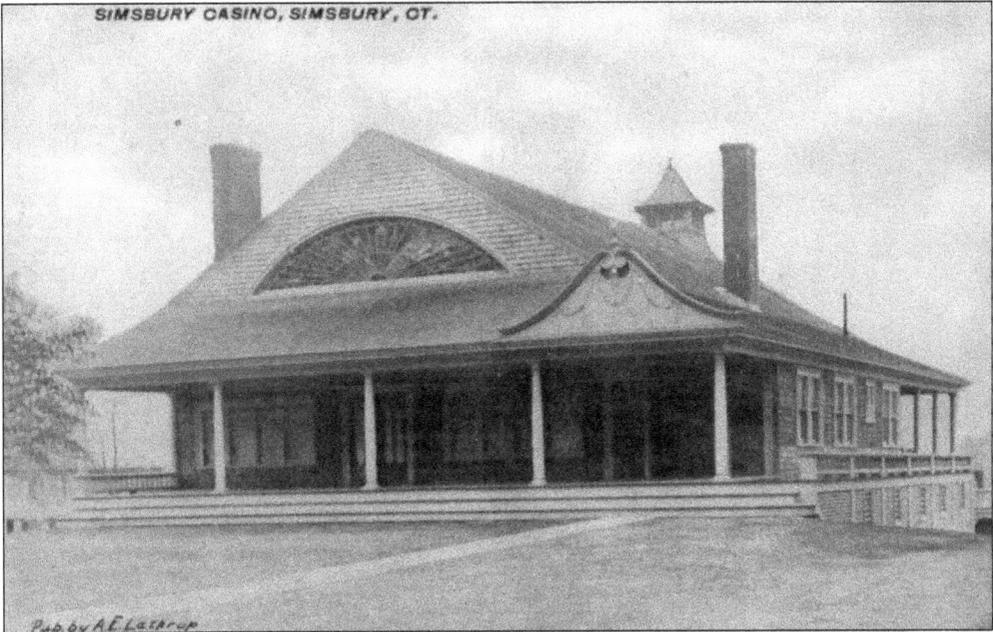

Private citizens built new or converted existing structures to meet a need for more gathering spaces. One was the Casino, erected in 1896, on Hopmeadow Street. It was a social club and housed an assembly hall, banquet hall, pool tables, and outdoor tennis courts. It served as the town's first movie theater and, in 1918, was used as an emergency hospital to quarantine patients during the influenza epidemic.

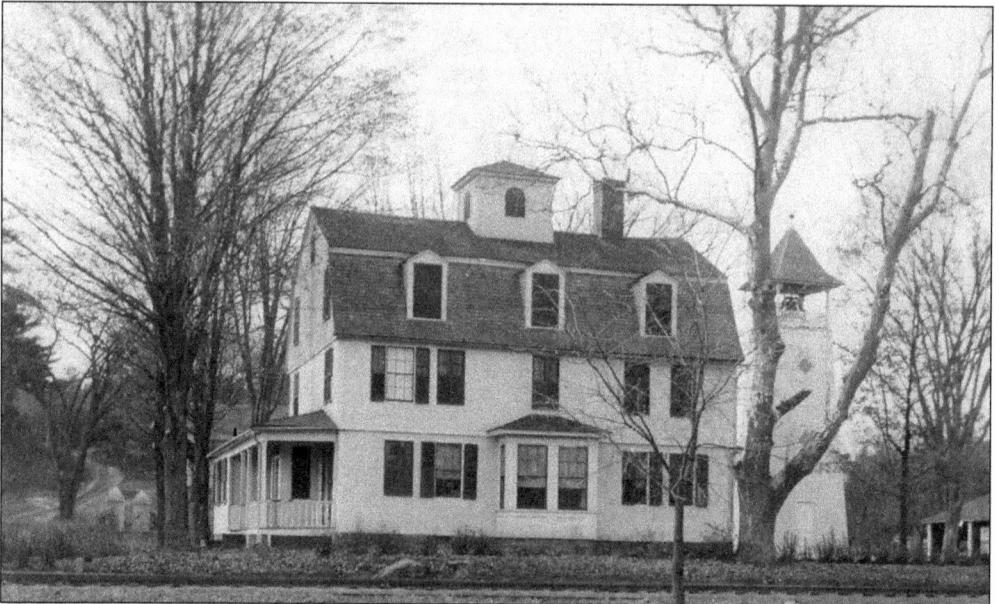

In 1905, Rev. Charles P. Croft and his wife, Julia, started the Neighborhood House in Weatogue in the old Mather-Phelps homestead that was donated by Antoinette Phelps. The bell tower was added at this time. The house was used for meetings and social events, and Reverend Croft made special efforts to include immigrant families and their children in the activities.

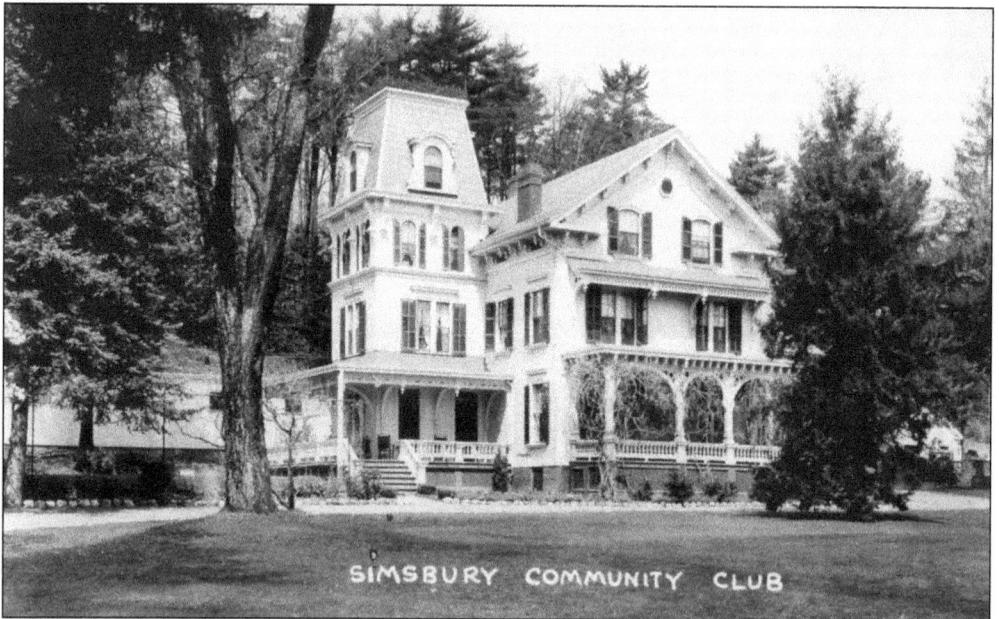

The former Robbins house on Hopmeadow Street served a similar social purpose. Annie Ellsworth Schultz purchased it and, in 1922, gave it to the town as a memorial to her husband, Emmett Schultz, for use as a community club. In addition to hosting meetings and card parties, it featured a bowling alley, tennis courts, and pool tables. It was demolished in 1950. The property is now Schultz Park.

By the 1920s, the needs of the town had outgrown both the capacity of its old town hall and private social clubs, like the Casino. Antoinette Eno Wood (1842–1930), the wealthy daughter of Amos R. and Lucy Phelps Eno and a summer resident of the elegant Eaglewood estate, provided funds and instructions in her will for a new community hall to be built as a memorial to her parents. The Casino was torn down and replaced by Eno Memorial Hall. It was dedicated on May 30, 1932. It housed the town offices, probate records, a courtroom, an assembly hall with a projection booth for showing films, a banquet hall, and rooms for the Abigail Phelps Chapter of the Daughters of the American Revolution, the Girl Scouts, and the Simsbury Historical Society.

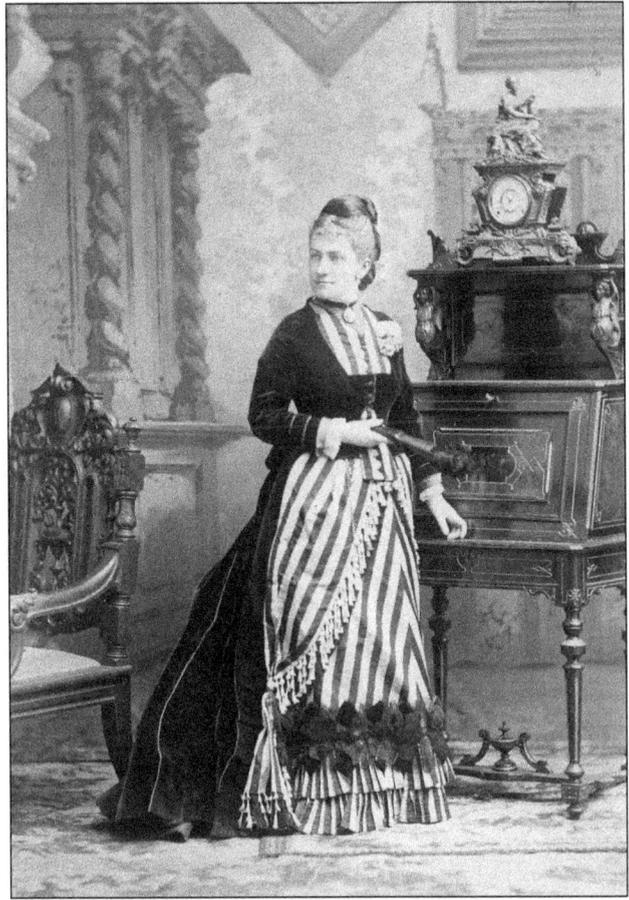

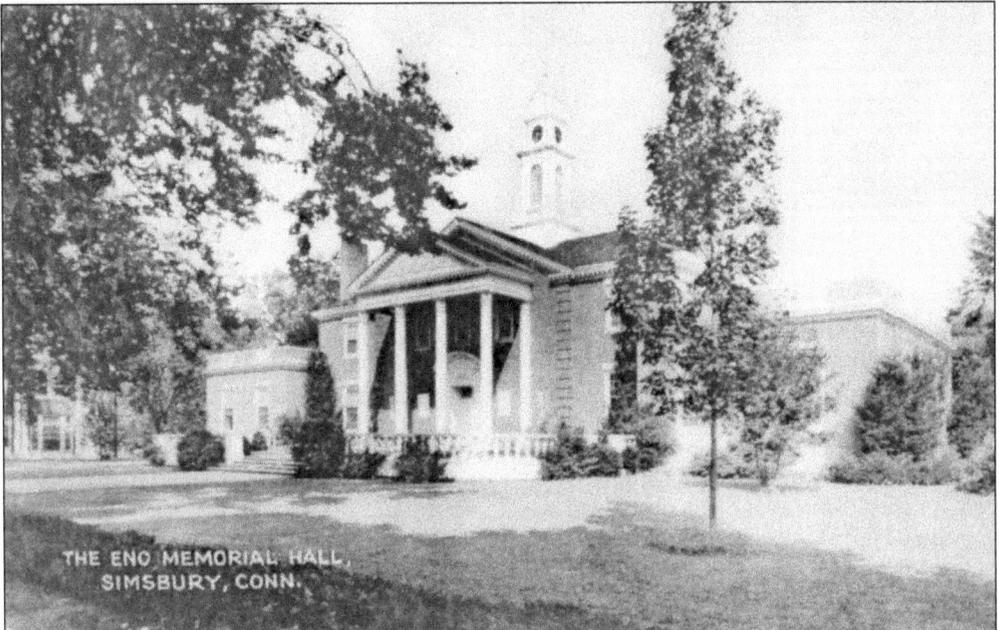

THE ENO MEMORIAL HALL,
SIMSBURY, CONN.

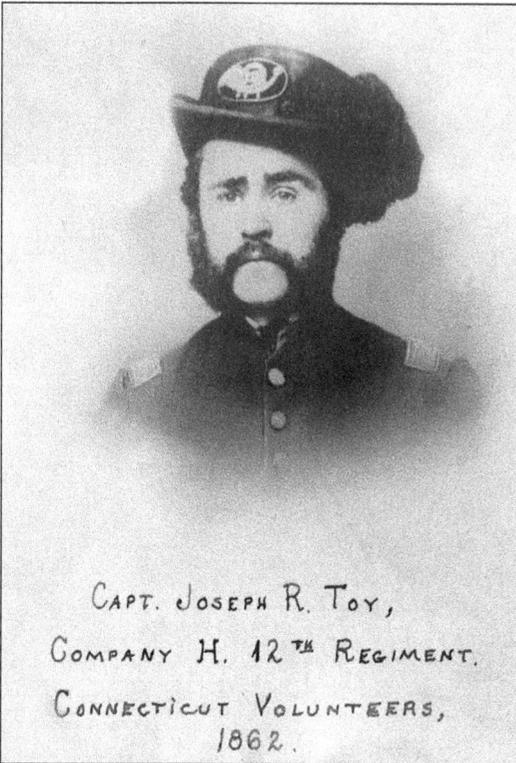

Bonds of community may be forged by war as well as by peace. During the Civil War, the town voted to pay a bounty to those who fought in the Union forces. More than 200 men from Simsbury served. One was Capt. Joseph Toy Jr. A popular figure in town, he volunteered but became an early casualty, dying of typhoid fever in a Union camp near New Orleans on June 21, 1862.

CAPT. JOSEPH R. TOY,
COMPANY H. 12TH REGIMENT.
CONNECTICUT VOLUNTEERS,
1862.

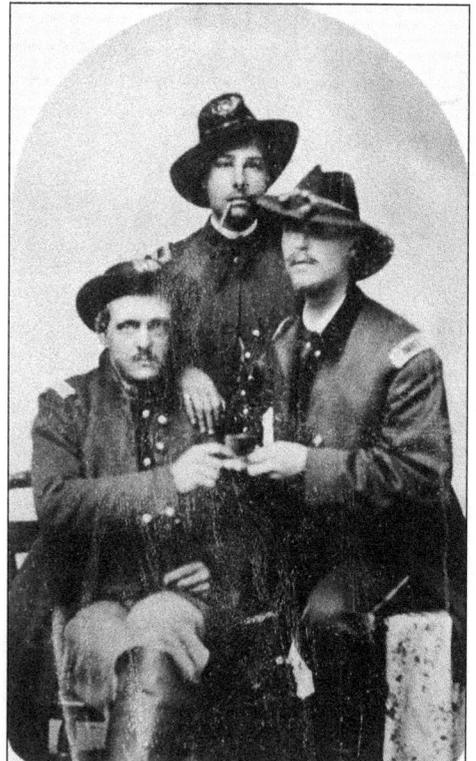

Lt. Alonzo Grove Case (left) was more fortunate. Here, he poses with Capt. Henry L. Beach of Hartford (center) and Lt. Wallace R. Andrus of Berlin of the 16th Regiment, Infantry, Connecticut Volunteers. Lieutenant Case was twice wounded, then captured by Confederate forces at Plymouth, North Carolina. He was imprisoned at Andersonville but survived. Two of his children perished from tuberculosis while he was away. (Courtesy of Connecticut State Library.)

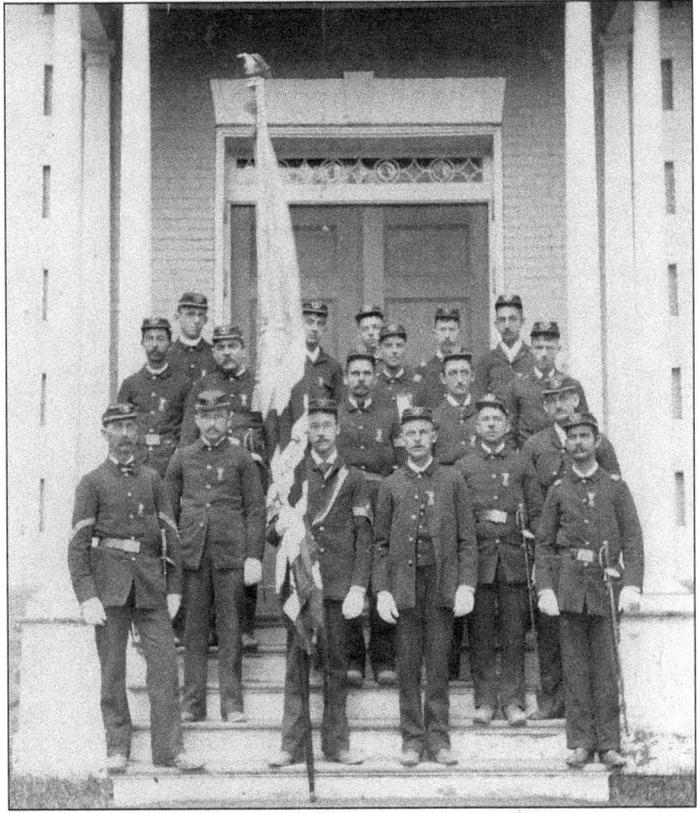

Patriotic sentiment remained strong after the war. In 1866, Union veterans organized the Grand Army of the Republic (GAR) and, in 1881, formed the Sons of Veterans of the United States of America to carry on the GAR's traditions. Simsbury started a local branch, the Oliver C. Case Camp, in February 1890. Burton Case stands at the far left of the back row; Alex McNulty is on the right end of the front row. Five years later, on July 4, 1895, the town dedicated a monument in Weatogue to its Civil War veterans. (Below, courtesy of Richard E. Curtiss.)

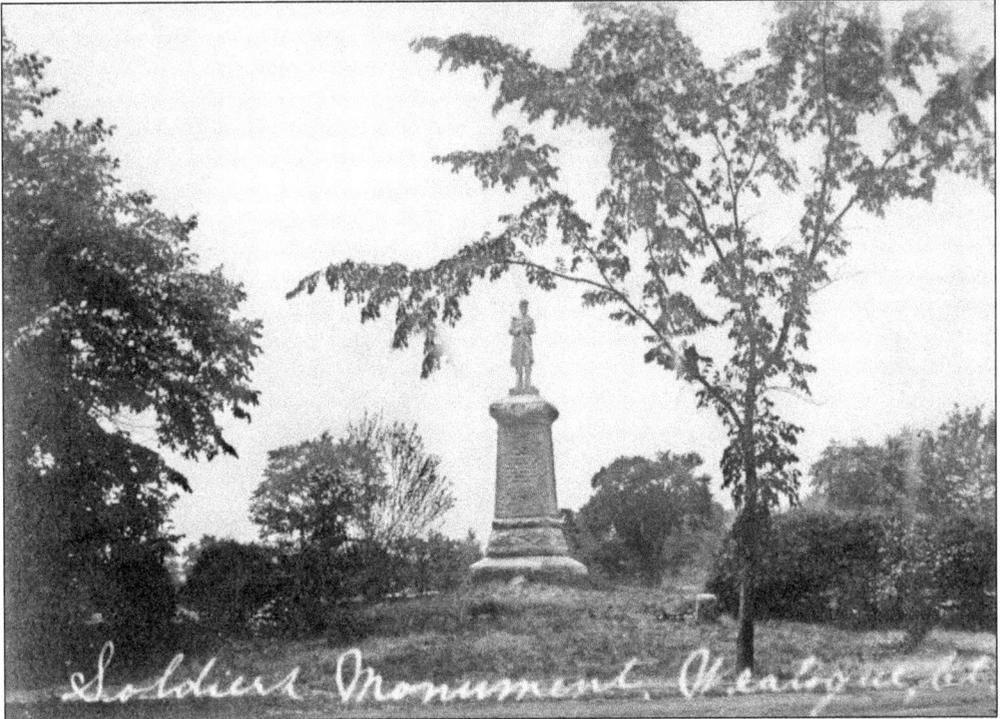

Soldiers Monument, Weatogue, Ct.

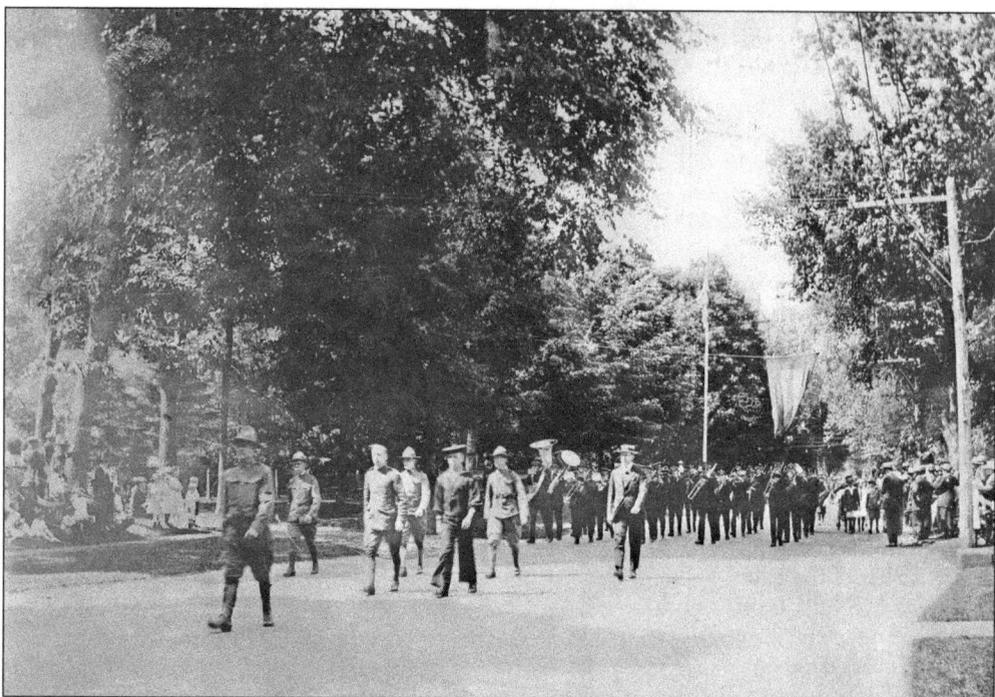

The onset of World War I generated a surge of patriotism. The town erected an Honor Roll on Hopmeadow Street to recognize its servicemen and dedicated it with a grand parade and ceremony on June 9, 1918. The parade began at 3:00 p.m. and was led by Capt. Jonathan E. Eno, his aides, and the 1st Regiment Band of the Connecticut State Guard.

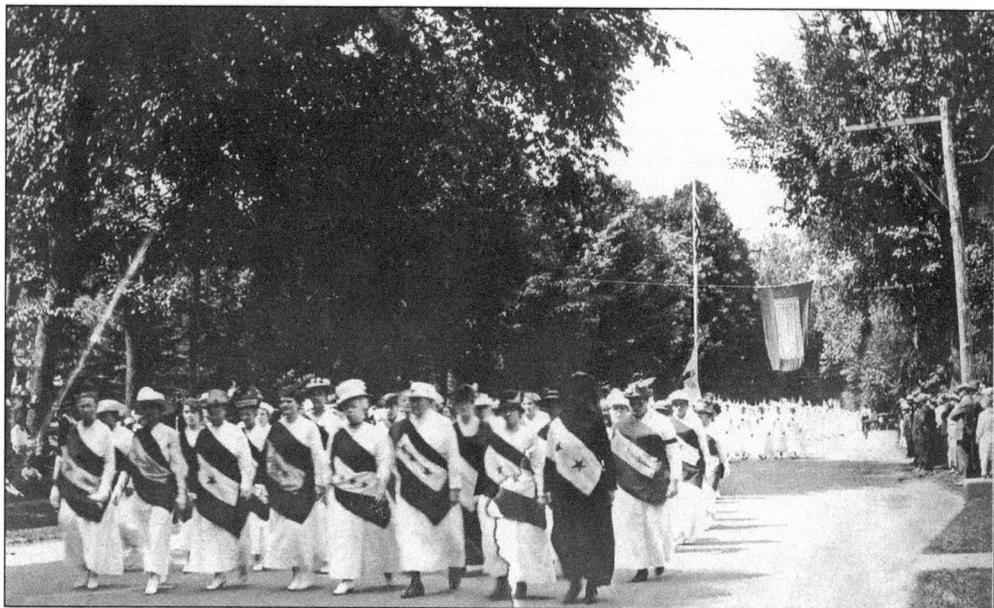

The "service division" was a striking feature of the parade. Female relatives of servicemen marched with a service flag draped over their shoulders, and each flag bore a star for a family member in the service. The marcher dressed in black may be a relative of Joseph Tomalonis, the first man from Simsbury to be killed in action. He died in France on April 29, 1918.

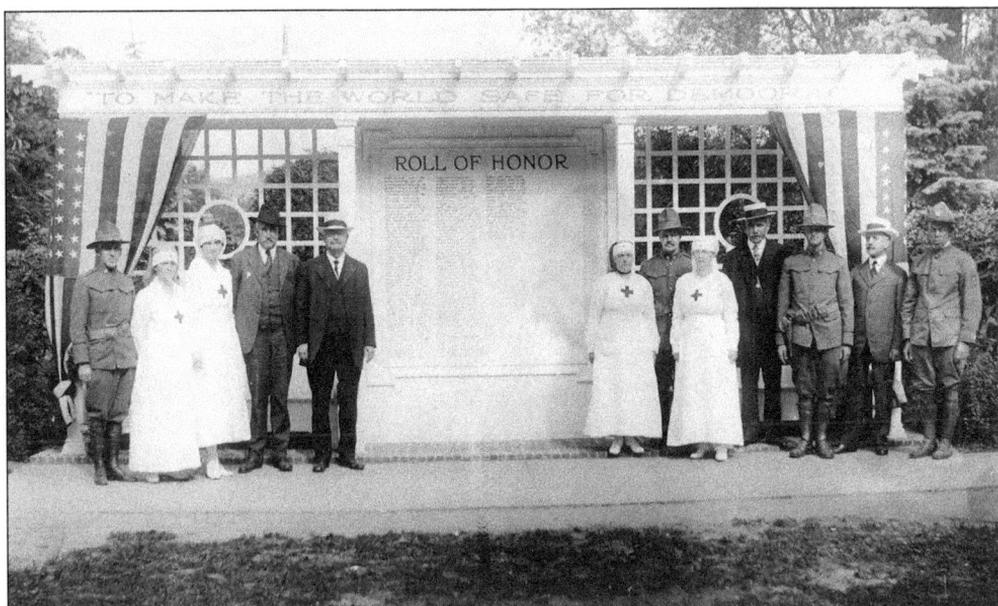

The Honor Roll was inscribed with the names of Simsbury's servicemen, 131 strong. The pavilion that enclosed it was located on the east side of Hopmeadow Street, opposite the town flag. In addition to Gov. Marcus H. Holcomb, local dignitaries on hand included Henry Ellsworth (far left), Annie Schultz, Belle Rollins, Mrs. George Eno, Mrs. Jeffrey O. Phelps, Andrew Welch, and Joseph R. Ensign.

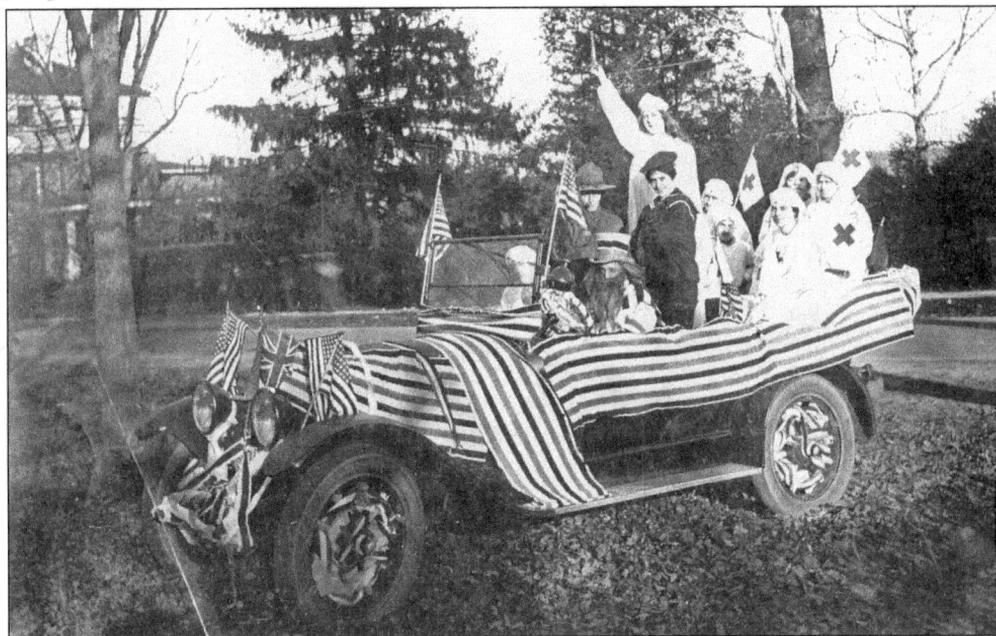

Five months later, the town celebrated the end of hostilities in Europe. Early on November 12, 1918, workers from the Ensign-Bickford Company held an impromptu march down Hopmeadow Street. Later that day, a parade wound its way through the town. The company's office staff arranged this float. Thelma Hall as "Liberty Enlightening the World" is shown being supported by the Army and Navy with Uncle Sam (Clarence Monks) at the wheel.

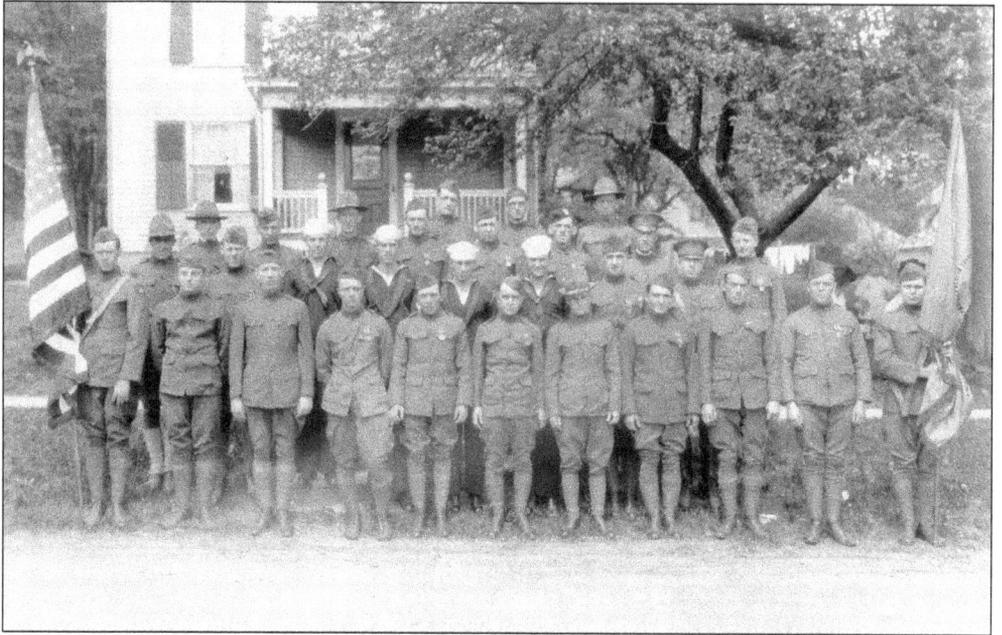

After the war, the returning veterans formed an American Legion post named for Joseph Tomalonis and George L. Hall, a Simsbury native who died on October 28, 1918, just two weeks before the war's end. George P. McLean donated land on West Street, and on May 22, 1923, the cornerstone for the legion hall was laid. Many veterans attended the ceremony in their service uniforms.

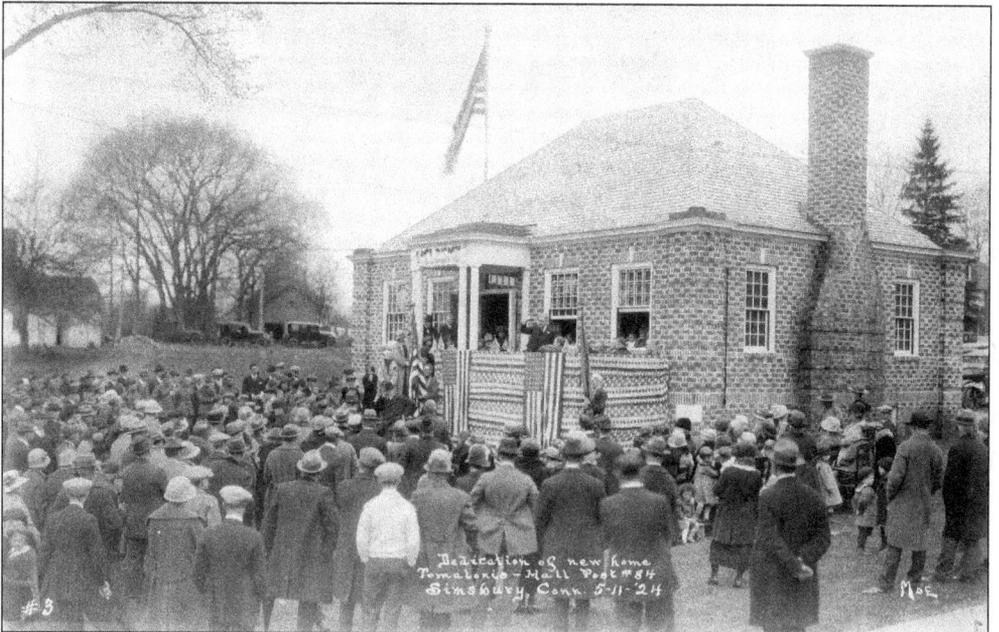

A year later, on May 11, 1924, the building was dedicated at a formal ceremony. Former congressman Augustine Lonergan addressed the crowd. Joining him on the platform were veterans from World War I, the Spanish-American War, and Civil War veteran Lucius W. Bigelow. The old legion hall stills stands on West Street and is incorporated into the facilities of the Simsbury Volunteer Ambulance Association.

Former president Calvin Coolidge and his wife, Grace (left), pose with former senator George McLean and his wife, Juliette. A legacy from Senator McLean established his 3,200-acre game preserve as today's McLean Game Refuge in Simsbury and Granby. Administered by a nonprofit foundation, which has added more than 1,000 acres, it is open to all for hiking, picnicking, and photography. (Courtesy of the George family.)

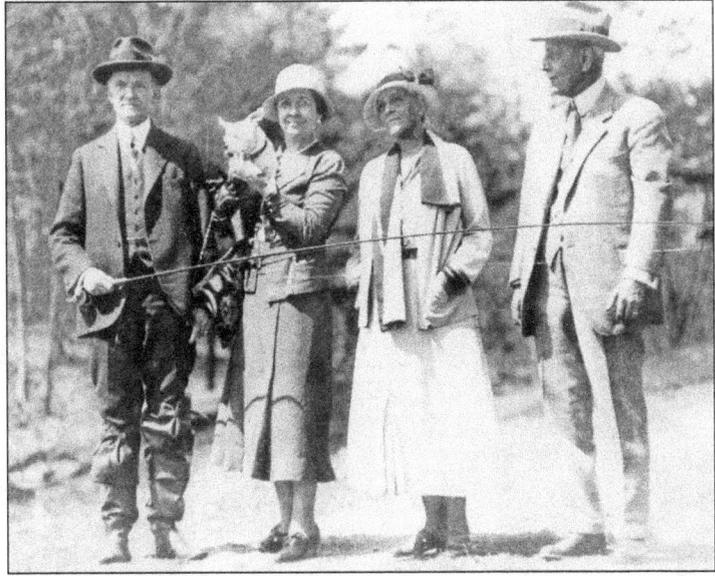

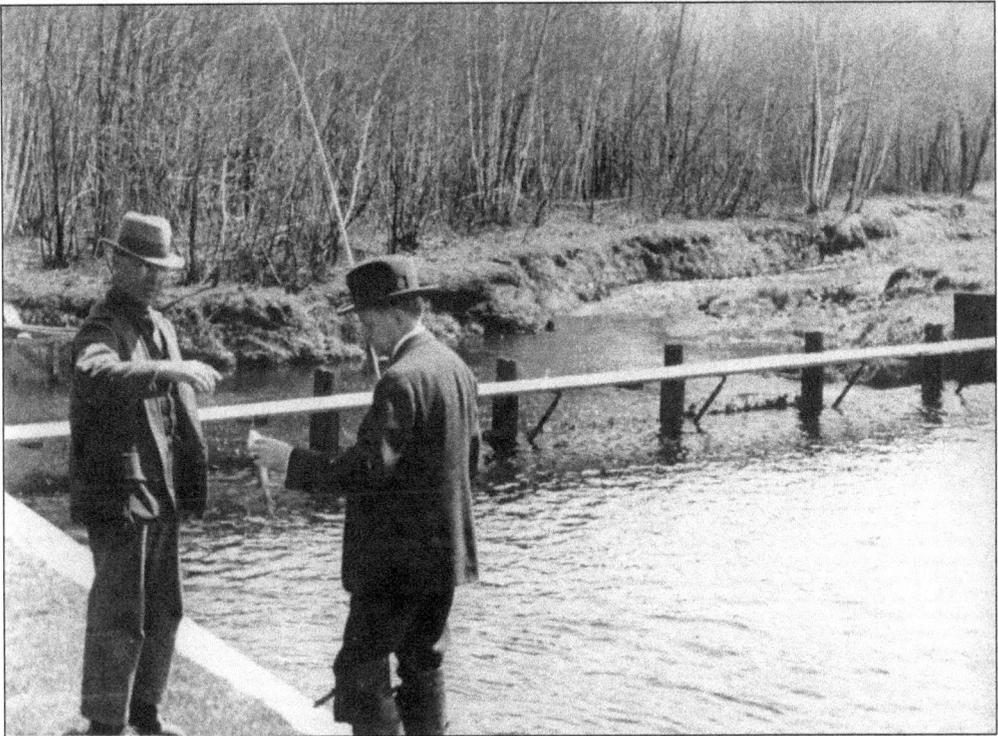

Calvin Coolidge (right) shows his catch to Amos George, a Mashantucket Pequot and caretaker of Senator McLean's private game preserve for 35 years. Coolidge visited the preserve often. Once, while fishing alone early in the morning, he was arrested by an unwary assistant caretaker. Presidents Taft and Hoover hunted and fished there, as well as US chief forester Gifford Pinchot. (Courtesy of the George family.)

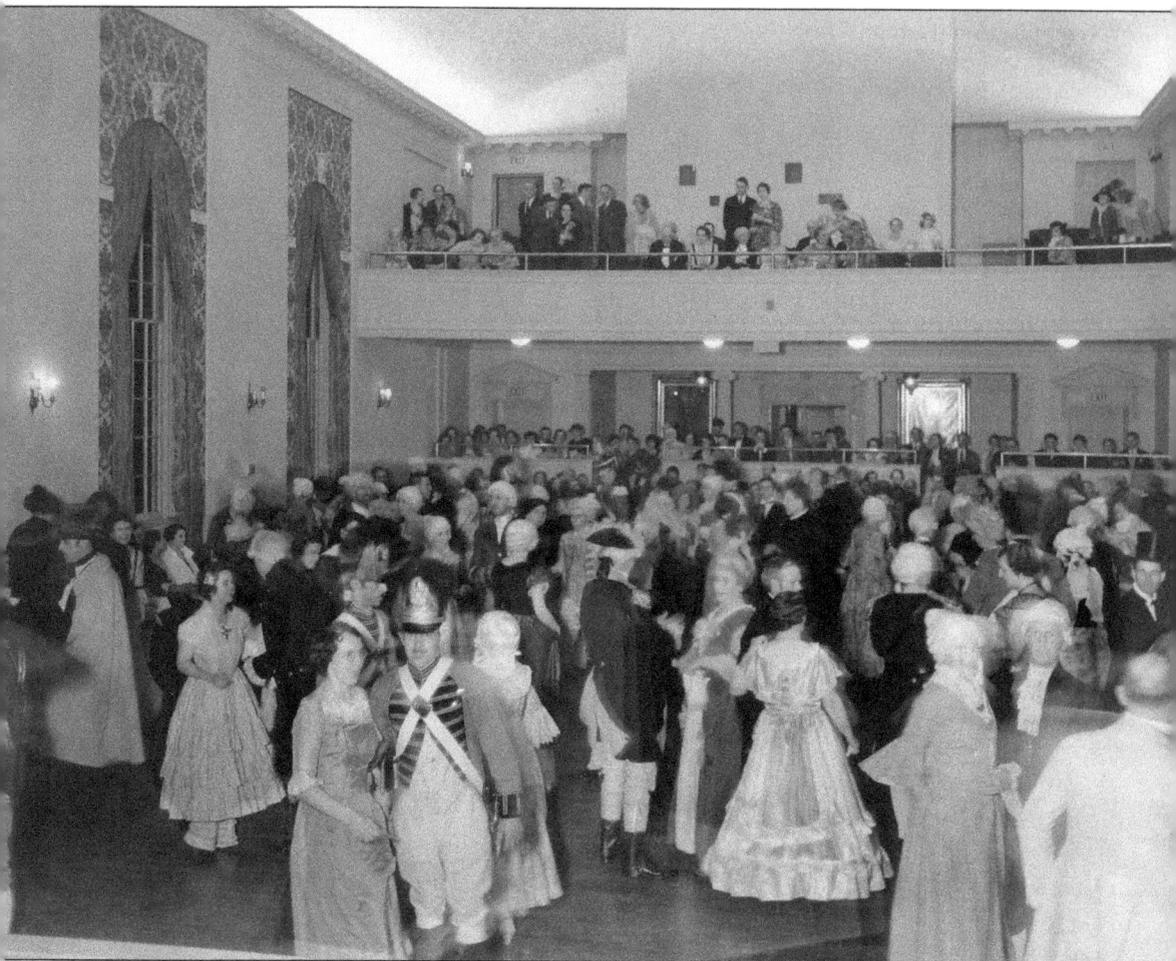

In 1935, Simsbury joined other towns in the state to observe Connecticut's tercentenary. Beginning with a costume ball and reception at Eno Memorial Hall on June 6, the town celebrated its past with historical exhibits, costume displays, school pageants, and tours of five historic houses. The festivities concluded on June 22 at a general meeting addressed by local notables as well as Simsbury native son and Pennsylvania governor Gifford Pinchot.

Six

AGRICULTURE

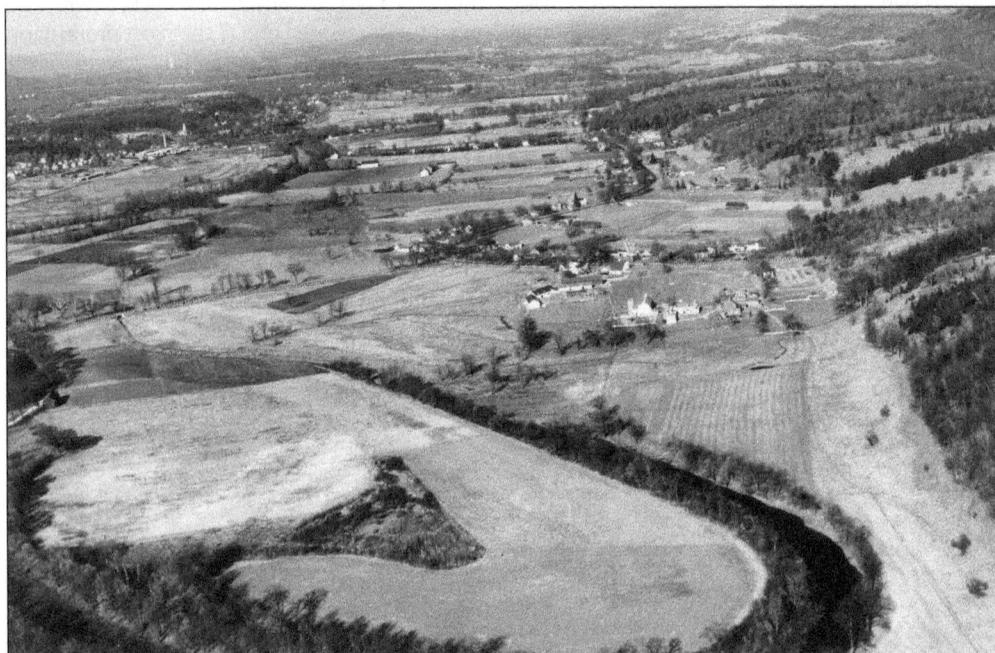

Agriculture was central to the life of Simsbury. The Farmington River deposited rich soils throughout the valley, and its meadows and grasslands were especially prized by farmers. Some of the farms of East Weatogue appear in this photograph from 1930. The line of Riverside Road runs along the top of the picture. The Congregational church's steeple and the smokestack at the Ensign-Bickford Company are visible in the distance.

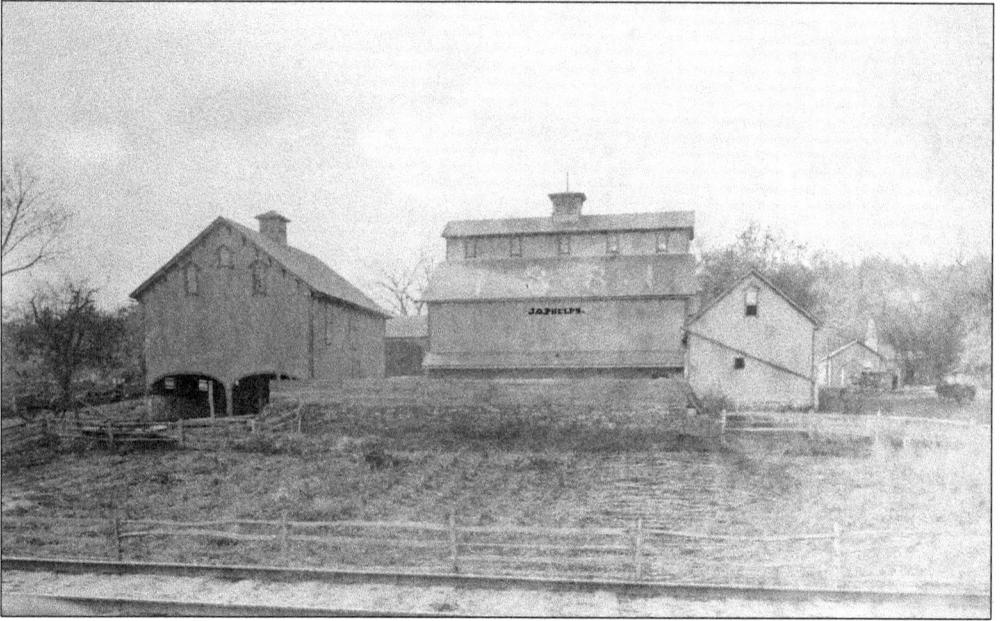

At first, nearly everyone worked a farm, even the ministers. Samuel Stebbins of the Congregational church had a reputation as an especially capable and shrewd farmer. Farms were everywhere, and in the late 19th century, Judge Jeffrey O. Phelps Jr. owned and operated one of the most prominent. It was located on Hopmeadow Street in Simsbury Center. The barns and outbuildings were visible both from the street and from the railroad line just to the east. The judge's fields extended even beyond that, all the way to the river. Yoked oxen and carts were familiar sights in town.

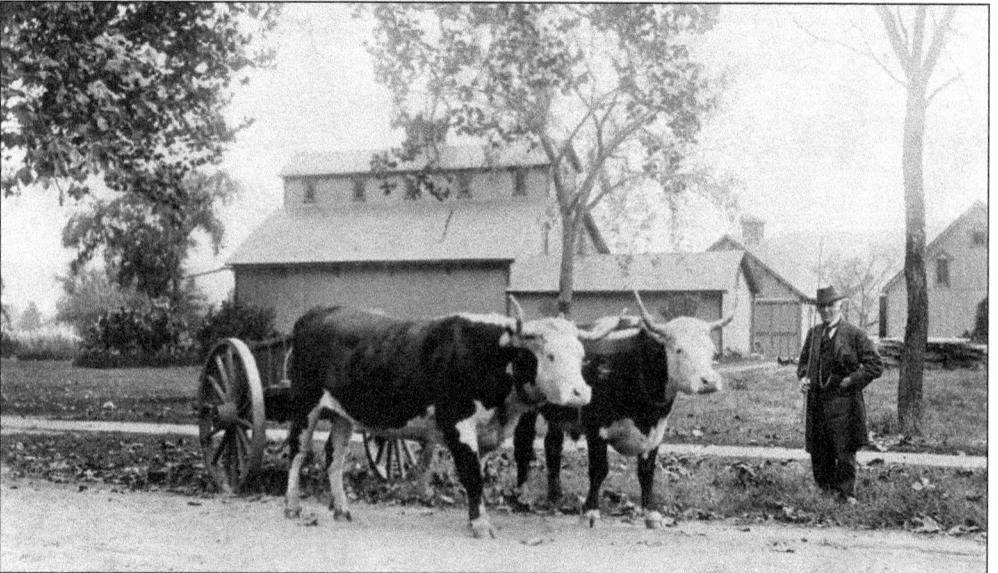

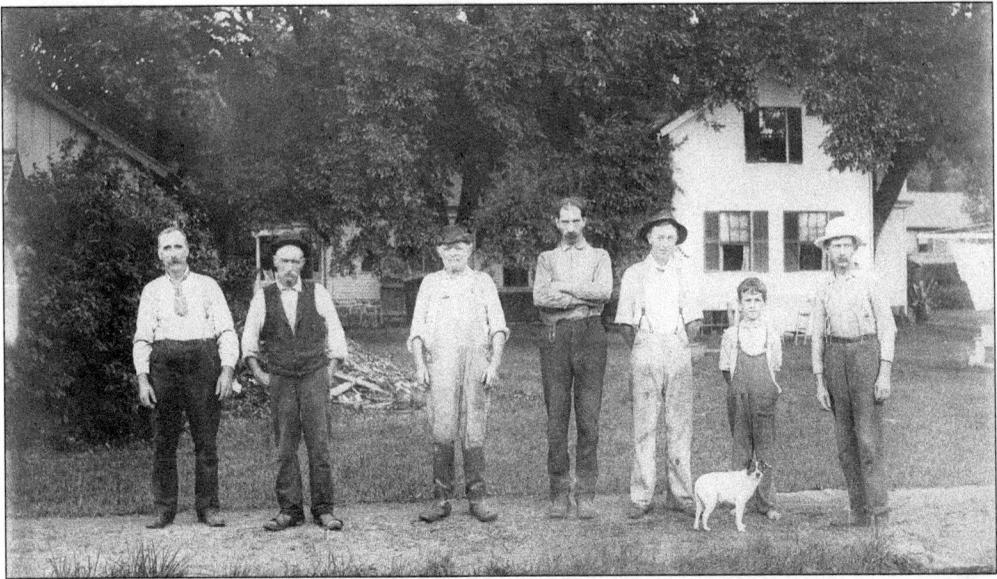

Agriculture is labor intensive, and running a farm required many workers. Some of the hired hands from the Phelps farm on Hopmeadow Street posed for this picture around 1900. A young Bill Neville stands behind a dog named Luna. Immediately to Bill's right are Bob Phelps and Tom Murphy. Jim Malloy stands at the far right.

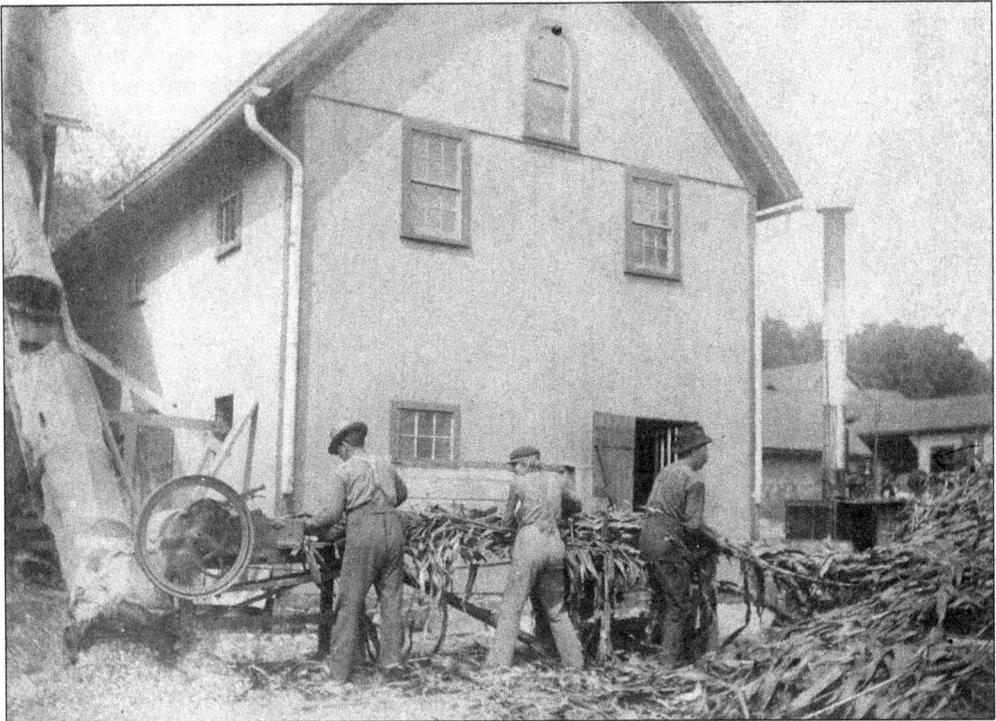

Progressive farmers also invested in new technology to help with the work. Both the silo at the Phelps farm and the chopping machine used to fill the silo (pictured) were innovations from the late 19th century. Shown here at work, from left to right, are Conn O'Mara, Horace Humphrey, and Tom Gilligan.

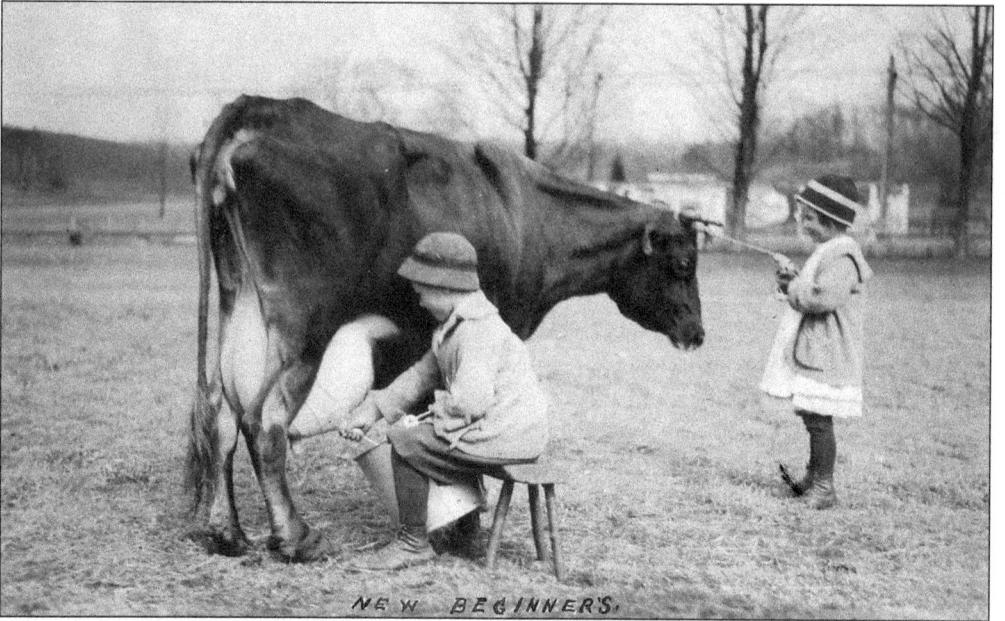

NEW BEGINNERS.

Farm life spanned generations. Some young children learned to do chores and work with animals at an early age, like the Latimer children, who are shown milking a cow in the above image. In the photograph below, Charles P. Case is seated on a mowing machine. His granddaughters, sisters Sarah Eno Bidwell (left) and Charlotte Phelps Bidwell, sit astride the horse. The times were changing, though, and agriculture was gradually becoming less traditional and more scientific. By 1915, the high school had introduced courses in agriculture to encourage interest in farming and to teach modern methods. (Below, courtesy of Charlotte Bidwell Bacon.)

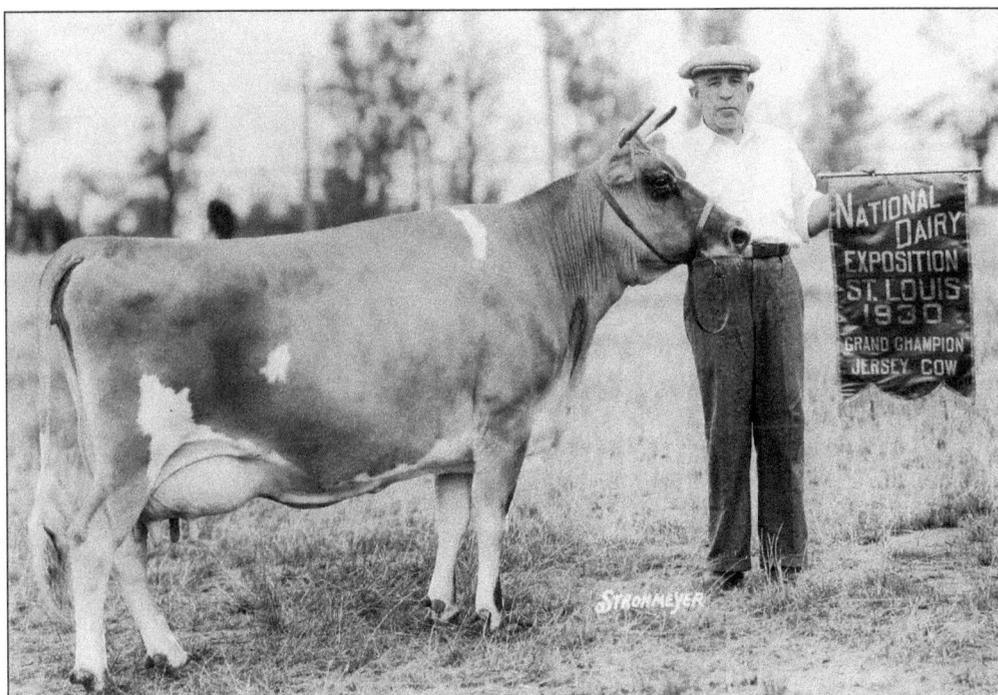

Some local farmers elevated the raising of prize dairy cows to competitive levels. John S. Ellsworth of Folly Farm in East Weatogue was well known as a breeder of prize cattle. Herdsman John Sloane stands next to one of Ellsworth's award-winning cows, the grand champion Jersey cow at the National Dairy Exposition in St. Louis in 1930.

Local farmers also raised poultry. J.C. Eddy, the owner of Hop Brook Farm, raised 200 to 300 hens. Robert Darling ran one of the largest poultry operations in the county with up to 3,000 hens. In 1934, Edward A. Oelkcut started the Lone Oak Poultry Farm. He developed a unique breed called "the Rokisland Fowl" at his operation, seen in this aerial view, on Great Pond Road.

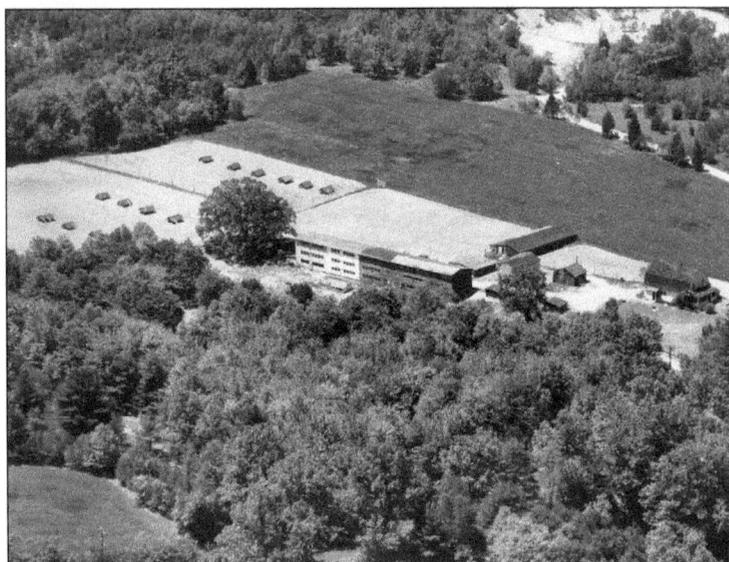

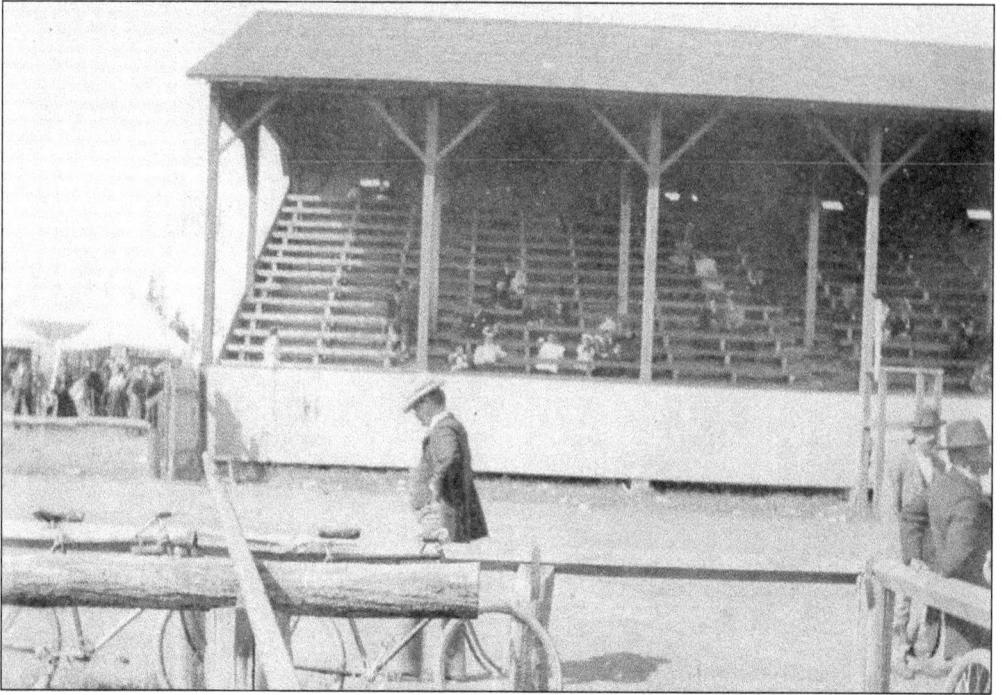

Throughout Connecticut, communities often held agricultural fairs each fall. The Simsbury Agricultural Society began hosting fairs in 1878, probably at the Union Fairground, the triangular section bordered by Firetown, Holcomb, and Barndoor Hills Roads. In 1886, Judge Jeffrey O. Phelps Jr. donated land for a new site for the fairs farther south on Firetown Road. The fairs were popular, often drawing several thousand people to the two-day events. Sightseers from Hartford rode the train to the Simsbury station, where buses waited to take them up the hill. When they arrived, they could take in the country air and view exhibits of prize-winning produce and farm stock. The fairgrounds included a grandstand and racetrack. Sulky races were a big attraction. Bicycle races and trick-riding demonstrations were also popular in the 1890s. (Below, courtesy of Richard E. Curtiss.)

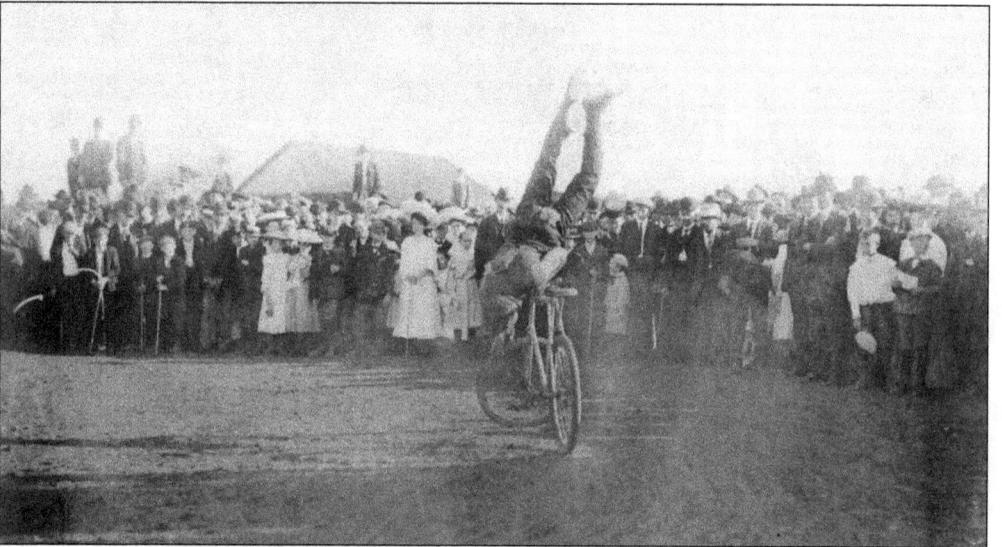

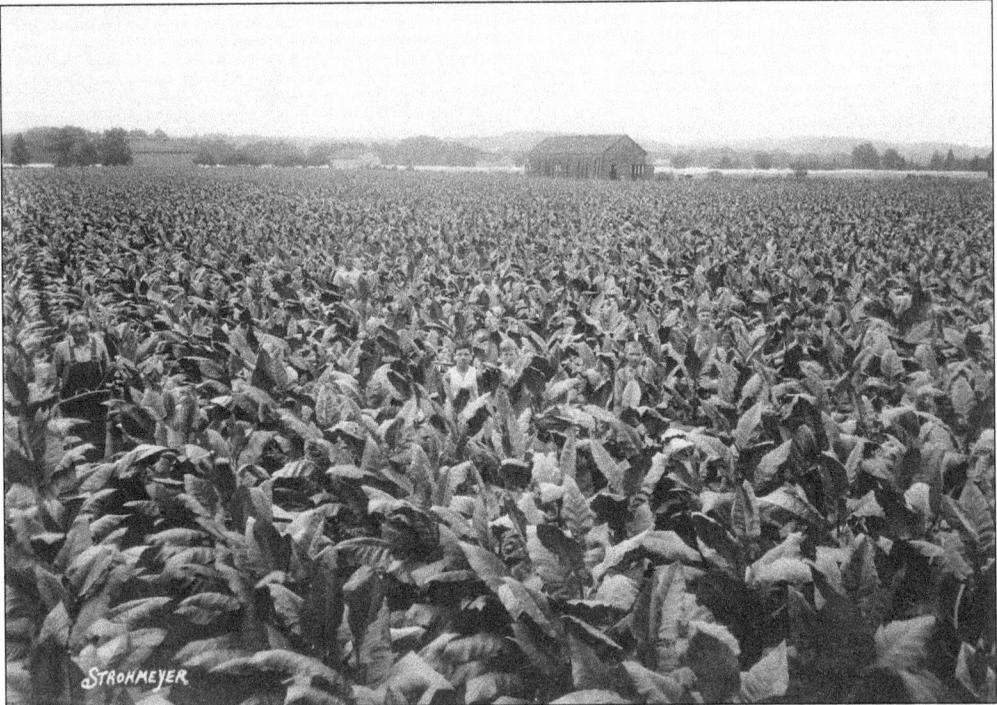

Tobacco became an important cash crop throughout much of the Connecticut River Valley, including Simsbury, by 1825. The area specialized in growing the leaf used as the wrapper, or outer layer, of the cigar. An early variety was Connecticut Valley broadleaf; later, Havana Seed broadleaf became popular. Large and small farms grew tobacco. At harvest time, all hands, young and old, were required to get in the crop. Look closely to see the workers in the field.

The workers are easier to spot in this photograph taken at Samuel T. Welden's farm. Welden stands on the far right. To his right is Charles H. Vining, grandfather to the Messenger children in the foreground. The man farthest in the background may have been the buyer. Simsbury High School now stands where the tobacco stalks once grew.

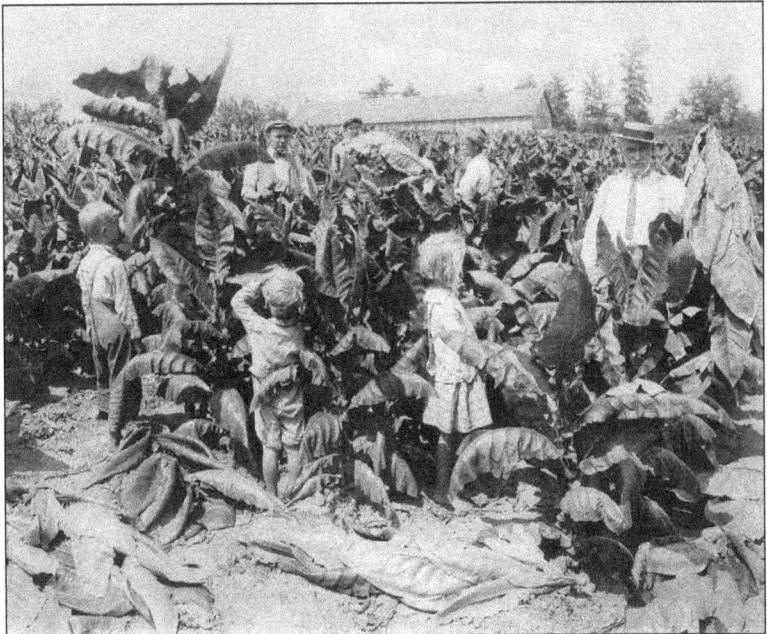

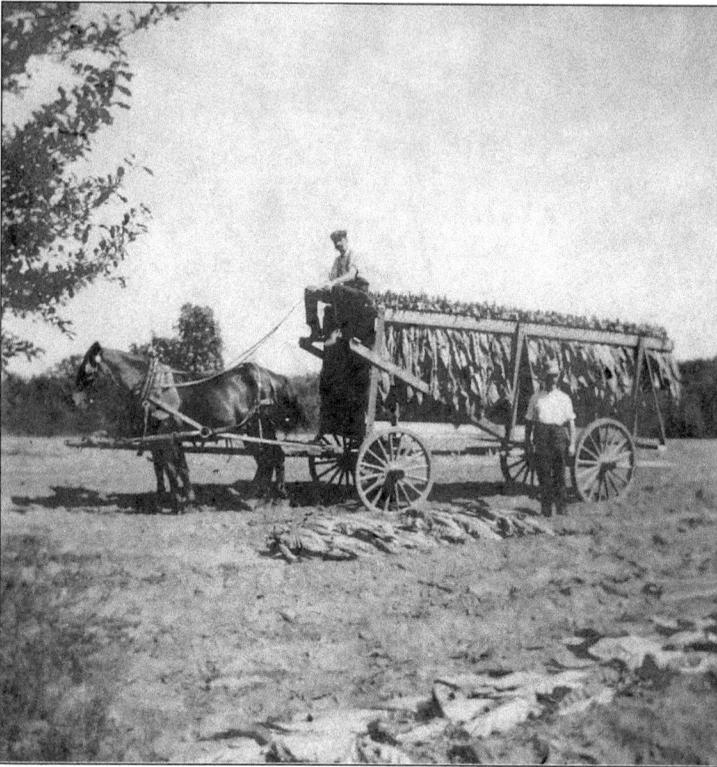

The fall harvest was a critical event. One Simsbury resident later recalled the process to gather broadleaf. After the tall plants were cut down with a small ax, children would pick them up and give them to an older worker who speared them onto a lath. Bigger boys carried the laths to wagons to be loaded onto racks like those seen here at the Robert Kerr farm on Firetown Road.

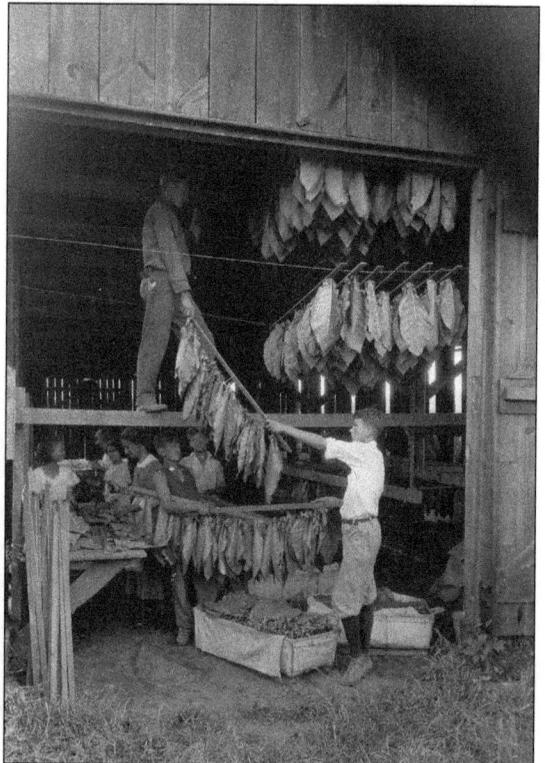

Both broadleaf and shade tobacco cured in tobacco barns. There, the laths and leaves were handed to workers inside. The barns had several levels of beams. Men handed the leaves to other workers standing above, who placed the laths horizontally across the beams. After the leaves had properly cured, they were packed into cases and shipped to buyers. This image was taken at Folly Farm in the early 1920s.

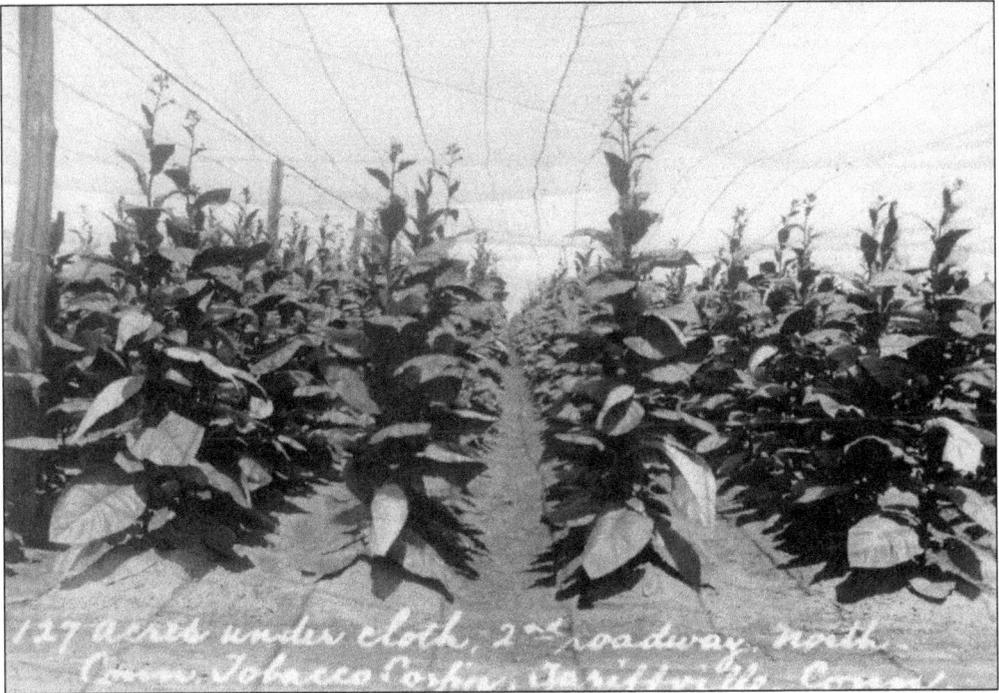

127 acres under cloth, 2nd Broadway north. Conn. Tobacco Corp'n, Tariffville Conn.

Late in the 1800s, a new type of wrapper leaf from Sumatra entered the world tobacco markets and threatened to displace the Connecticut product. In response, local farmers learned how to grow a high-quality leaf locally by shading the tobacco fields with cotton cloth. Ariel Mitchelson of Tariffville was one of the first to do so. The new method proved to be very successful, and within a few years, white tents covered hundreds of acres of farmland throughout the town. The large shade tobacco plantations, as they were called, were usually not owned by families but by corporations, like the Connecticut Tobacco Corporation at Floydville, East Granby, and the American Sumatra Tobacco Company at Meadow Plain. Cullman Brothers started at Terry's Plain and later moved to Firetown. (Above, courtesy of Richard E. Curtiss.)

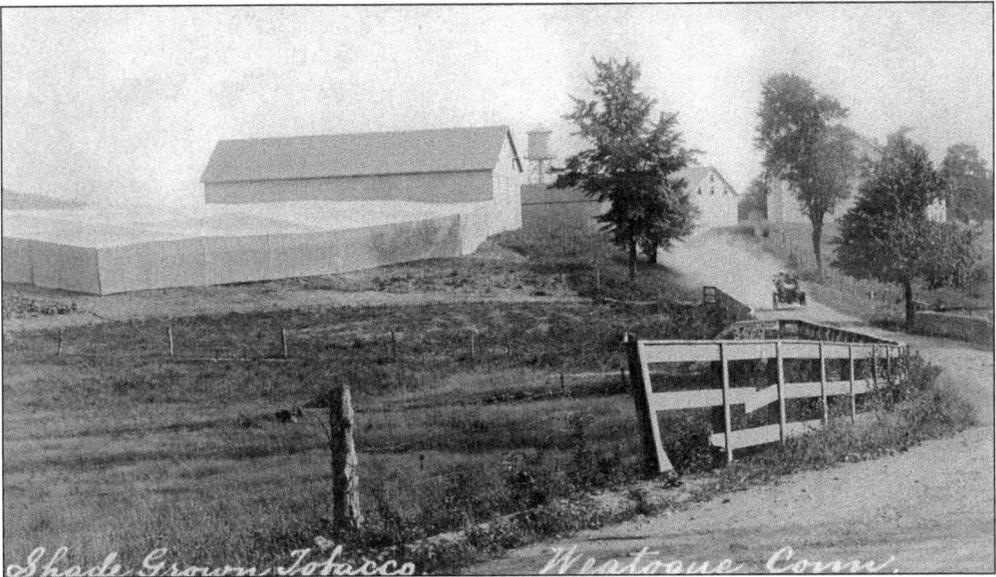

Shade Grown Tobacco. Weatogue Conn.

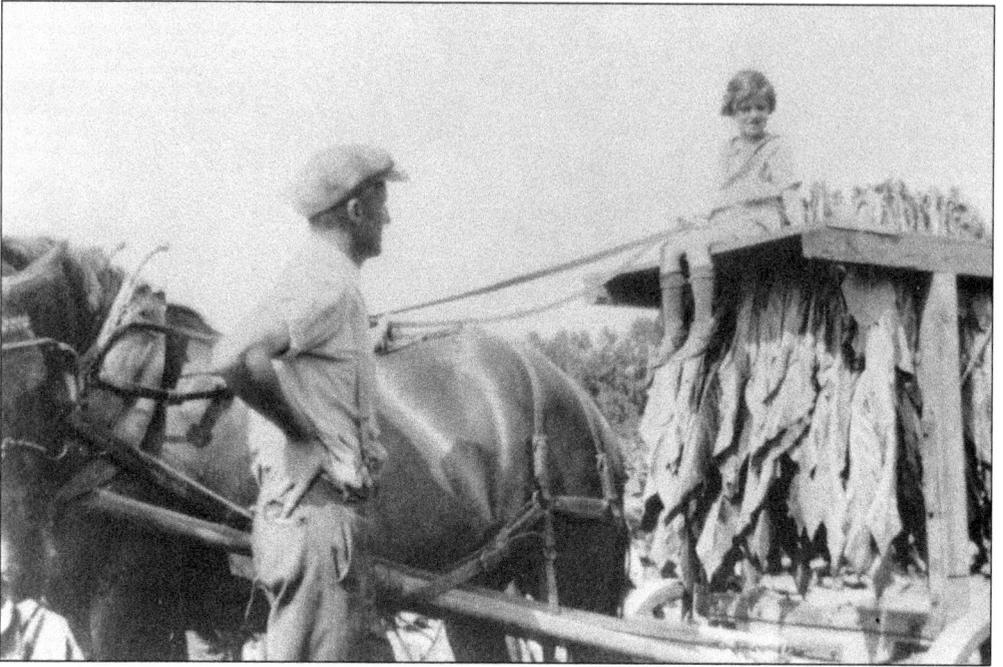

The success of shade-grown leaf brought with it a change in the local agricultural community. Few families had the resources to cover their fields with cotton tents. Arthur J. Hayes of Tariffville, shown with his daughter, ran a dairy farm and leased his tobacco fields. Others also rented or sold their land to the tobacco plantations whose owners often hired migrant laborers to bring in the harvest. Some of the earliest laborers were immigrants from Poland and Lithuania. They stayed at boardinghouses, like the Cullman Brothers camp in Tariffville. Later, workers were brought here from the South—Martin Luther King Jr. worked in the fields in 1944 and 1947—and from the Caribbean islands.

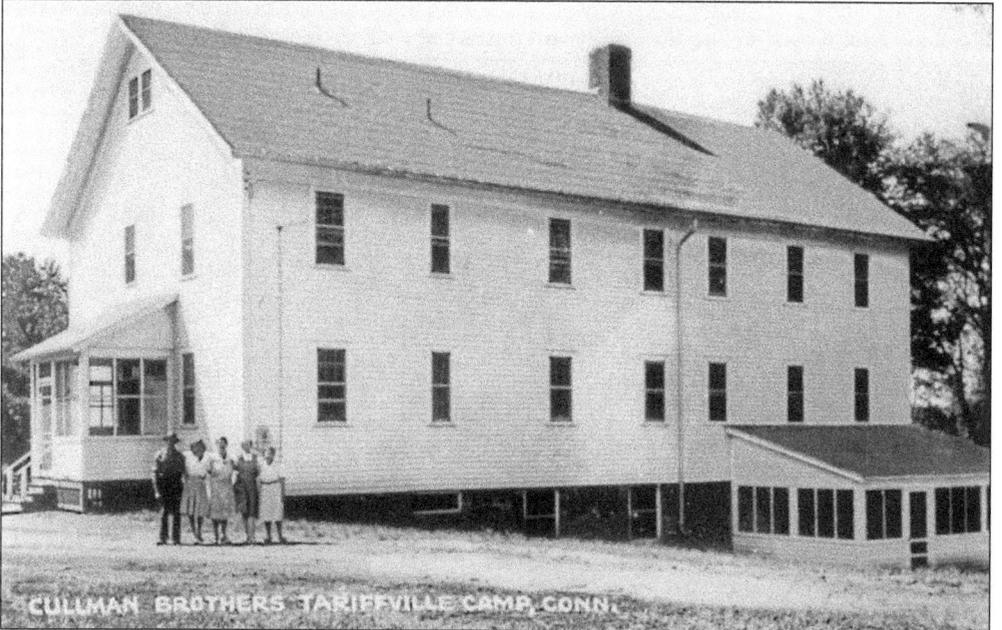

Seven

COMMERCE AND INDUSTRY

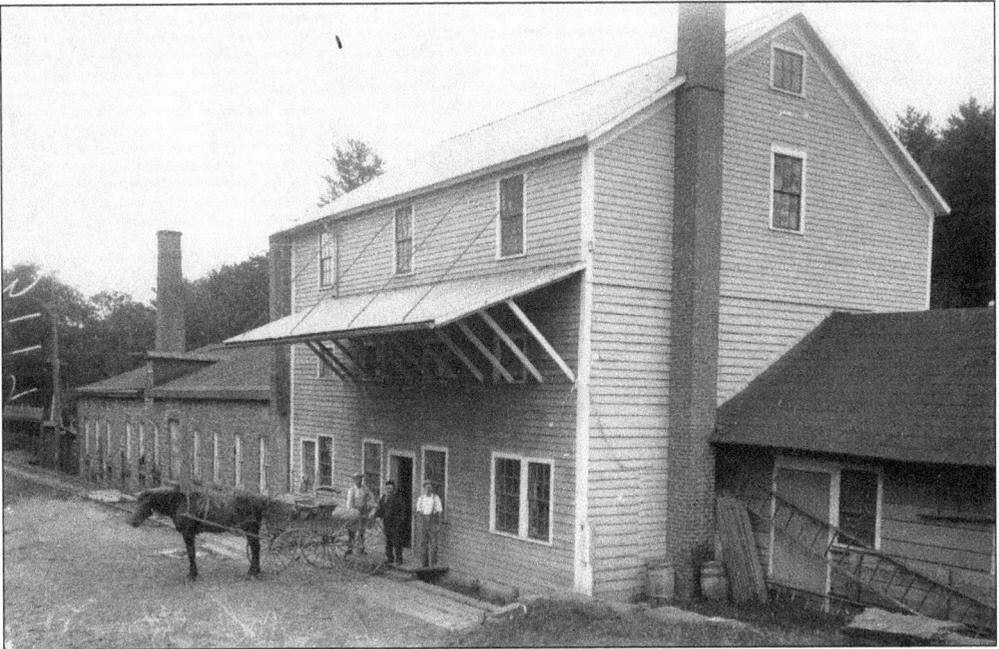

In 1678, Thomas Barber and three others agreed with the town to build a sawmill and gristmill on Hop Brook, along what is now West Street. Later, the mills were known as Tuller's Mills. Ralph Ensign owned and operated the gristmill shown in this image. The site also processed jute fiber to sell to the Ensign-Bickford Company as well as others. (Courtesy of Ashfield Historical Society.)

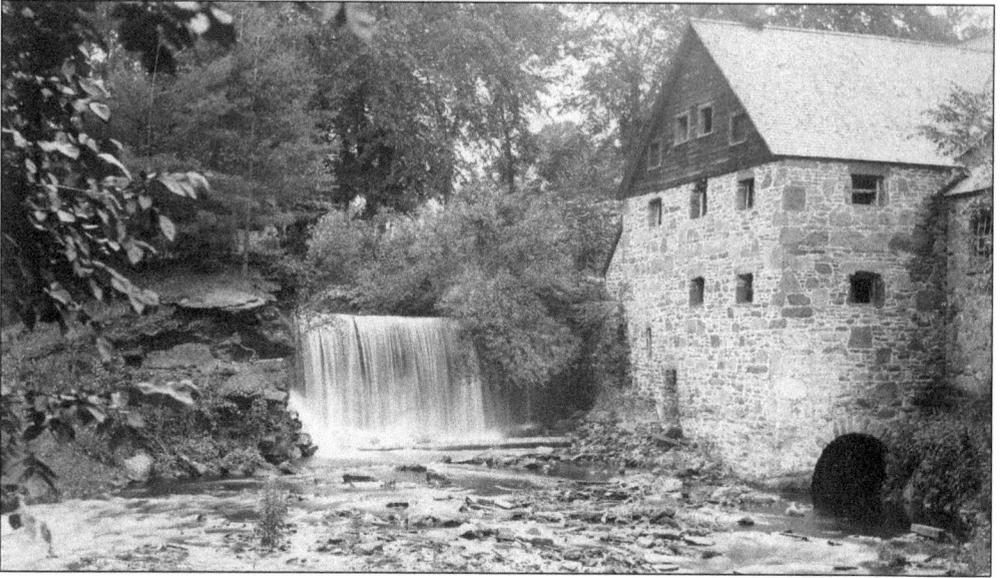

In 1803, a different gristmill on Hop Brook was converted to a distillery. Thomas Belden, a Hartford merchant, acquired it. With Belden's son Horace in charge, the mill gained a reputation for producing excellent gin. Horace passed the profitable business on to his son, also named Horace. The younger Belden, owing to "scruples of conscience," eventually closed the gin works. The mill was destroyed in the flood of 1955.

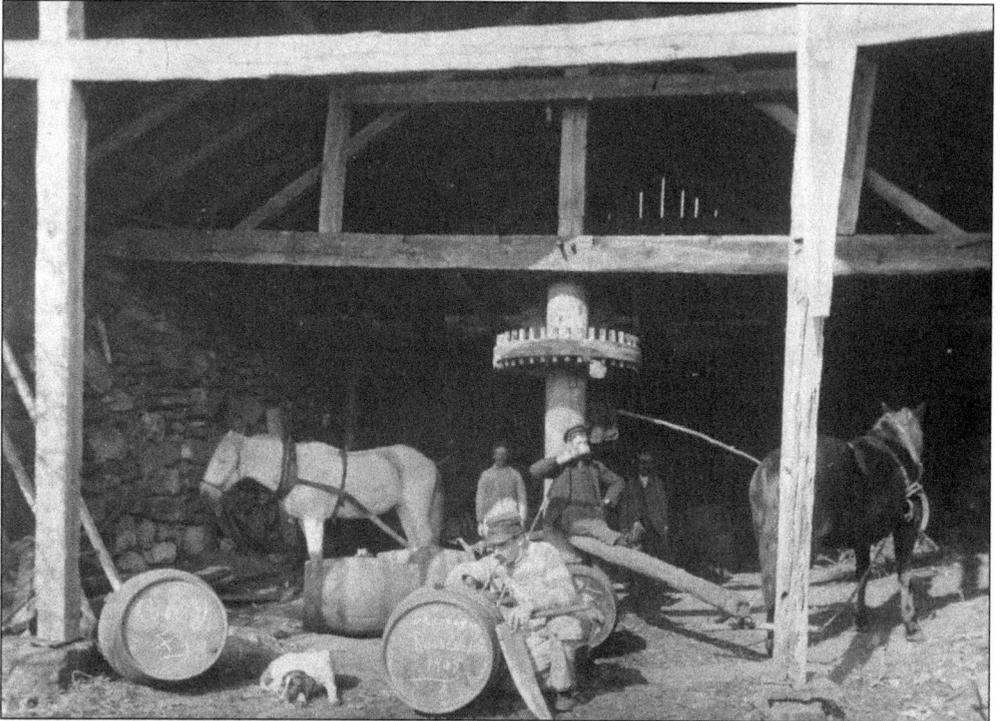

Cider presses were also common. For many years, cider was considered a healthier drink than water, and presses continued in operation into the early 1900s. The image here was taken at the Harry Walker cider mill on Woodchuck Hill Road around 1905.

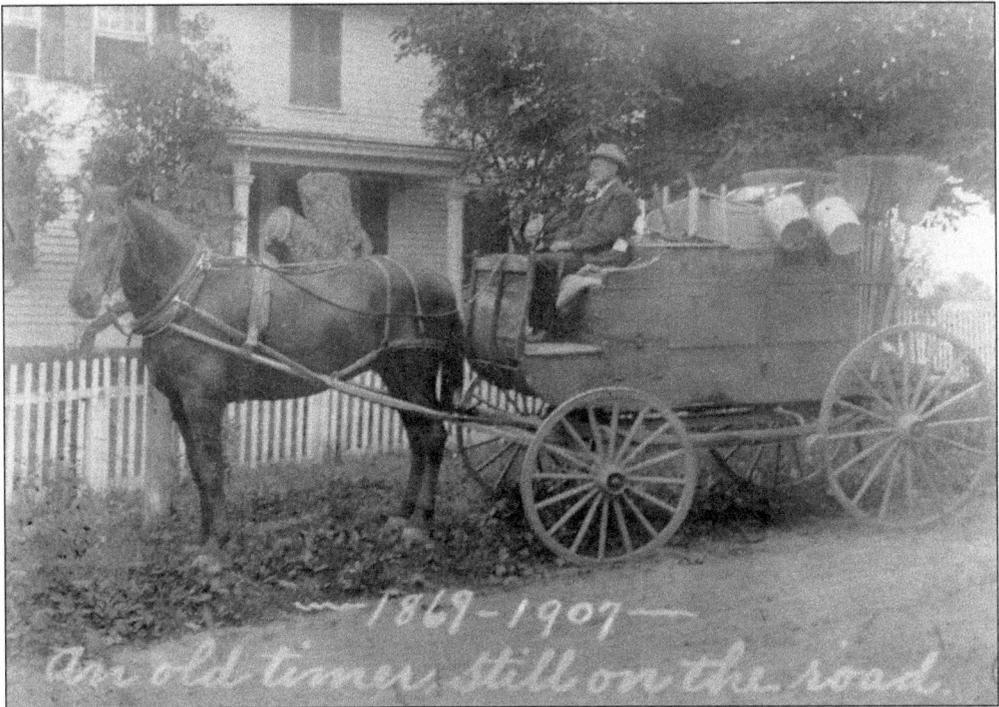

1869–1907
An old timer still on the road.

By the mid-1800s, people often shopped at the general stores in the villages, but there was still a need in outlying areas for the peddler's cart. Lucius Bigelow began operating one in 1869. His route ran from Winsted through Collinsville, Canton, Avon, Granby, and Simsbury. He finally closed his business in 1925. Today, his cart can be seen at the Simsbury Historical Society.

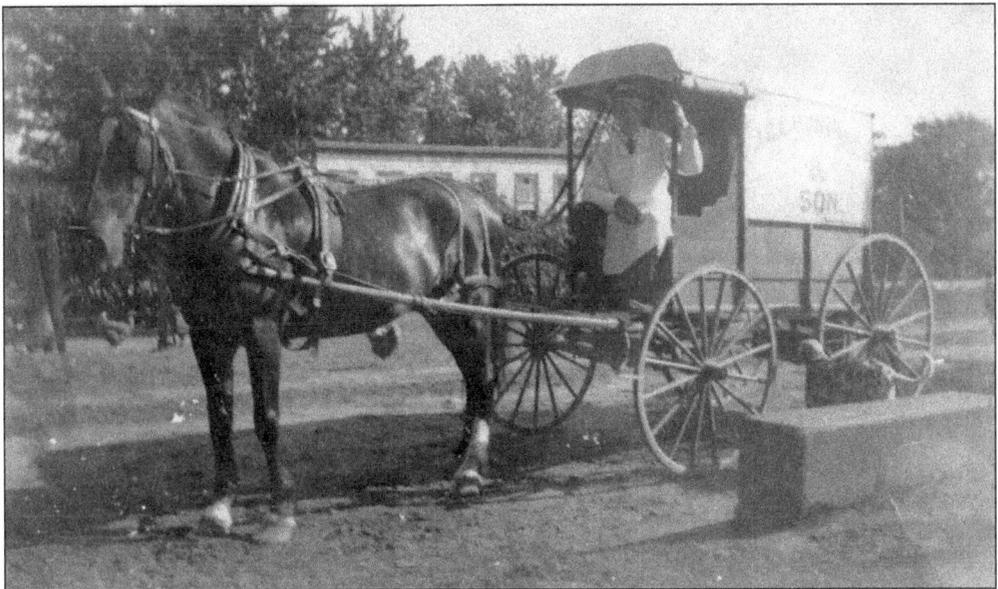

The three meat carts owned by J.C.E. Humphrey of East Weatogue were another familiar sight on Simsbury's roads during the late 1800s. The carts followed regular routes throughout Simsbury and West Avon. They delivered their loads of poultry, beef, pork, and lamb twice a week in their unrefrigerated wagons. Humphrey is seated on the wagon in this image.

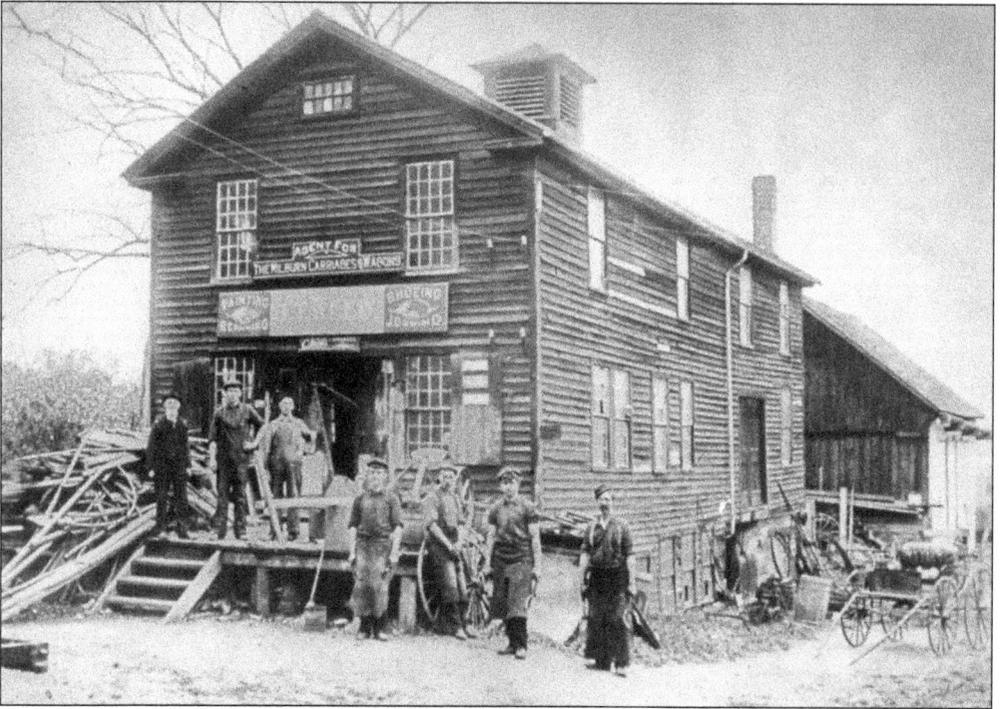

The Weed family's blacksmith shop was a fixture in Simsbury Center for nearly a century. It sold and repaired farm machinery and shod horses and oxen. Julius Weed started it about 1848. Later, his son John Thomas, the white-bearded gentleman at the far left, operated the shop. When John passed away in 1920, his son William Thomas ran it until his death in 1940.

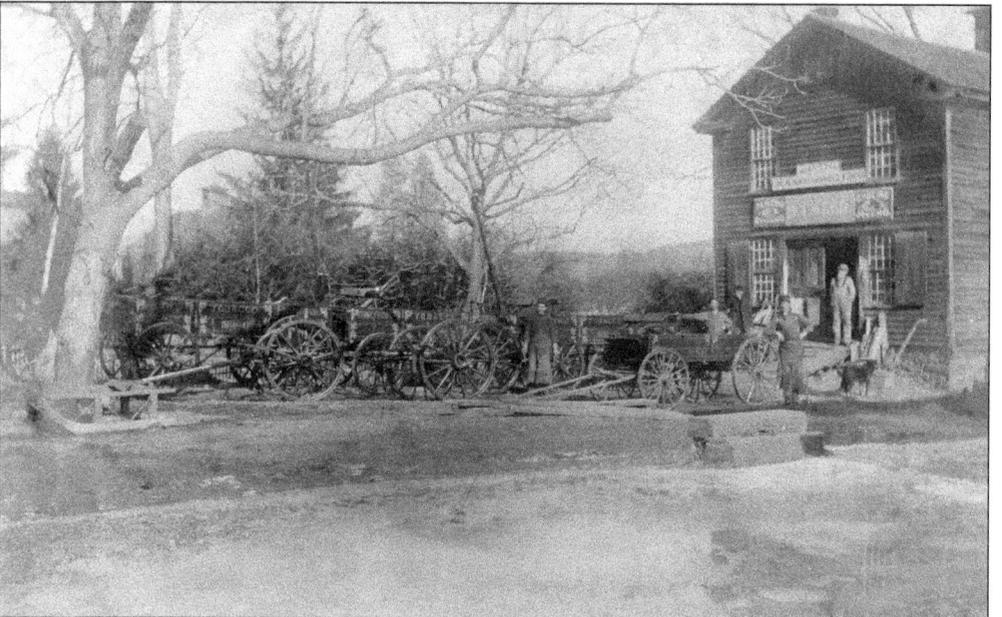

J.T. Weed also sold and repaired wagons. In this picture, taken sometime after 1901, the Milburn wagons display the label "Connecticut Tobacco Corporation" on their sides. The Connecticut Tobacco Corporation was located at Floydville plantation in East Granby.

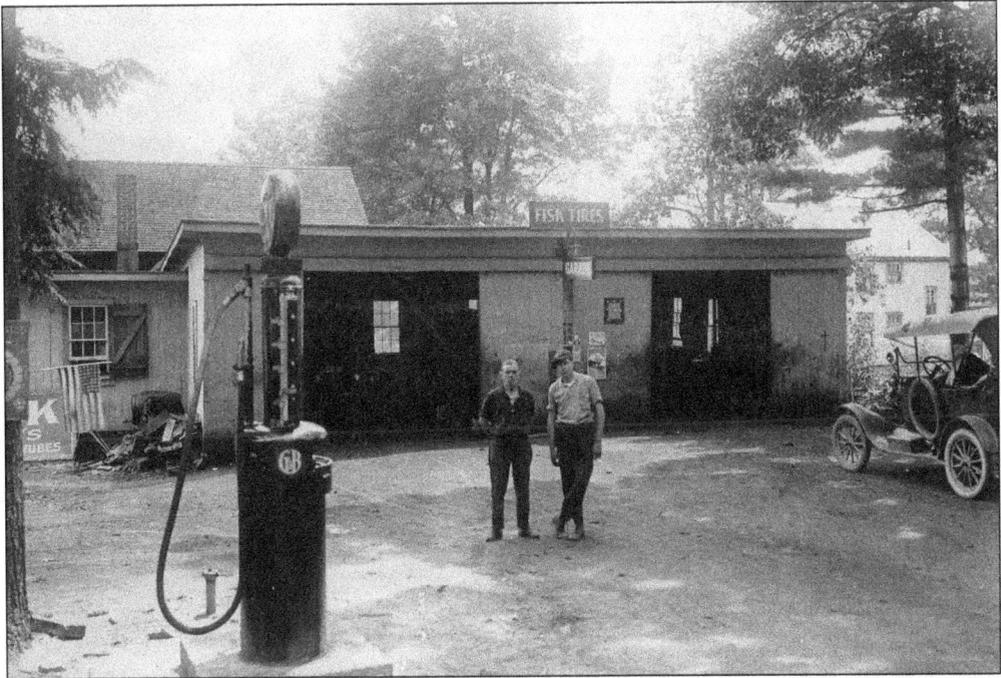

As cars and trucks replaced wagons and buggies on Simsbury's streets, service stations and garages appeared to sell them fuel, fix their tires, and service their engines. J. Joseph Kane (left) opened his garage in 1915 and retired 50 years later. Robert Pringle ran it during the time Joe Kane served in World War I. The shop was at 518 Hopmeadow Street, then called South Main Street.

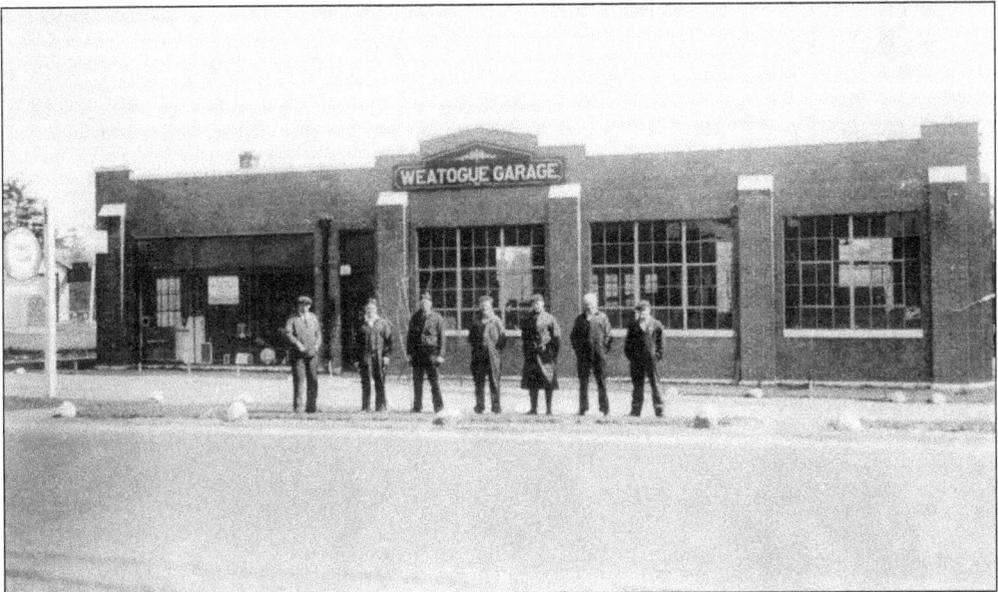

Robert Pringle (left) was born in Edinburgh, Scotland, in 1890. He began Pringle's Garage in 1922 in a rented cow barn on Canal Street. Moving to Hopmeadow Street, he renamed it the Weatogue Garage. The signs in the photograph show it was an authorized Buick and Pontiac service facility. Under his daughter and her husband, Mary and Walter Mitchell, and their sons, the garage has become the Mitchell Auto Group.

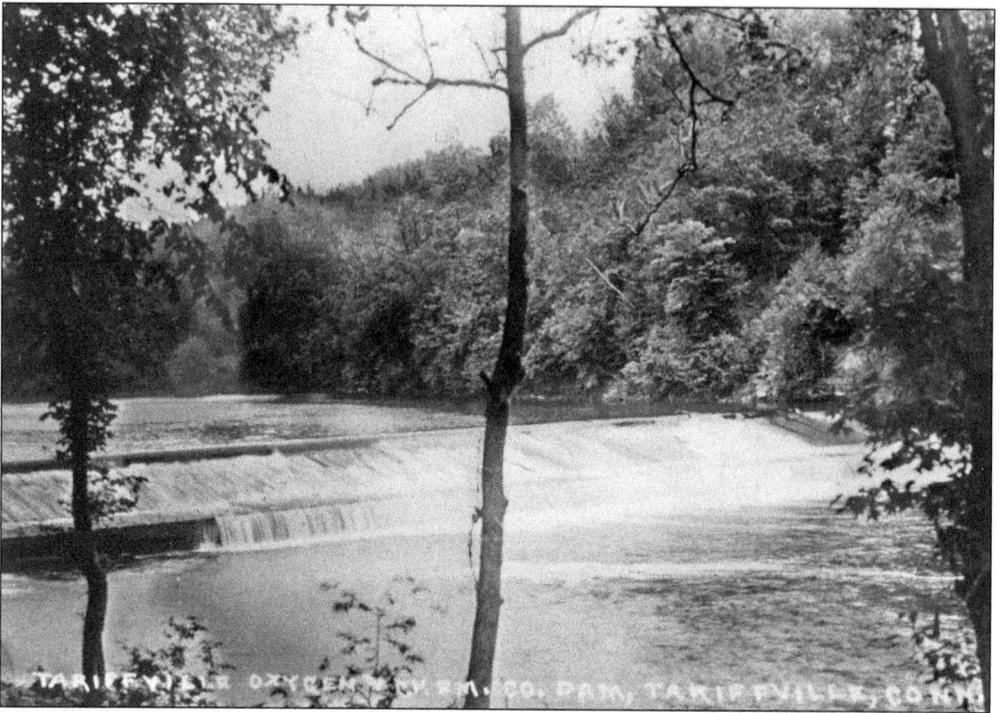

The flow of the Farmington River is especially strong at the village called the Falls, then Griswold's Village, before it became Tariffville. A series of companies harnessed the river's power to drive machinery in their factories. This photograph was taken when the Tariffville Lace Company occupied a mill on the river and trains ran over the trestle shown below. Manufacturing started here well before the advent of photography, though. It began to flourish in the early 1800s when Allyn and Phelps built a factory to draw wire for hand cards that were used to prepare fleece and fibers for spinning. In 1825, the Tariff Manufacturing Company built a bigger mill and began to produce carpets. By 1859, the Hartford Carpet Company had acquired the mills, and within a few years, its factories were in full operation, employing more than 600 people.

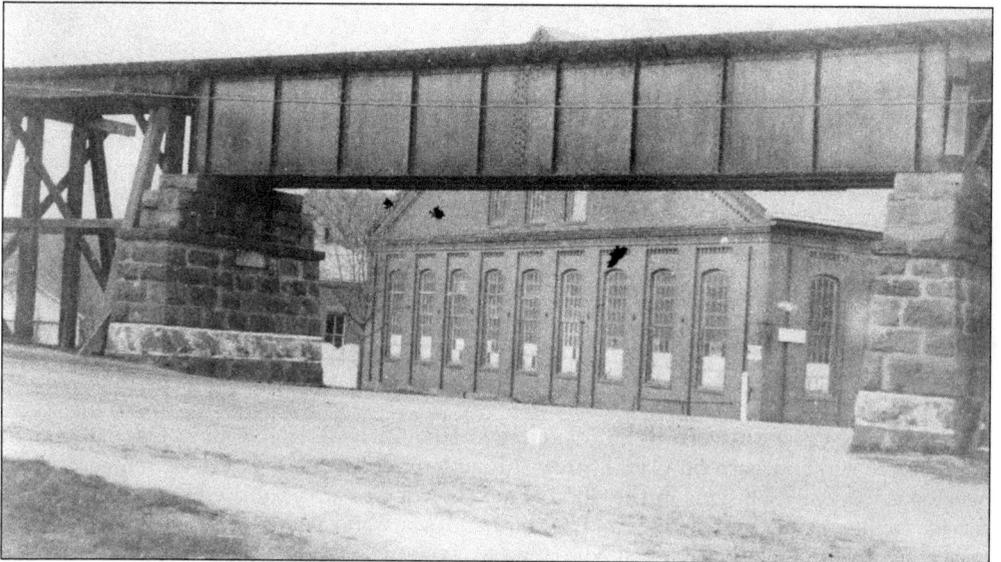

On the morning of June 10, 1867, fire broke out at the carpet works. It quickly spread through the mill. The village had no fire engine or telegraph office. By the time help finally arrived from Hartford, much of Tariffville was in flames. The carpet works and many homes were destroyed. The company chose not to rebuild in town and moved its operations to Thompsonville.

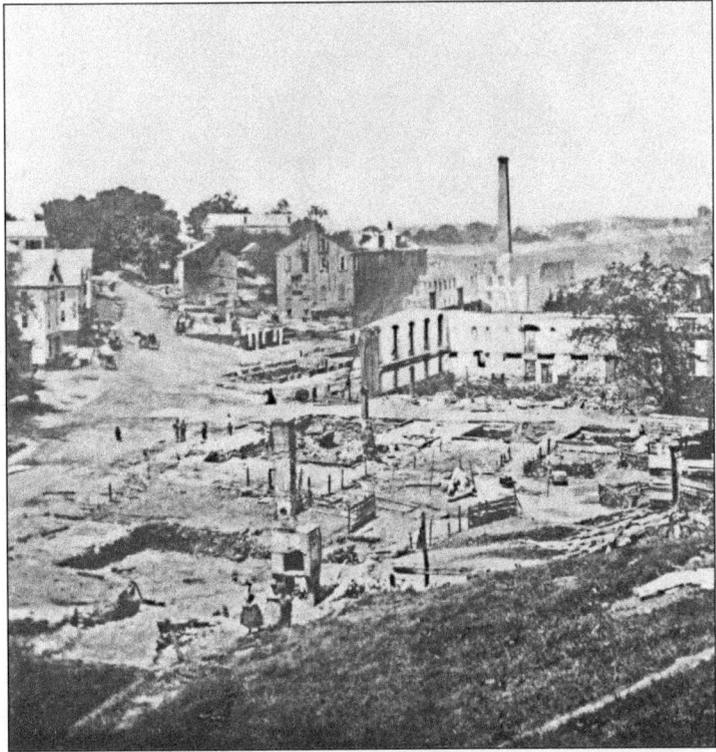

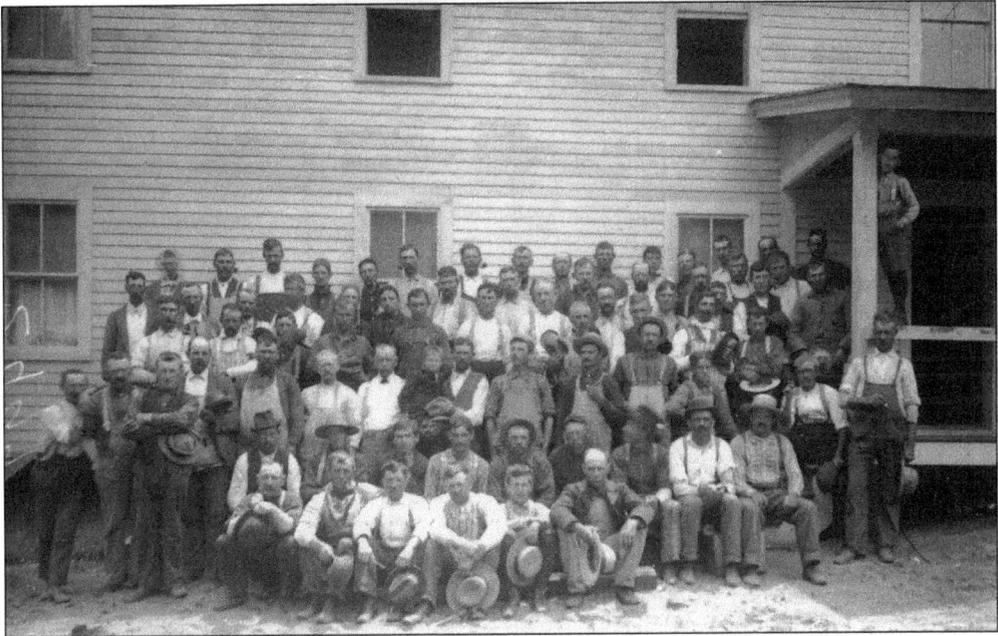

A series of smaller manufacturers followed the carpet works, including the Connecticut Screw Company, the Hartford Cutlery Company, and the Hartford Silk Company. The village's population rose and fell with the companies' fortunes. Many factory workers, as well as laborers hired by the tobacco producers, roomed in boardinghouses like the one shown in this photograph from about 1903. (Courtesy of Ashfield Historical Society.)

In 1831, an Englishman named William Bickford (pictured) invented safety fuse, a cord that allowed the black powder used in mining to be detonated safely. Richard Bacon, superintendent of the Phoenix Mining Company and Simsbury resident, heard of the new product and, in 1836, agreed with the English firm to form a new partnership, called Bacon, Bickford, Eales & Company, to manufacture the safety fuse in East Weatogue.

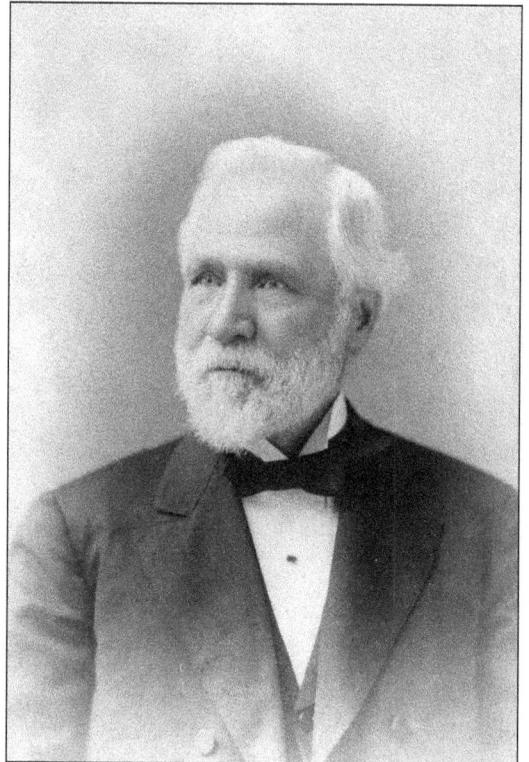

In 1839, the English firm sent an employee named Joseph Toy to Simsbury to manage its interests. The company grew steadily until a fire destroyed the East Weatogue factory in March 1851. At this time, Richard Bacon decided to retire from the business. Toy gained a controlling interest and moved the factory to Hop Brook in Simsbury Center. He renamed the firm Toy, Bickford & Company.

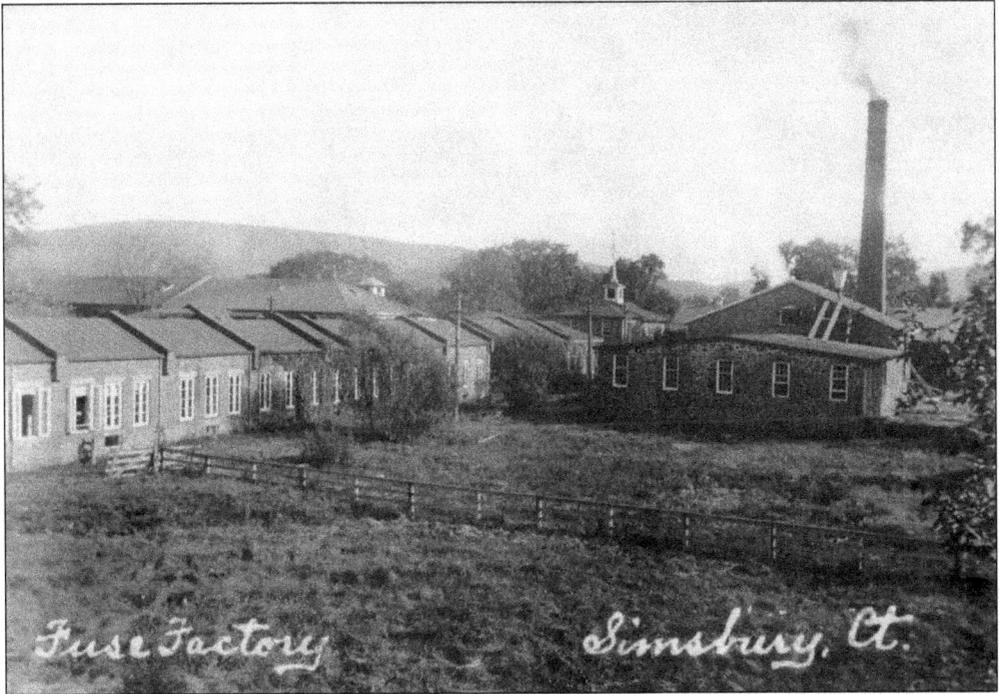

Fuse Factory *Simsbury, Ct.*

Under Toy's leadership, the company grew and prospered, selling millions of feet of safety fuse each year. The factory campus expanded to meet the demand for the product and took on its distinctive look. Many of the buildings in this image were constructed of brownstone from the quarry of A.J. Ketchin & Son in Tariffville.

When Joseph Toy died in 1887, ownership of the firm passed to his sons-in-law, led by Ralph Hart Ensign. The name was changed to Ensign, Bickford & Company. In 1907, it acquired the Climax Fuse Manufacturing Company of Avon and incorporated as the Ensign-Bickford Company (E-B for short). The company continued to grow and, by the 1920s, employed more than 600 workers at the Simsbury and Avon plants.

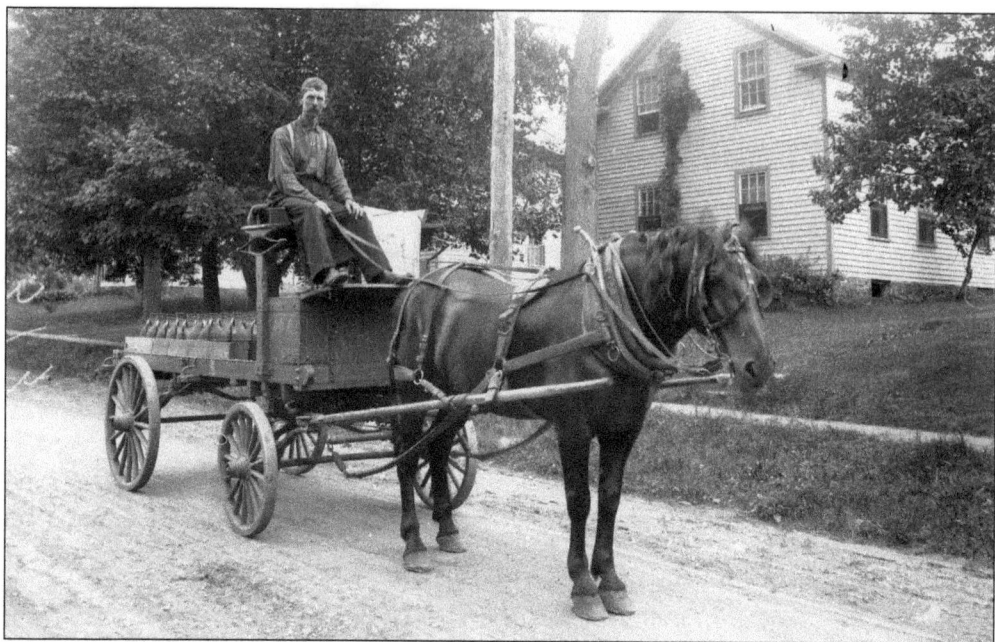

Work at the factory was hazardous because of the explosives and flammable materials used. Black powder was a crucial ingredient. It was stored in magazines that were located away from the factory buildings in "powder woods." Each day, a worker brought powder from the magazines to the factory, where it was mixed for the day's production. Charlie Graves poses with his wagon on Hopmeadow Street, with cans of powder packed neatly behind him. (Courtesy of Ashfield Historical Society.)

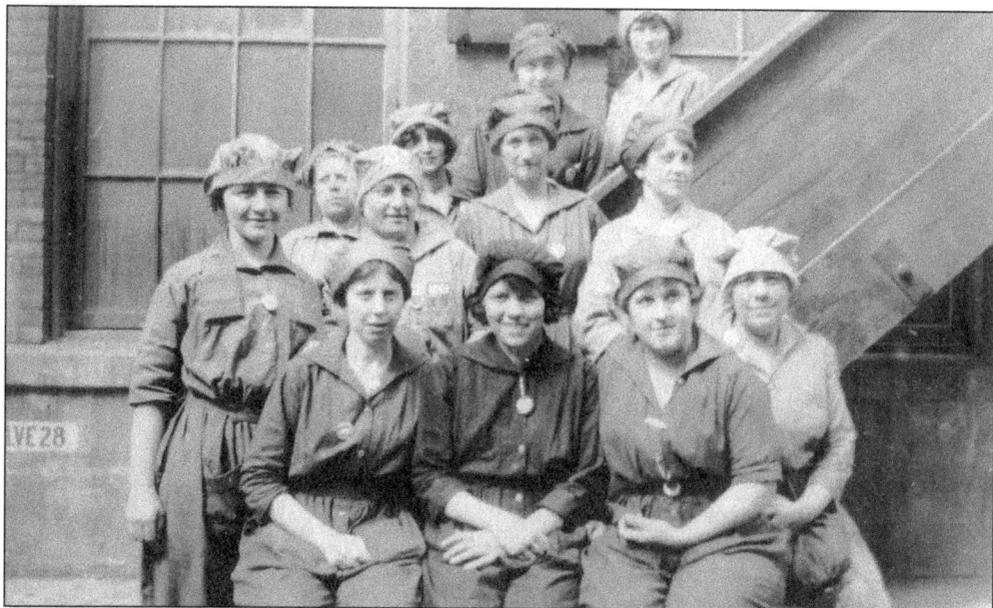

Women were an important part of the factory workforce. They were just as exposed as the men to the hazards of the business. The 12 women in this image from World War I may have helped make hand grenades for the war effort. In November 1918, two female workers were killed at the factory when a hand grenade exploded.

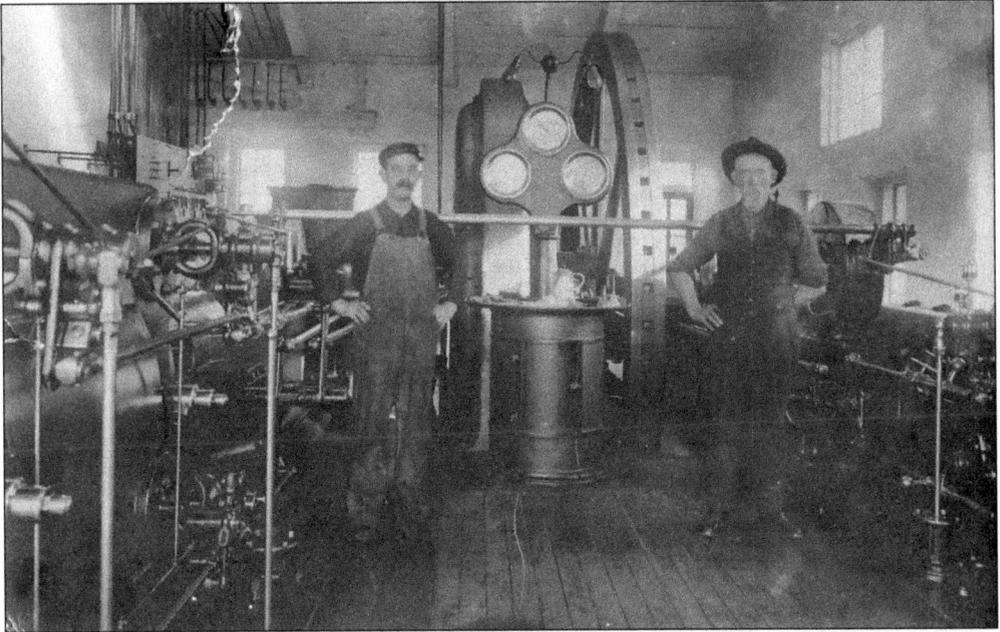

In spite of its hazards, E-B offered stable, long-term employment for many area residents. Alex McNulty (left) and Samuel Whitehead pose surrounded by the machinery of the factory about 1900. Whitehead was the son of one of the first employees in the original fuse factory, and his sons became long-term employees as well.

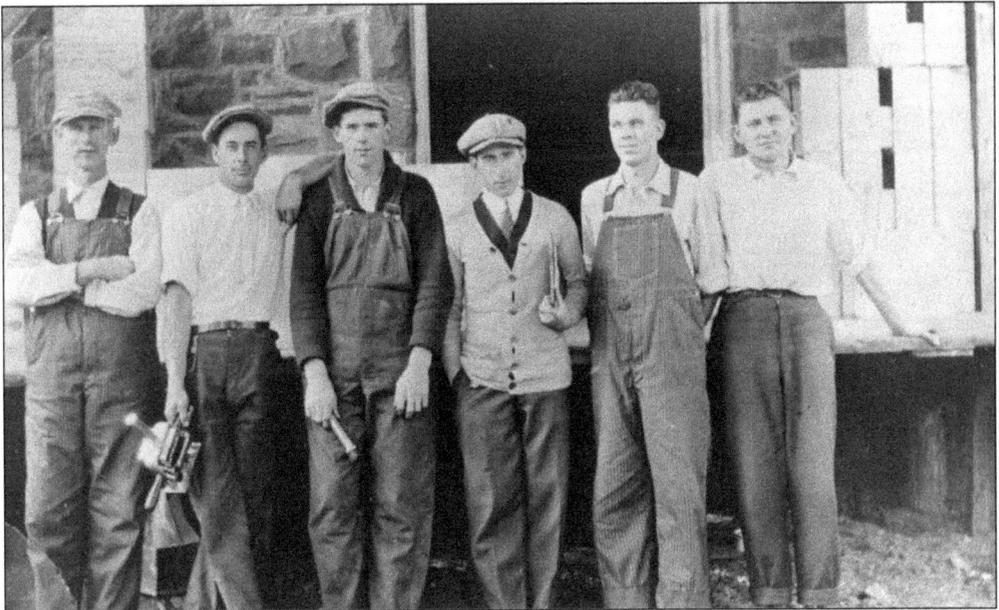

The shipping department crew posed for this picture around 1920. An older Charlie Graves stands on the left with his arms folded. Next to him are, from left to right, Charles Fletcher, Richard Curtiss, Leonard Miller, Edwin Jones, and Edward Quinn.

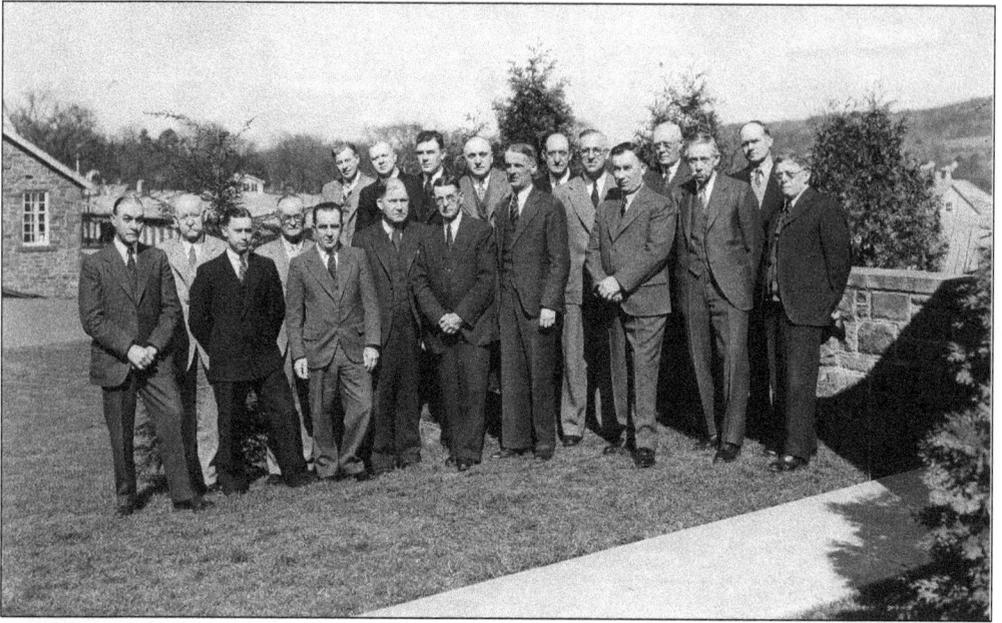

Supervisory and management positions at the company were the reserve of men for many years. Here, the foremen of the Simsbury and Avon plants are pictured in the 1930s. John Ketchin, at the far right, had worked for the company for four decades; several other men had worked for more than three.

Service Awards Presented at Dance

given in honor of the Employees

at Eno Memorial Hall

Thursday Evening, May 28, 1936

MR. ROBERT E. DARLING

We have stopped the dancing and asked for your attention because we wish to take this opportunity to introduce for the first time what we plan will become a permanent custom. I refer to the presentation of awards for length of service.

Heretofore we have honored a few men upon the completion of 50 years of service but 50 years is a long time to work for one company and few ever attain that distinction. Since we want to show our appreciation to all those who have worked for us a great many years, we are going to present tonight three classes of awards, namely, to those who have worked 25 years to 35 years, 35 years to 40 years and 40 years and over. The awards are respectively—silver service buttons, gold service buttons and testimonial scrolls. Since we are starting this custom tonight and wish to have it apply to all those eligible we are including those on our pension lists as well as those still actively working.

By way of explanation of the number of years of service credited to each employee, I may say that these years represent actual working time after deductions have been made for periods of time when the employee was for one reason or another not working for us. We have not, how-

44

ever, deducted for service away from the factory during the World War.

Mr. Robert Darling then announced the awards:—

SCROLL AND GOLD BUTTON

Thomas McCollum	—Worked	57 years	—Pensioner
Joseph R. Whitehead	— "	49	"
Jesse B. Haka	— "	47	"
Joseph R. Ensign	— "	46	"
Edward J. Dwyer	— "	44	"
James E. Mahoney	— "	44	"
William P. Quinn	— "	44	"
John H. Eno	— "	43	"
Walter W. Gillette	— "	43	"
Clinton B. Hadsell	— "	41	" —Pensioner
Charles G. Fletcher	— "	40	"
John E. Ketchin	— "	40	"

GOLD BUTTON

John J. Mahoney, Jr.	—Worked	39 years	
Mary Baldwin	— "	38	"
Otto E. Prowe	— "	38	"
Margaret Baldwin	— "	37	" —Pensioner
Katherine Edgerton	— "	37	"
Annie Prowe	— "	37	"
Henry E. Ellsworth	— "	36	"
Leon Edgerton	— "	36	"
William H. Hadsell	— "	36	"
Henry Spellman	— "	36	"
Wellington Case	— "	35	"
William G. Manion	— "	35	" —Pensioner
Alexander Pommeau	— "	35	"
George Whitehead	— "	35	"
Frank Zablocki	— "	35	"

45

The company celebrated its 100th anniversary in 1936. During a dance at Eno Memorial Hall, it recognized 83 employees for their years of service. Thomas McCollum headed the list with 57 years of service. Mary Baldwin won a gold button for her 38 years. Charlie Graves had previously retired, but that night the former powder wagon driver was acknowledged posthumously for his 51 years of service.

Eight

GETTING AROUND

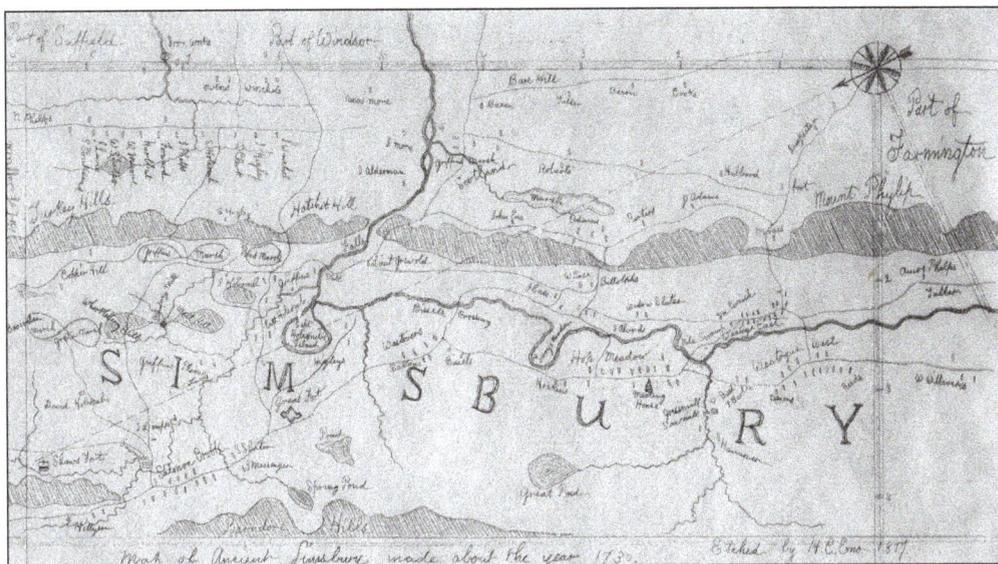

In 1670, Simsbury was a large town of 100 square miles divided by a river. Its size was later reduced, but the river remained, along with the debate over how and where to cross it. In 1877, H.C. Eno etched this copy of a map of the town originally drawn in about 1730. It marks two crossings at Hopmeadow and one each at Weatogue, Bissells, Crossing, and the Falls.

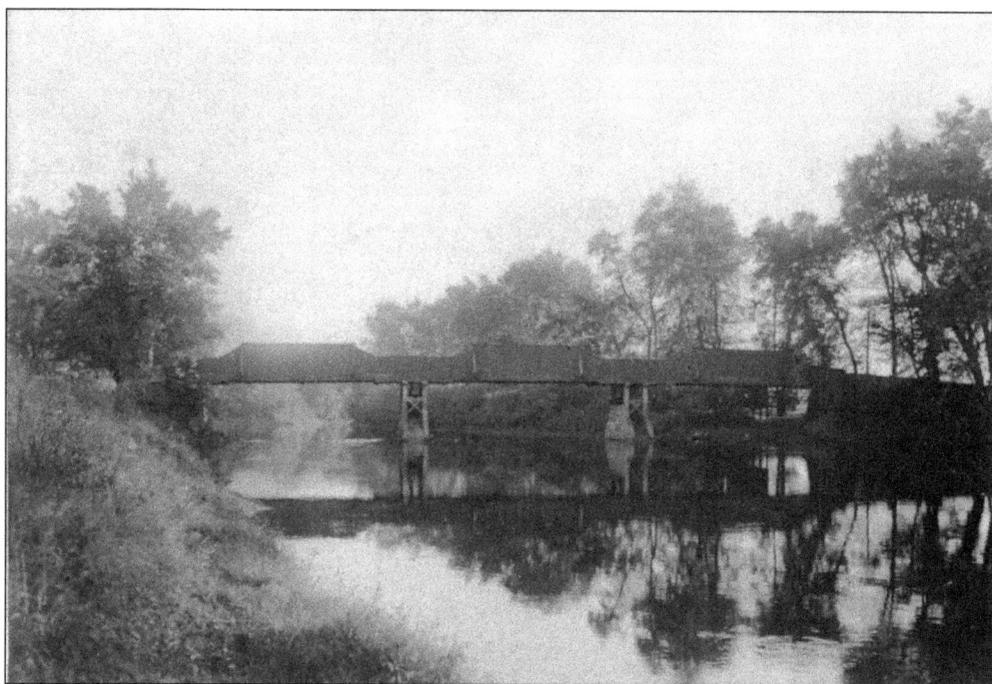

Townspeople resisted building bridges or ferries at the town's expense, so private groups paid for the crossings until the early 1800s. Bridges were mostly wooden affairs, supported by piers and abutments, like the bridge at Weatogue shown here. They were subject to damage from harsh weather and floods, and, on one occasion in 1875, a packet boat destroyed the Center Bridge, forcing it to be rebuilt.

By 1883, the town began to consider putting up more durable structures. In 1892, the selectmen hired John E. Buddington of New Haven to replace the Center Bridge with an iron bridge. Known as the Drake Hill Bridge, it survived this flood in 1938 and also one in 1955. Called the Flower Bridge, it remains in town as a landmark.

At first, townspeople personally had to make sure that the portion of the road that passed through or by their property was in good repair. In the early 1800s, the town paid men up to $1 a day to repair roads. By 1880, it formed a highway department to handle the work. Here, a crew and team of horses smooth the dirt and gravel surface of East Weatogue Street.

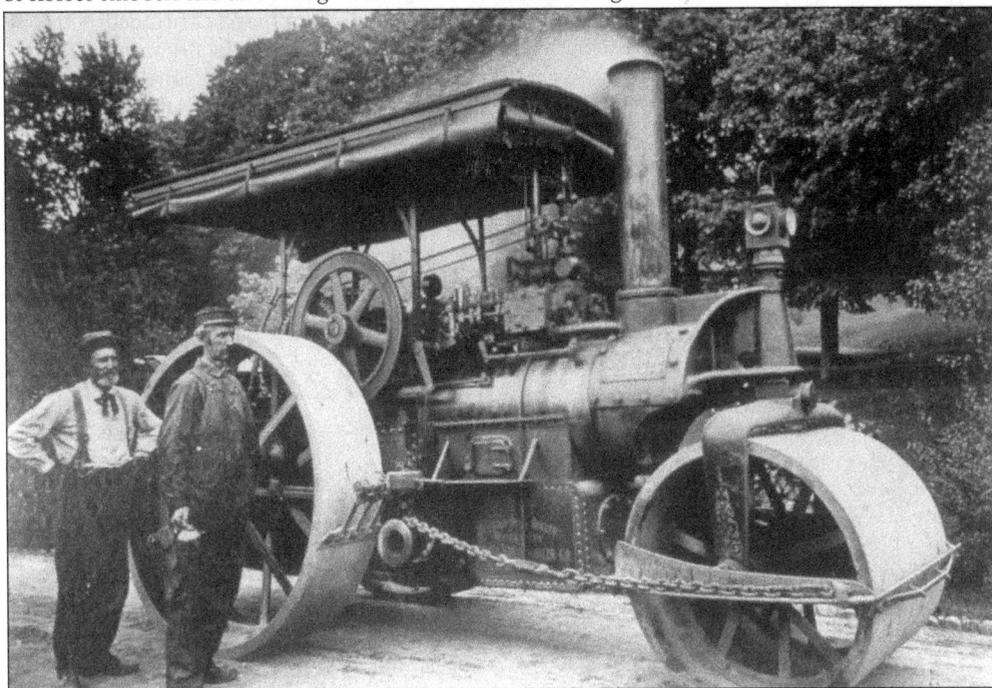

By the early 1900s, steam power had arrived to add to the muscle supplied by men and horses. The town bought a steamroller in 1907 for about $3,300 to help maintain its gravel roads. The man at the right is probably Charles E. Hoskins, the operator of the machine.

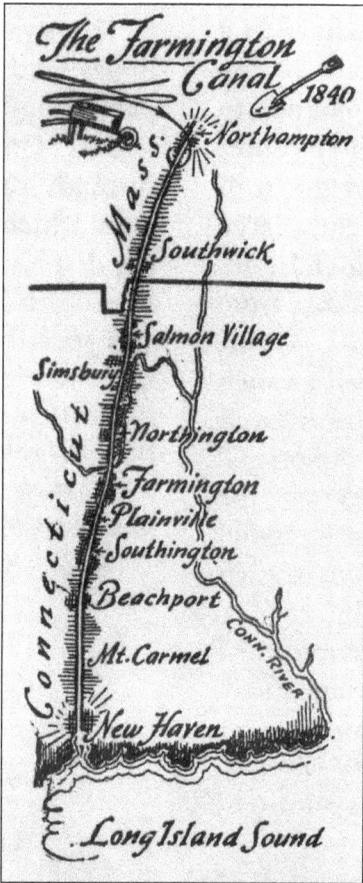

The Farmington Canal 1840

Northampton

Mass.

Southwick

Salmon Village

Simsbury

Northington

Farmington

Plainville

Southington

Beachport

Conn. River

Mt. Carmel

New Haven

Connecticut

Long Island Sound

In 1822, Simsbury joined in a venture to build a canal from New Haven to Northampton. Construction started when the first spade of earth was turned at a ceremony in Granby on July 4, 1825. By 1828, the section that passed through Simsbury was complete, and the Farmington Canal was open for business.

From the north, the canal ran along the west side of Hopmeadow Street to a point near the Methodist church, where it crossed to the east side of the street. It crossed again to the west side of the street near the Congregational church and continued south. Calvin Barber built an aqueduct to carry the canal waters over Hop Brook. The ruins of the aqueduct arches can still be seen today.

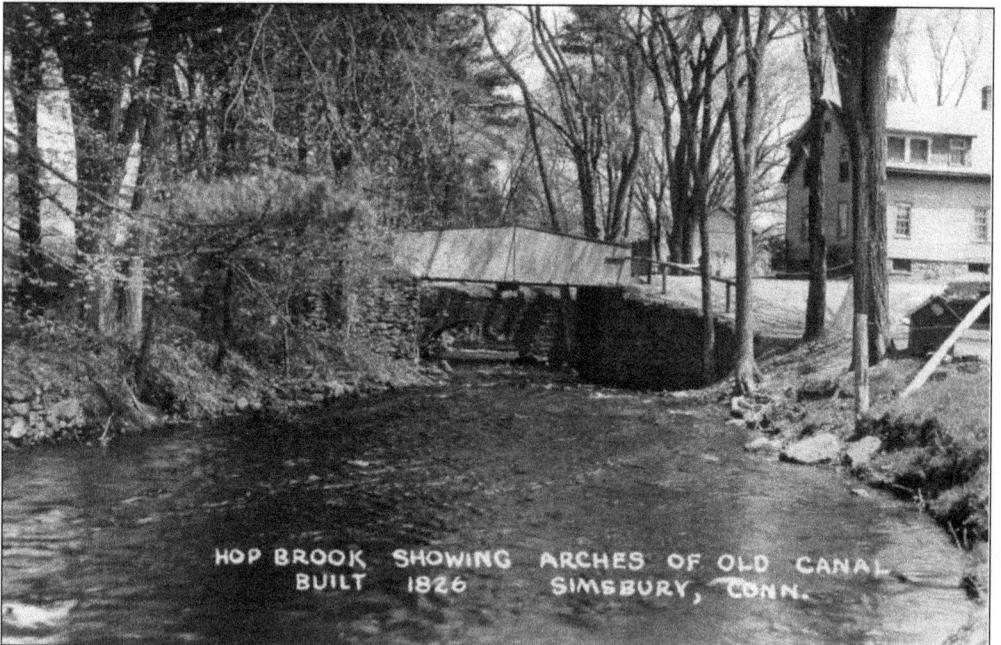

HOP BROOK SHOWING ARCHES OF OLD CANAL
BUILT 1826 SIMSBURY, CONN.

The canal never prospered, and by 1848, boats stopped running it. Hard on its heels came the railroads. First was the New Haven & Northampton Railroad, also known as the Canal Railroad. Extending north from New Haven, by 1850 it reached Salmon Brook in Granby. In 1871, a second line, the Connecticut Western Railroad, began to carry traffic between Hartford and points west. (Courtesy of William F. Curtiss Jr.)

2 WESTWARD.			HARTFORD TO STATE LINE.								FIRST SUB-DIVISION.			
Distance from Hartford	STATIONS.	Distance between Stations	1 Ex. Sun. 1st Class Passenger	3 Ex. Sun. 1st Class Milk and Passenger	201 Sun. only 1st Class Milk and Passenger	7 Daily 1st Class Milk and Express	5 Ex. Sun. 1st Class Passenger	317 Sat. only 1st Class Passenger	9 Ex. Sun. 1st Class Passenger	13 Ex. Sun. 1st Class Passenger		195 Daily 2d Class Freight		
			A M	A M	A M	A M	A M	P M	P M	P M		P M		
0.00	Hartford........N	0.00	8.15	8.40	11.15	2.00	4.40	5.50
0.34	Walnut Street.....	0.34	8.18	8.43	11.18	2.03	4.43	5.53	7.00
4.13	Cottage Grove......	3.79	f 8.24	f 8.49	11.24	f 2.10	ᴴ 4.50	f 5.59	7.10
5.68	Bloomfield........D	1.55	s 8.28	s 8.53	ᴴ11.27	f 2.13	s 4.53	s 6.02	7.14
8.87	GriffinsD	3.19	s 8.35	s 8.59	f11.32	f 2.19	s 4.59	s 6.09	7.21
9.78	Barnards	0.91	s 8.39	s 9.03	f11.34	f 2.23	f 5.02	f 6.12	7.24
11.80	TariffvilleD	2.02	s 8.45	s 9.09	s11.40	s 2.29	s 5.08	s 6.19	s 7.45
13.32	Hoskins............	1.52	f 8.49	f 9.12	11.43	f 2.32	f 5.11	f 6.23
15.07	Simsbury........N	1.75	s 8.56	s 9.18	s11.47	s 2.37	s 5.19	s 6.32	s 8.10
17.44	Strattons..........	2.37	f 9.00	f 9.22	11.51	f 2.42	5.23	f 6.36
21.88	Canton........D	4.44	s 9.11	s 9.31	f11.58	s 2.50	s 5.32	f 6.45	8.27

The presence of two railroads ensured the town was well supplied with rail service. Each line ran several trains daily. Canton and Tariffville were just minutes away from Simsbury Center. Simsbury students continuing their education after grammar school took the train into Hartford to attend classes. After the completion of the new high school in 1907, students from neighboring towns rode the train to attend classes in Simsbury.

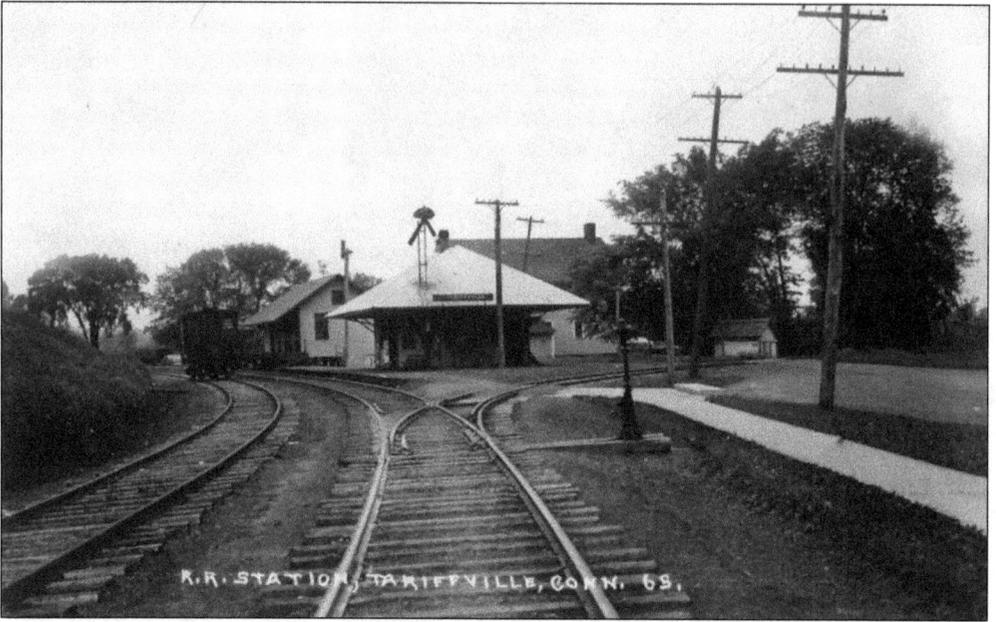

R.R. STATION, TARIFFVILLE, CONN. 6S.

Because of its importance as a manufacturing center, Tariffville enjoyed service from both railroads. In 1850, the Canal Road ran a one-mile extension east to connect the village to its main line. In 1869, the Connecticut Western Railroad chose to run its line west through Tariffville rather than by a more southerly route through Farmington. The tracks started in Hartford, crossed over the Farmington River beyond Tariffville station to other stops in Simsbury, and then traveled through Satan's Kingdom in New Hartford and other points in Connecticut on their way over the Poughkeepsie Bridge to stations in upstate New York.

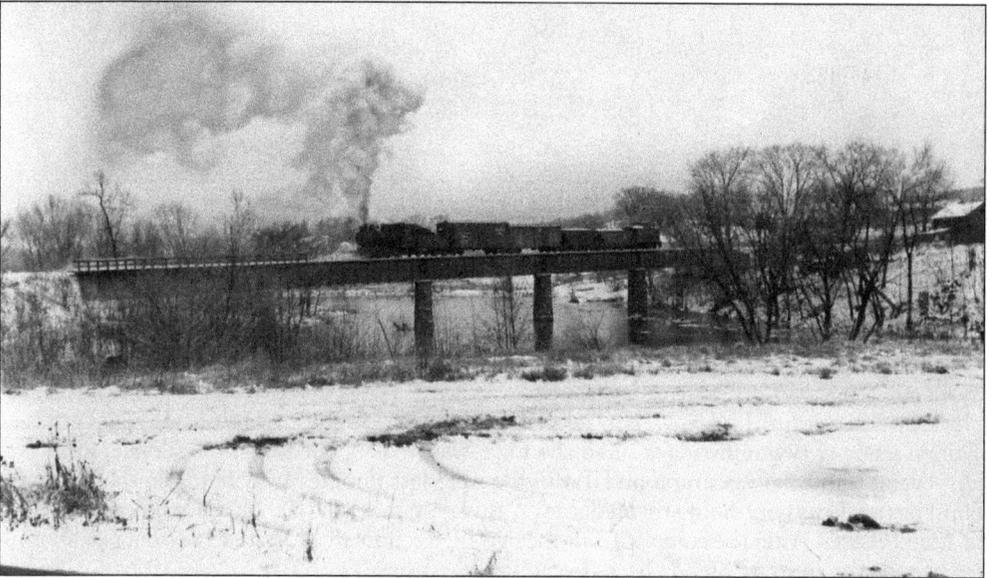

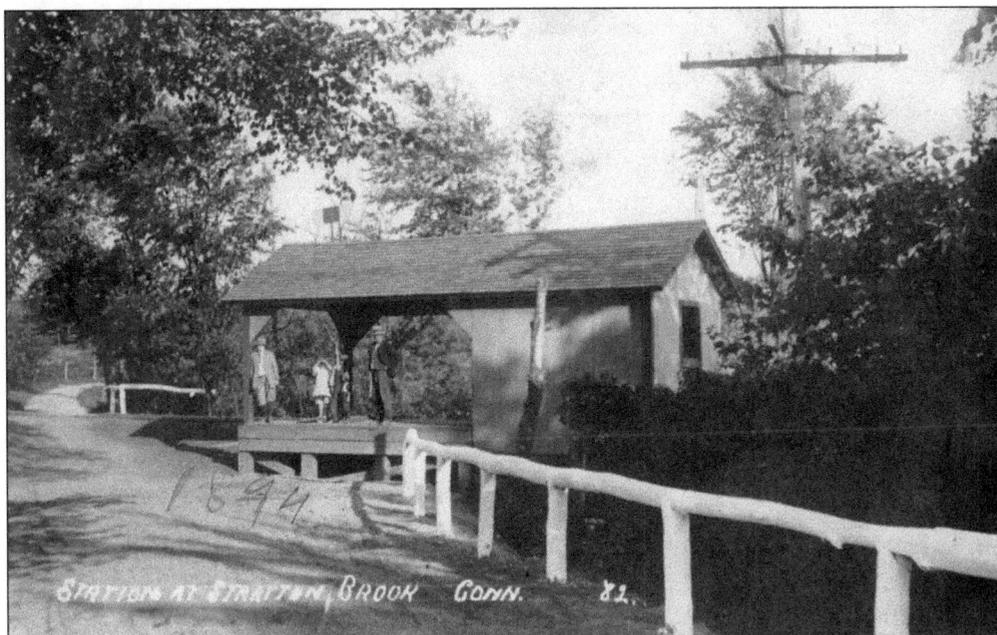

Three small stops served the town in addition to the main stations in Simsbury Center and Tariffville. The Canal Road maintained one in Weatogue just north of the district school. At the Stratton Brook station, shown here, Connecticut Western trains picked up passengers as well as dairy products from West Simsbury farms.

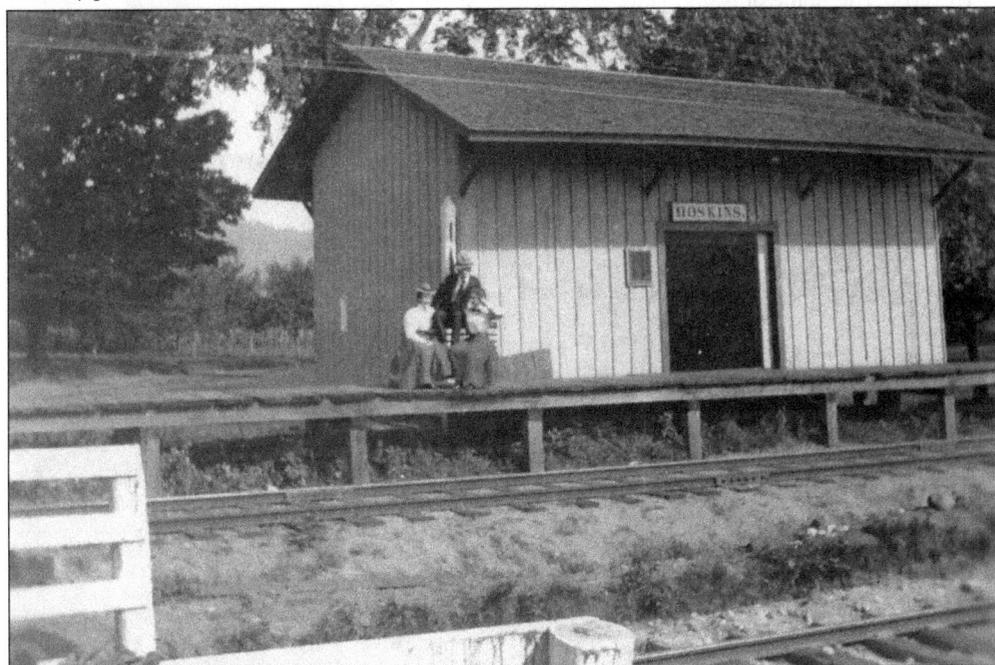

The Hoskins Station stop, near Hoskins Road, was the northernmost stop in town. Here, passengers might catch the Connecticut Western to travel to Tariffville, Bloomfield, or Hartford. Like the Stratton Brook station, it was a "flag stop" where the train took on or dropped off passengers on signal.

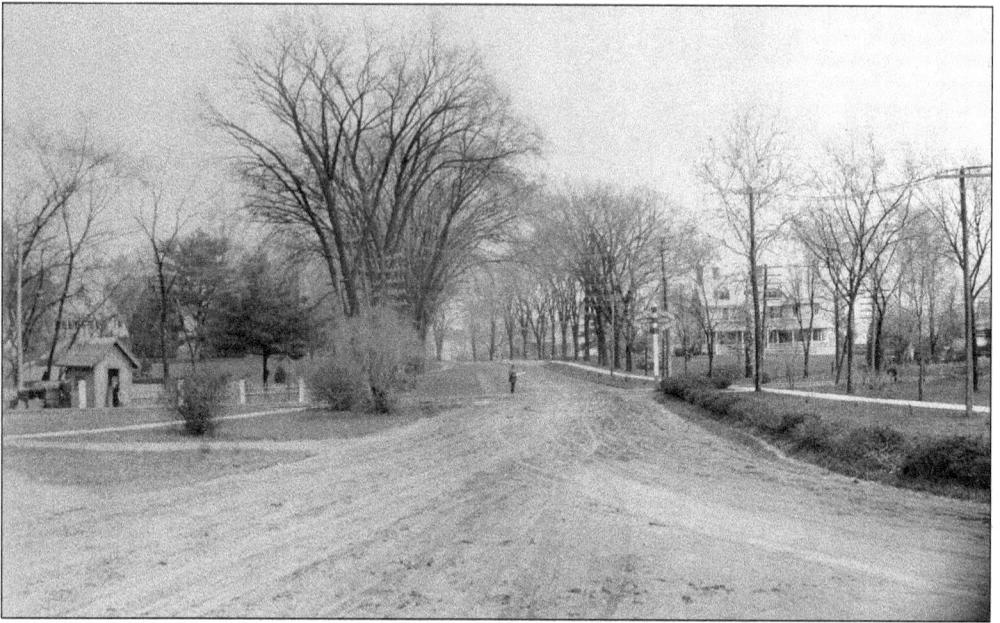

Train travel was not without its dangers. Railroad crossings could be hazardous for pedestrians and automobiles. For a time, the railroads employed crossing guards; the one in this photograph waits for the westbound train (on the far right) to cross an unpaved Hopmeadow Street. Behind the small guard house on the left is Eaglewood, the home of Antoinette Eno Wood. On the right is Treverno, the home of Ralph Hart Ensign.

This image, taken some years later, shows the tracks crossing Hopmeadow Street, now paved, as they emerge from between the Congregational church and the old town hall. On the left stands the Robert Darling residence, later known as the Cannon Building. (Courtesy of William F. Curtiss Jr.)

Train wrecks, though infrequent, could be deadly. One of the most famous occurred in Tariffville on January 15, 1878. That night, the bridge spanning the Farmington River collapsed under the weight of a Connecticut Western train carrying passengers home from a revival meeting in Hartford. A total of 13 people died, and many more were injured. The exact cause of the collapse was never fully determined.

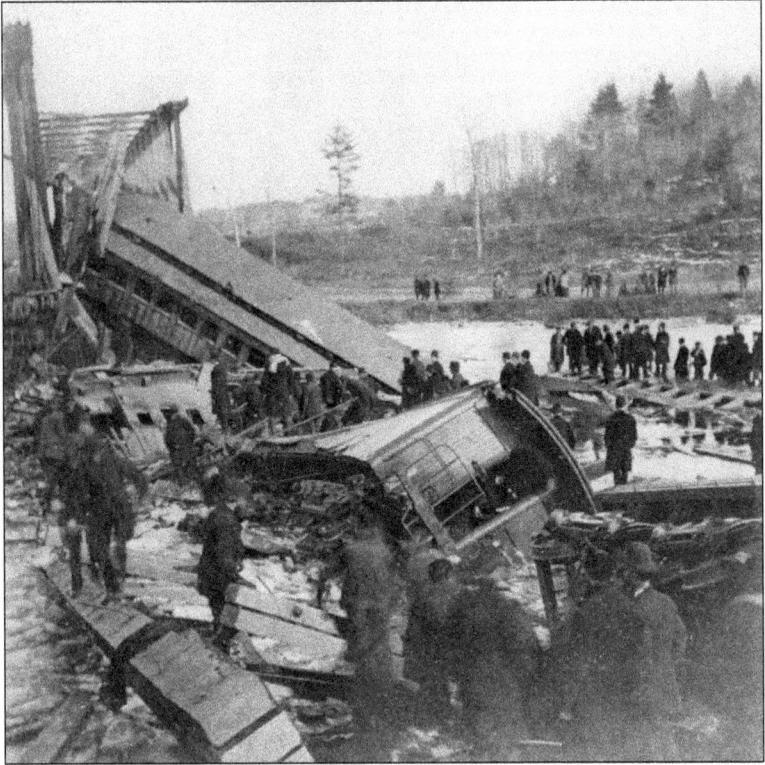

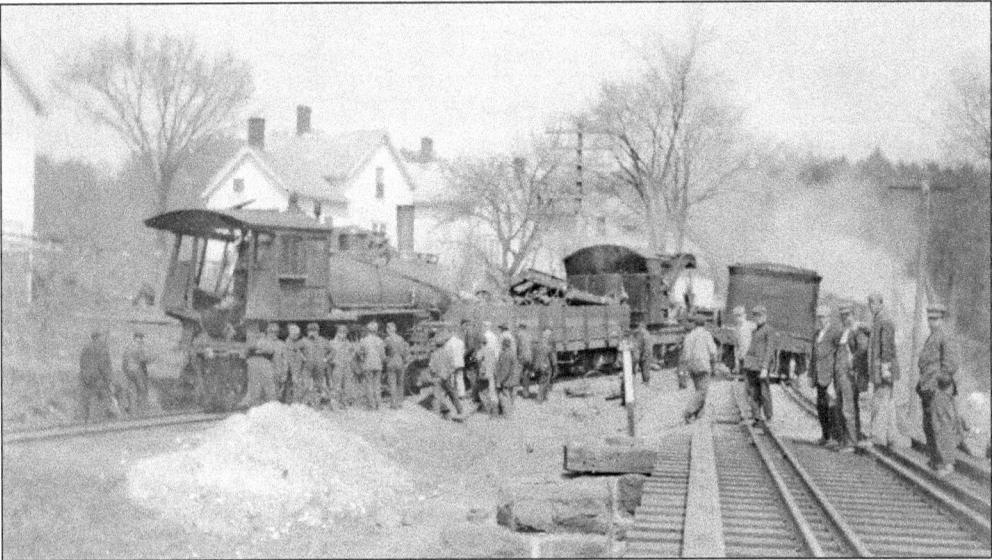

A less calamitous accident occurred on April 18, 1911. A passenger train traveling eastbound collided with a freight train extending out from the siding at the gristmill on West Street. Although the train cars were badly damaged, casualties were minimal. Two people received minor injuries, and there were no fatalities.

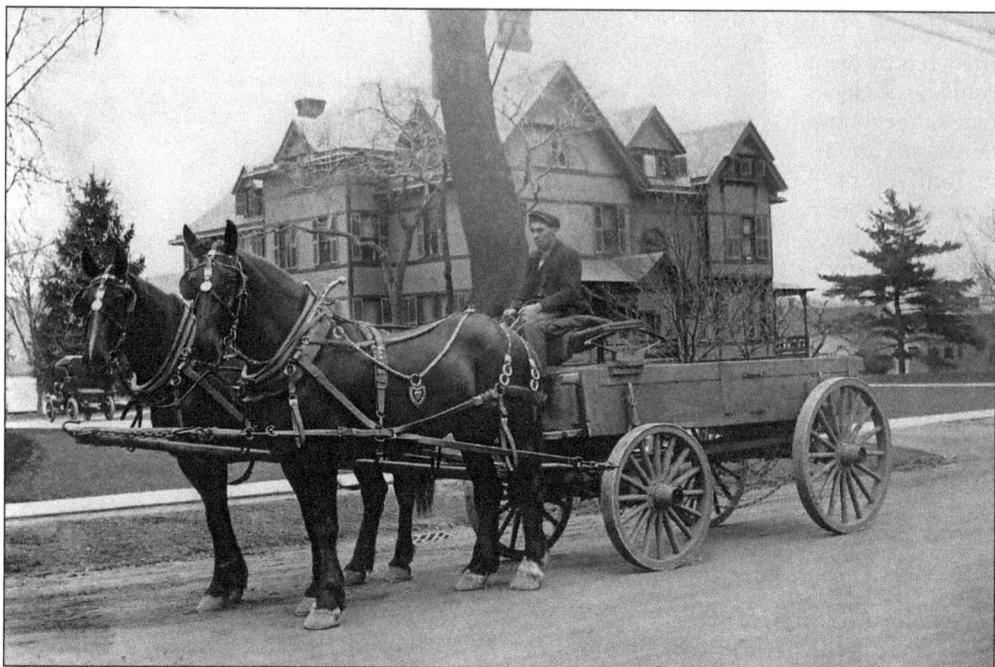

Until the late 1800s, local travel relied on horsepower for both business and pleasure. The sight, sound, and smell of horses were features of everyday life. Tom Hunt holds the reins of this team and wagon parked on Hopmeadow Street in front of the Ellsworth house. As a teamster, he worked for the town and also hauled granite up Plank Hill Road for cemetery monuments. (Courtesy of Richard E. Curtiss.)

Horses and buggies moved people as well as property, and just as they do today, owners took pride in their ride. Andrew Welch, who served for many years as Simsbury's first selectman, was also the superintendent of the Eaglewood estate on Hopmeadow Street. Here, he strikes a pose in front of the train tracks, with his horse as neatly attired as he.

116

Cars first appeared on Simsbury streets beginning about 1900 when Joseph R. Ensign purchased an Oldsmobile complete with tiller steering and a one-cylinder engine. Other cars soon appeared and, within a few years, became familiar sights on village streets, at least during good weather. Josephine Toy is seated in the car shown here.

The introduction of the Model T in 1908 eventually made private ownership of cars possible for many, but there was also a need for public transportation. Livery businesses provided automobile services to other towns and to downtown Hartford. In 1915, Joseph Tousignant began a jitney service to run small buses to Hartford and nearby villages on a regular schedule. Walter A. Griffin ran a jitney operation as well.

117

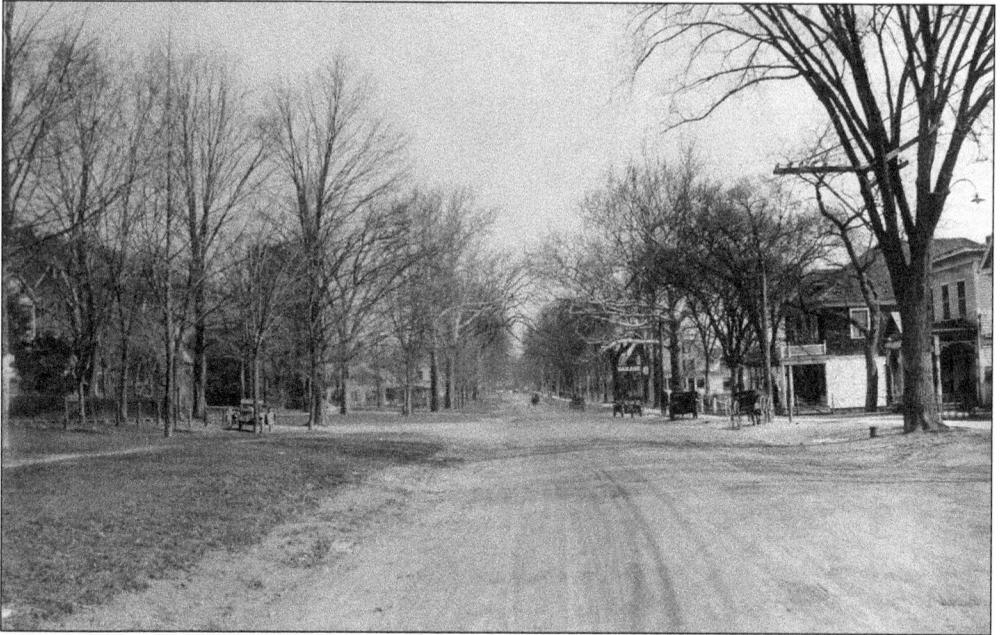

As streets and roads were paved and the cost of cars came down, automobile travel became more routine. For a time, cars and horses shared the roads, as shown in this photograph of Hopmeadow Street. By 1916, however, the *Hartford Courant* was reporting that travel by automobile had become so common in Simsbury that few horses were available for livery service.

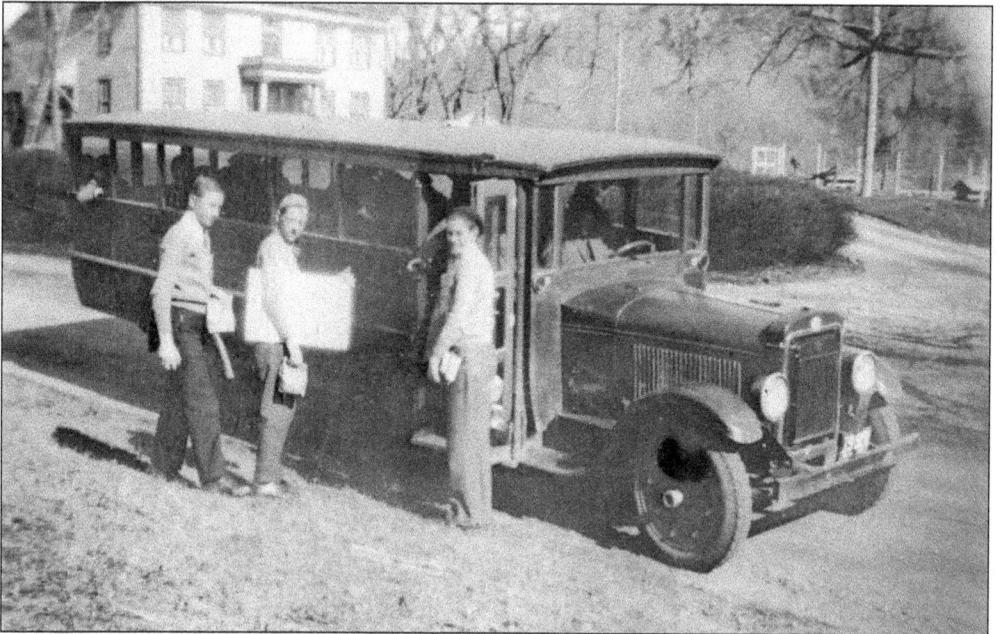

By 1929, automobiles were the preferred means of transportation, even for schoolchildren. In that year, the town entered into a four-year contract with the Salter Express Company to transport students from the Bushy Hill and West Simsbury areas to the Central Grammar School and the high school. From left to right, Oliver Tuller, George Comstock, and Robert Elliott prepare to board the bus in West Simsbury Center in this 1931 photograph.

Nine

SCHOOLS

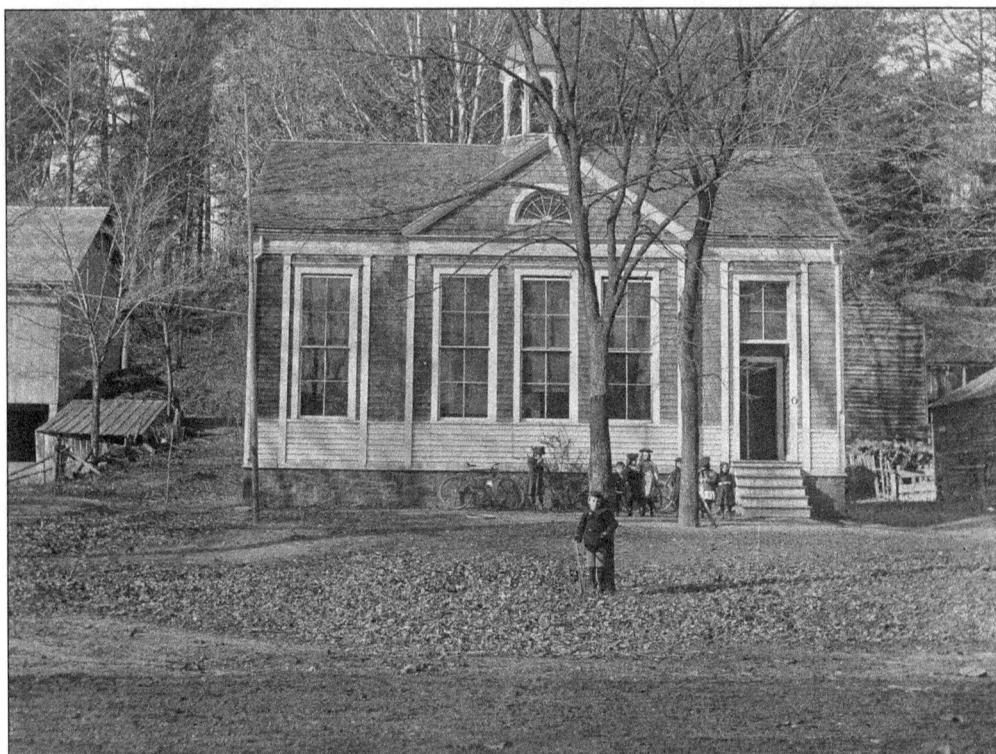

The district school was common to many Connecticut towns. Simsbury had 13 districts in 1823. Two districts, Scotland South and Scotland North, eventually fell within Bloomfield's boundaries, and the New and Center Districts replaced the Middle District. The Hop Meadow District School is shown here. It was located north of the Methodist church. After it closed in 1913, the building was moved across the street and used as a garage.

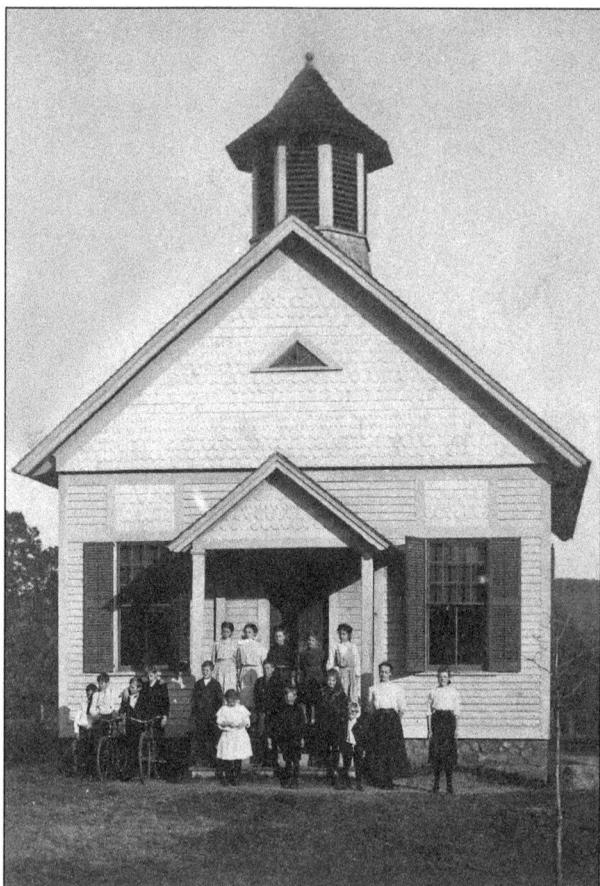

District schools taught students in grades one through nine. Usually, one teacher was assigned to each school. Until 1920 or so, children were required to attend school until age 14, but the law was not strictly enforced. Attendance at the school in West Weatogue, seen here, varied between 20 and 40 pupils.

Most of the school buildings were one-story wooden structures. The Center District School on Firetown Road and the Farms District School in West Simsbury, seen here, were exceptions; both were built of stone. The latter also served as a meeting site for the Community Club of West Simsbury, which held plays and entertainments there. The building is now used as a private residence.

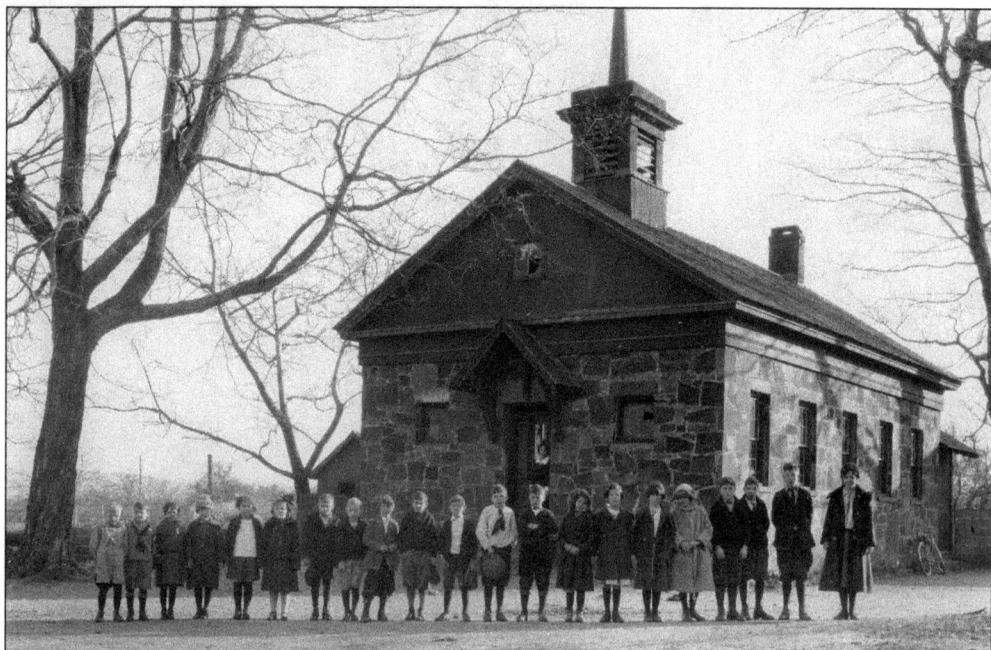

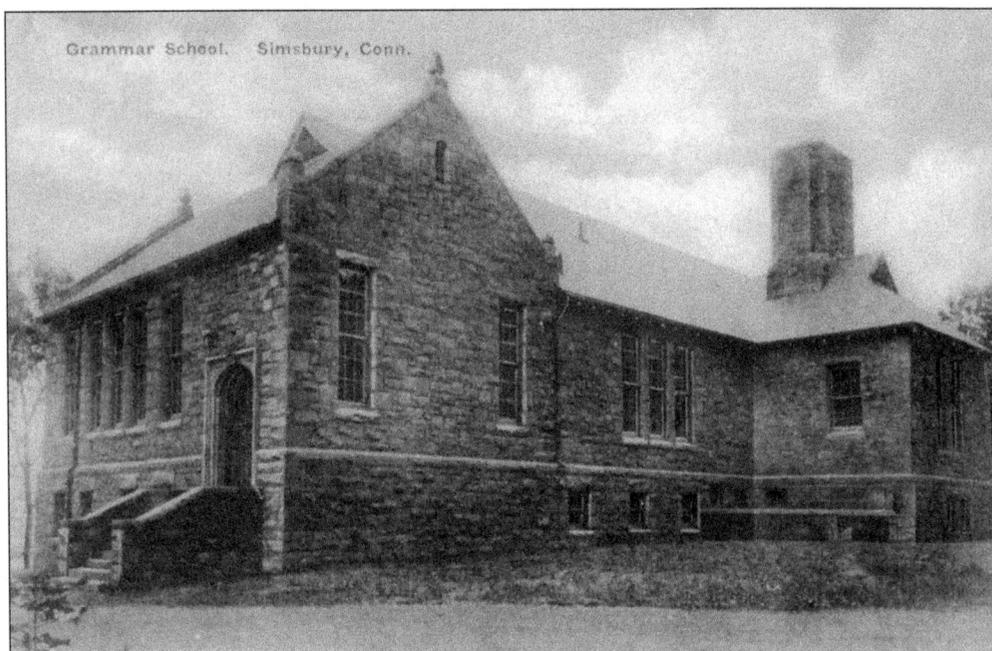

Grammar School. Simsbury, Conn.

Beginning in the early 1900s, the town consolidated the district schools. It built a new grammar school in Central, funded in part by Ralph Hart Ensign, on Massaco Street in 1913. The schools in Weatogue, Hopmeadow, and Center Districts were closed and their students were sent to Central. The Meadow Plain and Union Districts followed in 1930, with the Farms District in 1932.

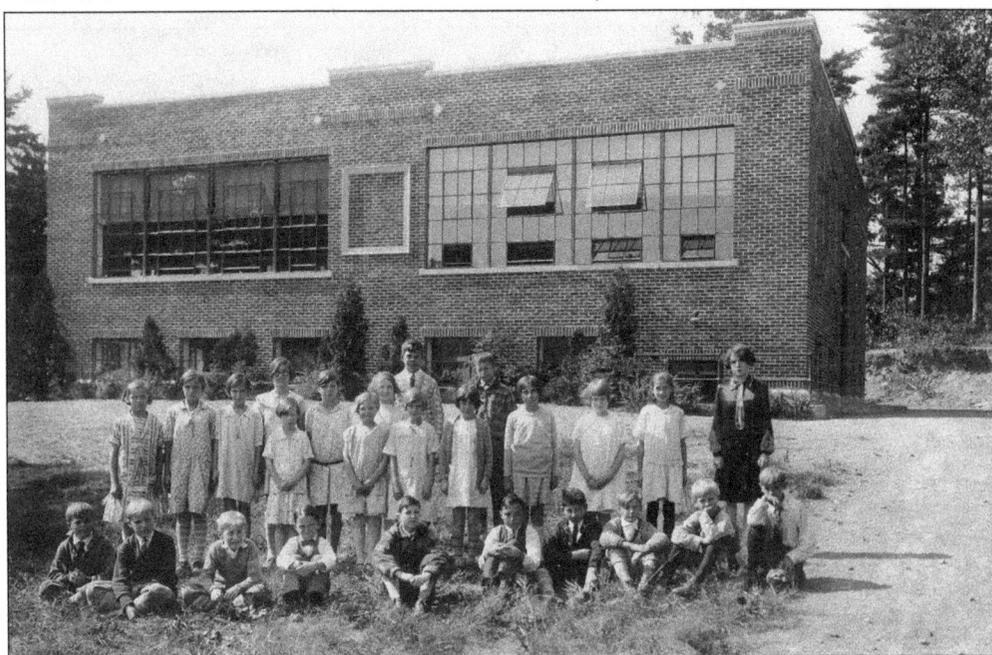

In 1927, the town built the new South School at Hazel Meadow on land donated by the Ensign-Bickford Company. Many immigrant families lived in the tenement housing near the factory. Their children attended classes during the day, and by 1930, the adults could take evening courses in English and arithmetic under the tutelage of a director of adult education.

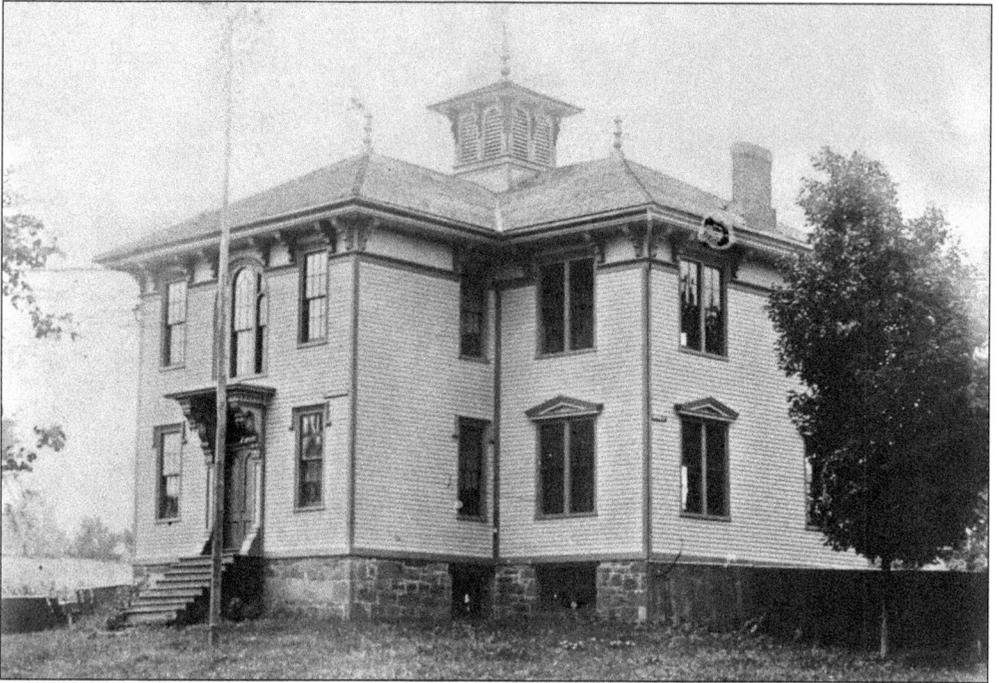

The Tariffville District School was the largest in the town. It had four rooms in its two stories and was one of only two schools in town to enjoy the luxury of a furnace. It was also one of the first district schools in the state to have its own library. In 1925, a new grammar school replaced it.

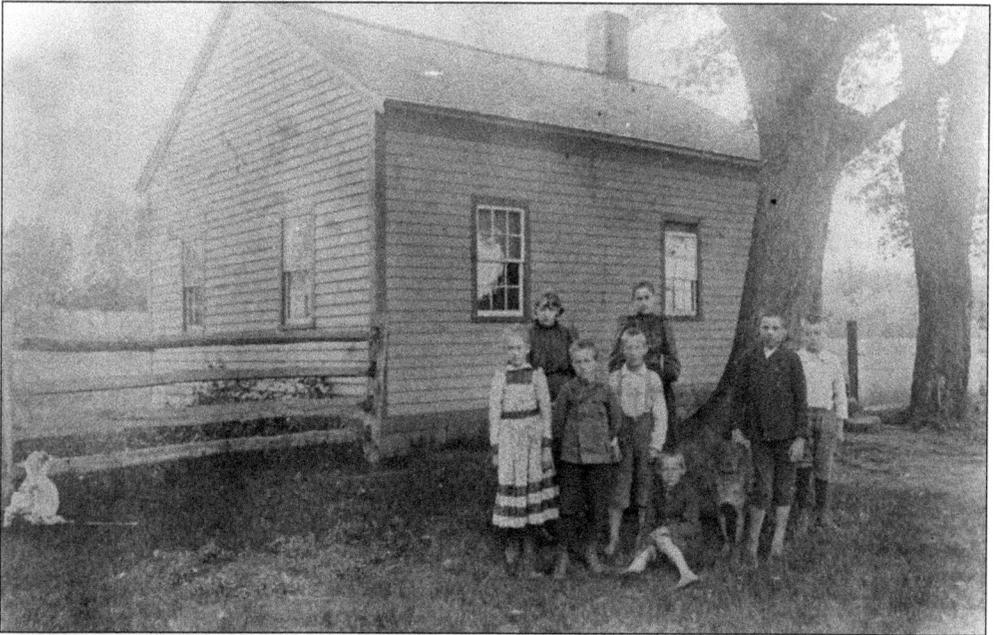

The first Tariffville school had joined with the Griswold Village School in 1865. The Hoskins Station School, shown here, consolidated with Tariffville in 1926. The building was eventually used as an office by the Wagner Ford dealership. In 1930, the students at the East Weatogue and Terry's Plain began attending Tariffville, and those two district school buildings closed.

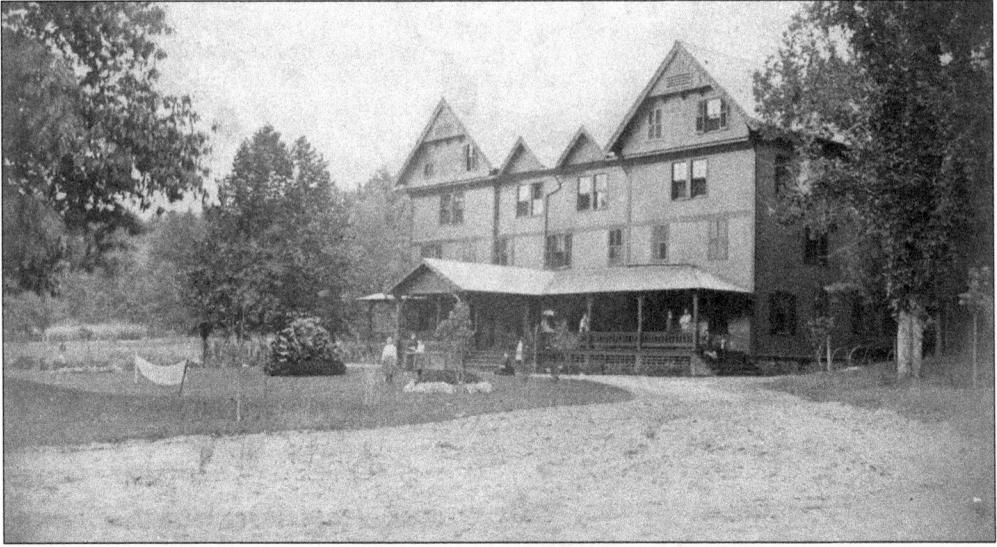

No public high school existed in Simsbury before the early 1900s. In 1879, John B. McLean, grandson of former Congregational minister Allen McLean, started a private school called the Simsbury Academy. In 1888, he built a new structure on Hopmeadow Street and renamed the school the McLean Seminary. It served as a school until the early 1900s. It was razed in 1963 to make room for the Sycamore Apartments.

Students wanting to continue their education after grammar school, like Carrie Shepard Rowley (second from left in the first row), attended private or "select" schools, such as John B. McLean's, to prepare them for college and careers in business. The McLean Seminary also offered courses to train teachers. Some of the boarding students in this photograph may have been preparing for jobs as district schoolteachers.

In 1903, the town finally decided to establish a high school. The first classes met on the third floor of the McLean Seminary. A few years later the town voted to erect a new high school, but it was built entirely with private funds. Horace Belden, shown here, donated most of the money.

A.J. Ketchin & Son of Tariffville won the contract to erect the building. On December 27, 1907, the town gathered to dedicate its new school, located at 933 Hopmeadow Street. Ex-governor George McLean was on hand as well as other local dignitaries. In 1967, the town built a new high school on West Street. The former high school now houses town offices, the probate court, and the police department.

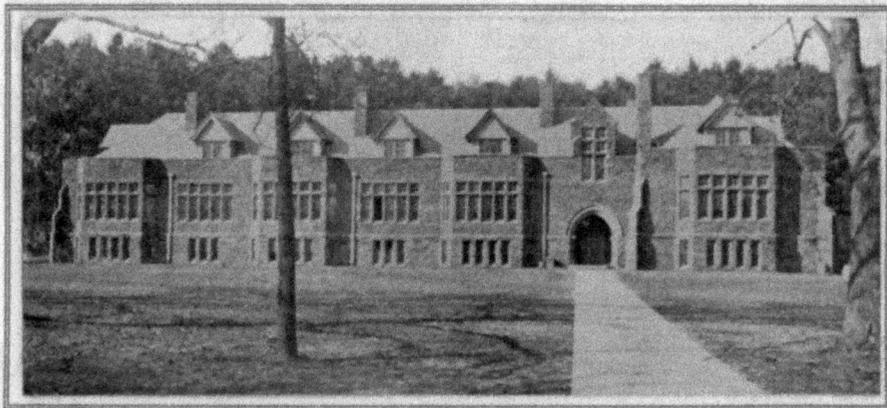

Simsbury High School
Opening Exercises
December 27th, 1907
at 2.30 p. m.

Charles I. Matthews, a former Harvard player, enjoyed success coaching Simsbury High School teams in the early 1920s. Above, he stands at the far left of the third row with the 1921 football team. The team finished the season undefeated and was considered one of the top small-town teams in Hartford County. Matthews also coached both the boys' and girls' basketball teams. In the 1921–1922 season, the boys' team won the county league championship. The girls' team, shown here, compiled a 10-3 record but lost in the league championship game to Collinsville. Coach Matthews is flanked by Ethel Goodwin, left, and Alberta Messenger.

In 1897, J.B. McLean became Simsbury's first superintendent of schools. He is credited with raising teaching standards, modernizing the curriculum, and improving school facilities. He died in 1923 after a lifetime of dedication and service.

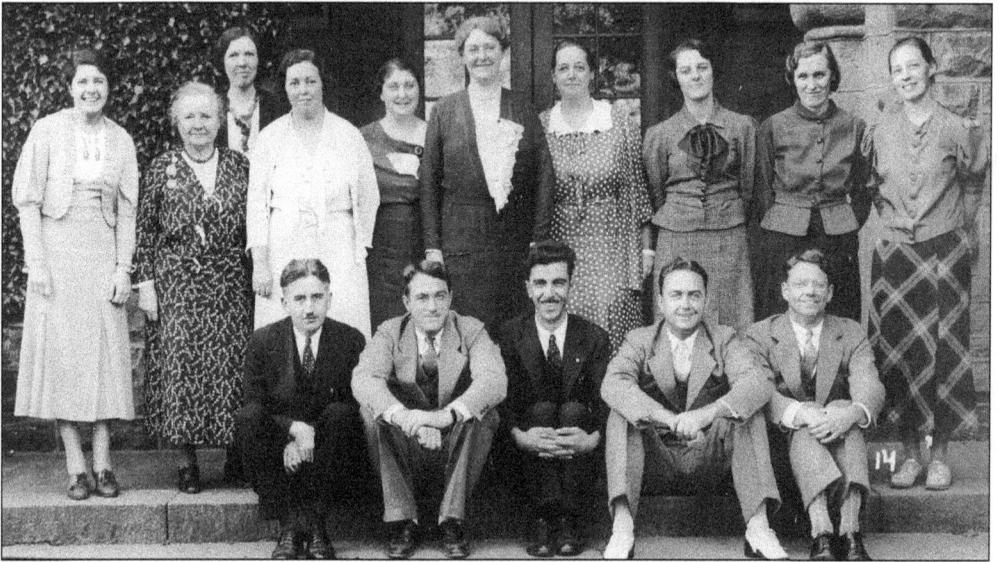

The faculty of the high school posed for this picture in 1934. Henry James, seated in the middle of the first row, became the superintendent of schools in 1936 and held that post until 1959. Eliot P. Dodge, seated at the far right, served as a teacher, high school principal, and general supervisor of instruction during his long career.

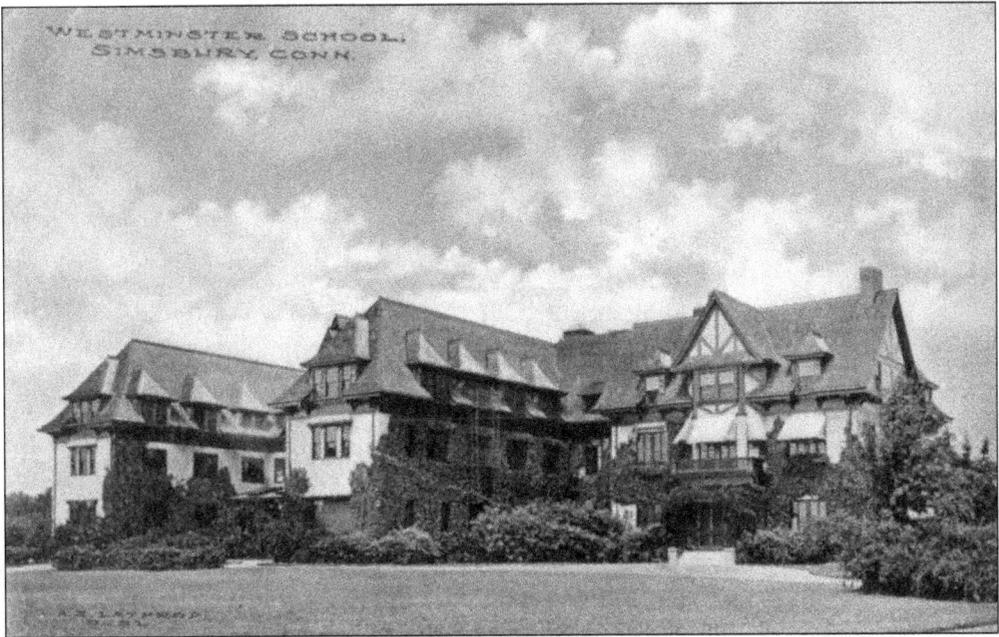

Two private schools have enjoyed a long association with Simsbury. In 1900, the Westminster School moved to Simsbury from Dobbs Ferry, New York. Its campus occupies most of Williams Hill, just north of Simsbury Center and west of the Farmington River. It was originally a boys' boarding school but is a coeducational boarding and day school now.

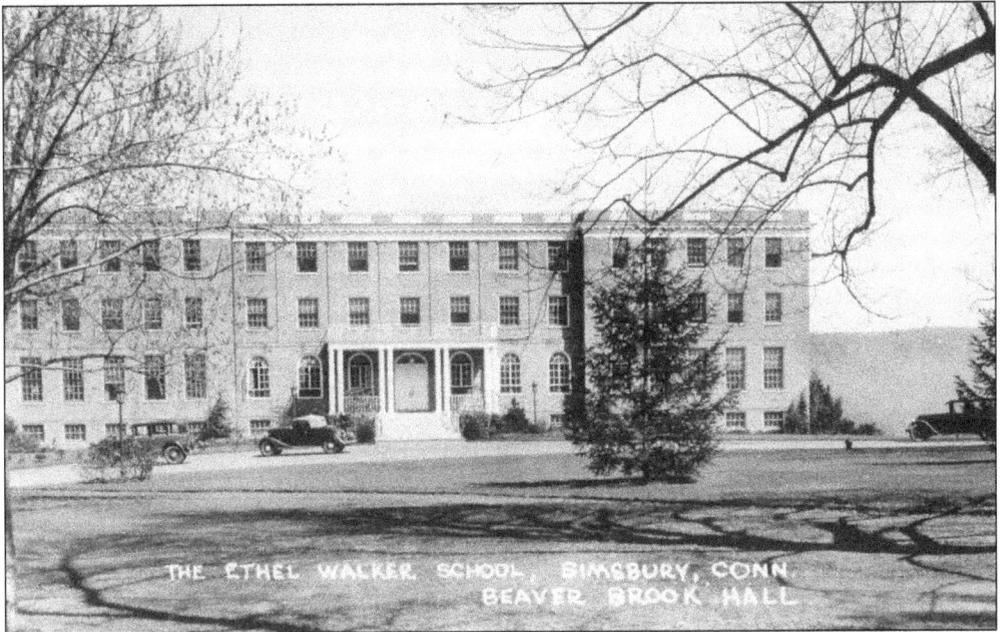

After six years in Lakewood, New Jersey, Ethel Walker moved her school for girls to Simsbury in 1917 (see page 48). When the original building, Beaver Brook Hall, burned in 1933, Walker rebuilt on the same site and called the new structure, pictured here, Beaver Brook Hall. Today, it serves as the focal point on the school's extensive grounds. The Ethel Walker School is known both for its strong academic traditions and also for its world-class equestrian program.

Visit us at
arcadiapublishing.com

www.ingramcontent.com/pod-product-compliance
Lightning Source LLC
Chambersburg PA
CBHW050554110426

42813CB00008B/2353